ANGLOMANIA

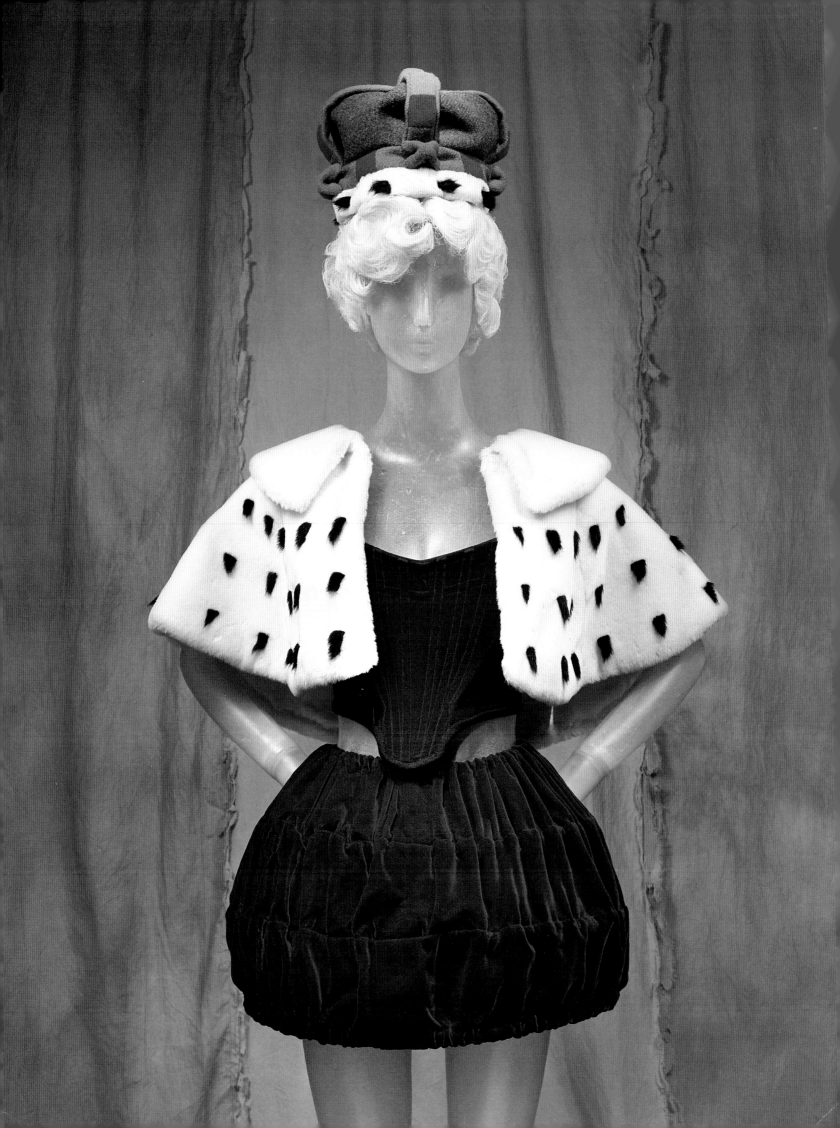

AngloMania:
Tradition and Transgression in British Fashion

Andrew Bolton
With an Introduction by Ian Buruma

The Metropolitan Museum of Art, New York
Yale University Press, New Haven and London

This catalogue has been adapted from the exhibition

"AngloMania: Tradition and Transgression in British Fashion,"

held at The Metropolitan Museum of Art, New York,

from May 3 to September 4, 2006.

The exhibition and this catalogue are made possible by

BURBERRY

Additional support has been provided by

CONDÉ NAST
PUBLICATIONS

Published by The Metropolitan Museum of Art, New York

John P. O'Neill, Editor in Chief

Gwen Roginsky, Associate General Manager of Publications

Joan Holt, Editor

Paula Torres, Production Manager

Design by Takaaki Matsumoto/Matsumoto Incorporated, New York

Photography by Joseph Coscia Jr. of the Photograph Studio, The Metropolitan Museum of Art

Color separations by Professional Graphics, Inc., Rockford, Illinois

Printed and bound by Mondadori Printing S.p.A., Verona, Italy

Front cover: David Bowie and Alexander McQueen. Coat worn by David Bowie, 1996

Back cover: Malcolm McLaren and Vivienne Westwood. Ensemble, ca. 1977–78

Frontispiece: Vivienne Westwood. Ensemble, autumn/winter 1987–88

Cataloging in Publication Data is available from the Library of Congress

ISBN: 978-1-58839-206-0 (The Metropolitan Museum of Art)

ISBN: 978-0-300-11785-1 (Yale University Press)

CONTENTS

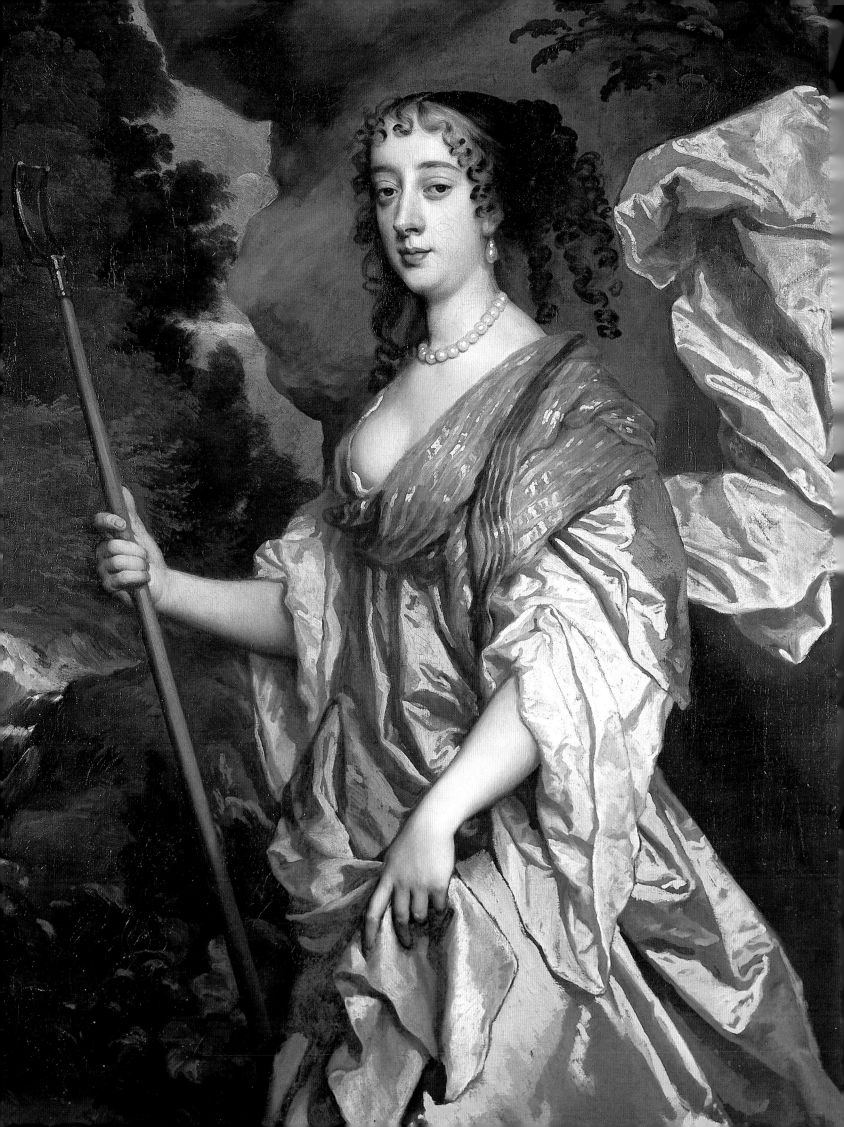

The year 2006 marks the 150th anniversary of Burberry. As we reflect on the signature qualities that have enabled Burberry to withstand the test of time, our British provenance resonates as a treasured hallmark.

It is, therefore, a great honour to collaborate with The Costume Institute of The Metropolitan Museum of Art in support of "AngloMania: Tradition and Transgression in British Fashion." Capturing the spirit of British style in its juxtaposition of modern clothing with period art and furniture, the exhibition and this catalogue highlight iconic looks from Burberry alongside those of our colleagues and countrymen in the UK fashion field.

We see "AngloMania" as a glorious salute to our heritage, as well as to the unparalleled range, diversity, and creativity of design in Great Britain today. For this recognition, we owe our thanks to The Costume Institute and the extraordinary team that made it possible.

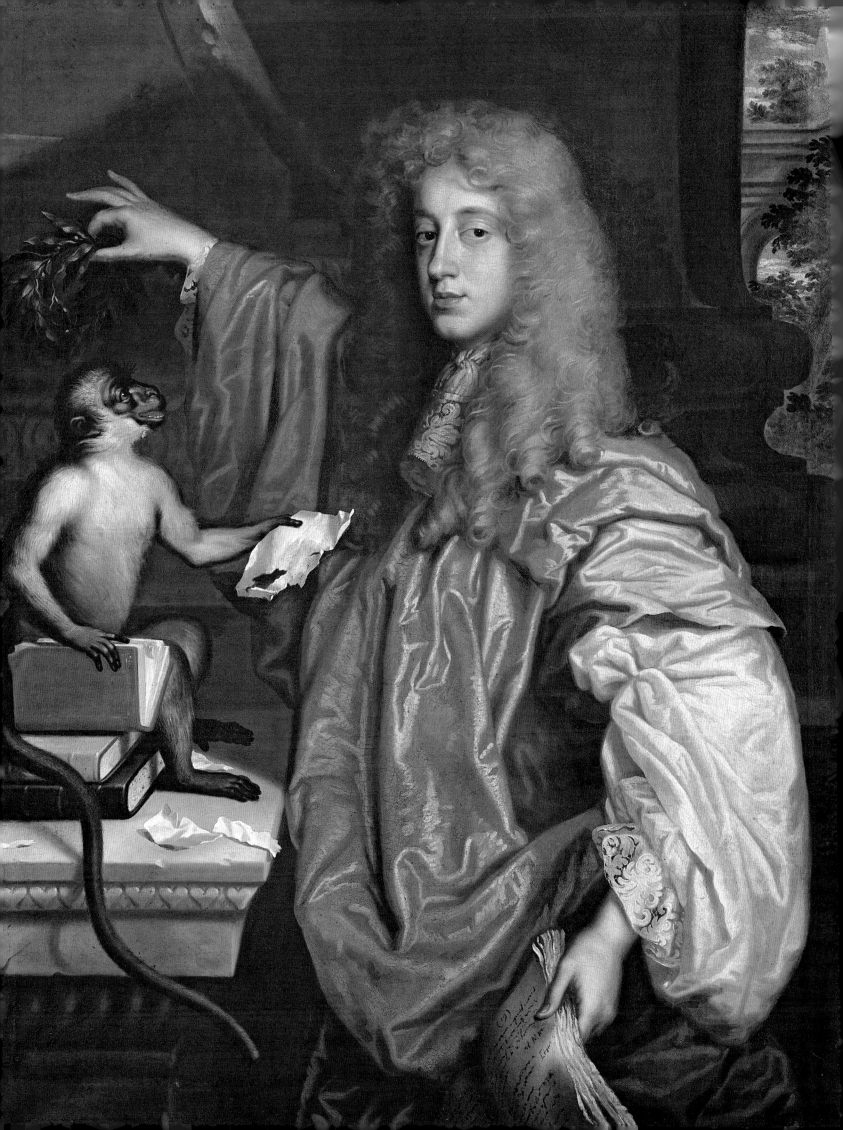

Over the past thirty years, British fashion has been defined by a self-conscious assimilation of historical references. In their search for novelty, designers have exhumed and adapted past styles in an audacious manner. Their historicism, while selective, is rarely literal or time specific. Rather, it is a mingling of traditions and inspirations that come together in wholly new ensembles and silhouettes. In the exhibition "AngloMania: Tradition and Transgression in British Fashion," held this year at The Metropolitan Museum of Art, these new fashions were juxtaposed with those from the eighteenth and nineteenth centuries in a series of ironic theatrical vignettes in the Museum's English Period Rooms, The Annie Laurie Aitken Galleries. This installation, which resulted in startling insights into representations of Englishness, was a radical departure from the exhibition "Dangerous Liaisons: Fashion and Furniture in the Eighteenth Century," held two years ago in our French Period Rooms, The Wrightsman Galleries, in which costumes and furniture of the same period blended harmoniously. In "AngloMania" modern fashions seemed to clash with their historical counterparts and surroundings. It was a collision, however, that not only provided deeper insight into our understanding of Englishness, but one that also challenged our perceptions and perhaps even established notions of museological practice.

The exhibition and this handsomely illustrated catalogue represent another collaboration between The Costume Institute and the Department of European Sculpture and Decorative Arts. "AngloMania" was organized by Andrew Bolton, curator, The Costume Institute, with support from Harold Koda, curator in charge, The Costume Institute; Ian Wardropper, Iris and B. Gerald Cantor Curator, European Sculpture and Decorative Arts; and Daniëlle O. Kisluk-Grosheide, curator, European Sculpture and Decorative Arts. The vignettes, elegantly staged by Patrick Kinmonth and Antonio Monfreda, were expertly photographed by Joseph Coscia Jr. of the Museum's Photograph Studio. The preface and chapter texts were written by Andrew Bolton. The introduction is by Ian Buruma, Luce Professor of Democracy, Human Rights, and Journalism at Bard College.

"AngloMania" would not have been possible without the generous contribution by the Annie Laurie Aitken Charitable Trust for the renovation and restoration of the English Period Rooms. Encompassing decorative arts from the late sixteenth to the late eighteenth century, these remarkable galleries include many rooms considered to be the finest outside of England. We are also indebted to the donors who enabled the purchase of the costumes in the exhibition that are now in The Costume Institute. We also wish to thank the lenders not only for their loans but also for allowing us to reproduce their costumes on the following pages.

We are extremely grateful to Burberry for their generous support of both the exhibition and the catalogue. We would also like to thank Condé Nast for their additional support and their tireless efforts on behalf of The Costume Institute.

Philippe de Montebello
Director, The Metropolitan Museum of Art

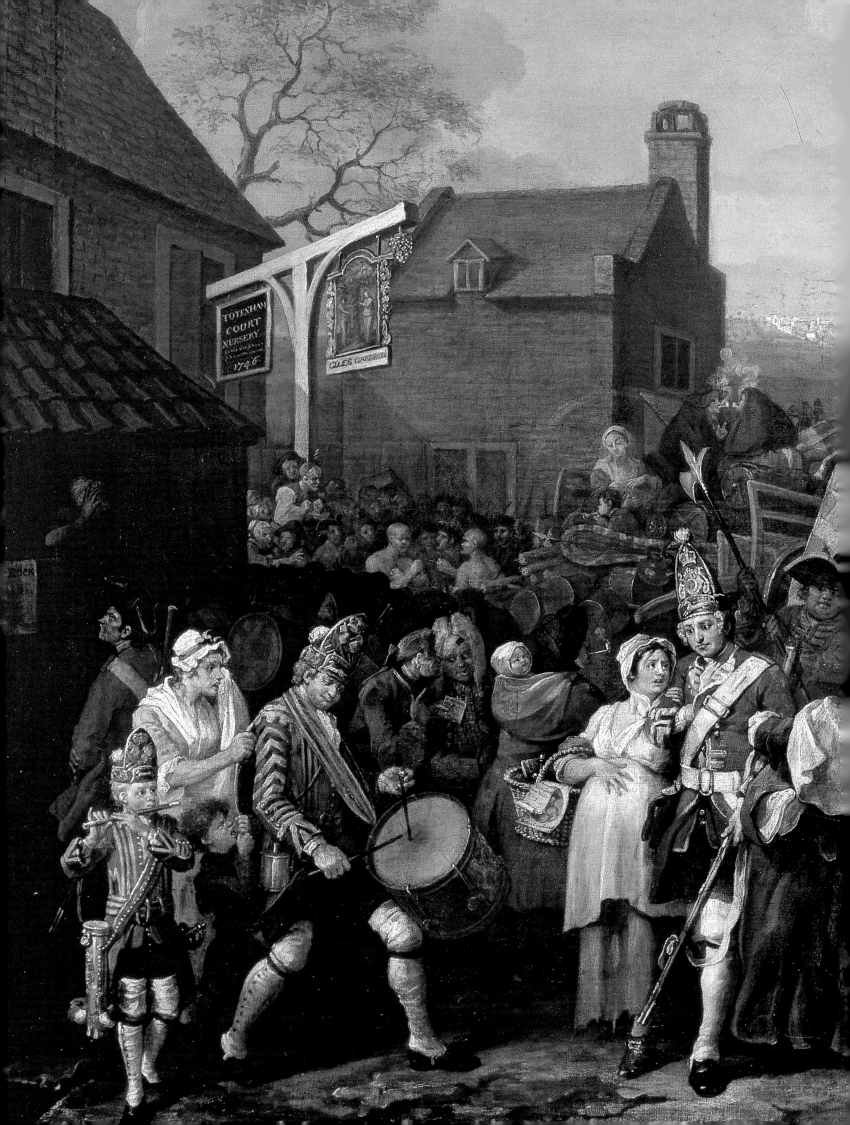

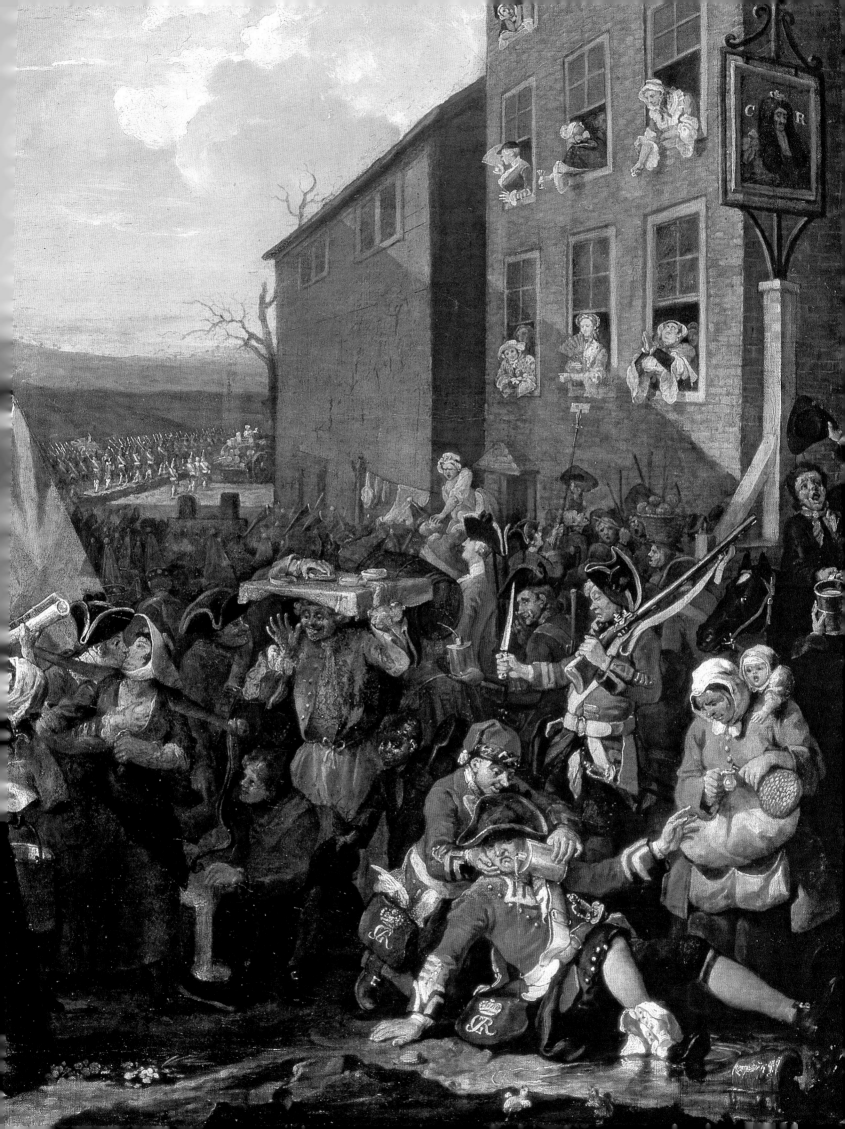

In 2004, The Costume Institute collaborated with the Department of European Sculpture and Decorative Arts on the exhibition "Dangerous Liaisons" in the French Period Rooms, The Wrightsman Galleries. At the time, there were discussions about expanding the exhibition to encompass the English Period Rooms, The Annie Laurie Aitken Galleries. It was felt, however, that the premise of the exhibition, to establish a discourse between fashion and furniture through a series of erotically charged vignettes inspired by libertine imagery and literature, was more suitable to the French rooms than to the English rooms. This decision was not arrived at by curatorial capriciousness, but by the nature of the interiors themselves. There is no equivalent in the English rooms, as there is in the French rooms, of a *salon ovale* or a *cabinet des glaces*, small rooms designed, in part, to facilitate intimate encounters. Nor are there examples of specialized furniture, such as a *table mécanique* or a *table de voyage*, tables with various functions designed, again in part, to define carefully cultivated identities and sociabilities. While the French rooms were installed primarily to showcase masterworks from the Museum's collections rather than to recreate actual room settings, they reflect the density of objects typical of French interiors of the period, as well as the range of furnishings required to facilitate leisured conduct. In France, artful living was central to the creation of cultural identity in a way that it was not in England. As Mimi Hellman observed in her introduction to the catalogue for "Dangerous Liaisons," "This design sophistication was widely regarded as uniquely modern and uniquely French, a sensitivity to personal comfort and convenience that existed in no other place or time."

While we have to be careful of defining notions of Frenchness or Englishness in any context, such definition is precisely the premise of the exhibition "AngloMania." Historically, France and England have defined themselves in deliberate contradistinction. This is true, especially, in the eighteenth century, when for the English the threat of a French military invasion was omnipresent. Indeed, England was at war with France from 1701 to 1714 (War of the Spanish Succession), from 1740 to 1748 (War of the Austrian Succession), and from 1756 to 1763 (Seven Years War). Against these threats, England sought to assert its national identity by affirming, or, rather, reaffirming its national distinctions. Most critically, it pitched English liberties against French tyrannies, a "propaganda of antithesis" eagerly embraced and promoted by cultural patriots such as William Hogarth. Particularly noteworthy is his *The Gate of Calais* (ca. 1848–49, pp. 14–15). Loaded with satiric vitriol, the painting, which records a visit to France by Hogarth in 1748 during which he was arrested and deported for sketching the ramparts of Calais, conveys the artist's claim that France was characterized by "poverty, slavery and insolence, with an affectation of politeness." Set against the city gate, Hogarth presents a group of Gallic stereotypes, including strutting soldiers to represent military tyranny and emaciated workmen to represent the misery of the people. Dominating the scene is a large hunk of beef that stands as a symbol of England's superior prosperity, attributable to its superior liberties.

This image of England was not limited to patriots. Voltaire, who first visited England in 1726 (thirty-eight years after the Glorious Revolution that established the country's constitutional monarchy), strenuously advocated England as a model of freedom and tolerance. Like Hogarth, Voltaire had personally experienced the heavy hand of French tyranny. His early satirical writings, which attacked the aristocracy and the government, resulted in several stretches in the Bastille. Indeed, his visit to England between 1726 and 1728 was one of exile, following a squabble with an aristocrat by the name of chevalier de Rohan. In England, Voltaire found "liberty of conscience," and through his writings on English culture, most notably his *Letters Concerning the English Nation* (1733), he effectively instigated "modern" Anglomania, or *anglomanie*. As it emerged in the 1740s, Anglomania was a political and intellectual phenomenon (*anglomanie* was also known as *philosophisme*), channeled through the works of Voltaire, and later Montesquieu, specifically his political treatise *The Spirit of Laws* (1748). By the 1760s, however, Anglomania had become associated with customs, manners, and fashions. In clothing, it was manifested by an increasing emphasis on plainness, simplicity, practicality, and informality (men in France, it should be noted, had begun to adopt the more casual styles associated with England as early as the 1740s, a fact that points to the close connection between sartorial and ideological Anglophilia throughout the

eighteenth century). The 1780s saw an even more fevered interest in England, with French men and women turning to English sports, novels, theater, gardens, and even cuisine, to define their identities and express their fashionability.

In its subsequent manifestations, Anglomania, as Ian Buruma outlines in the introduction to this catalogue, has remained a stylistic phenomenon. Moreover, it has remained a fantasy, based, as it is, on a caricature of England, concocted from the essential "otherness" of the outsider's perspective of Englishness. However, this caricature, like all caricatures, is not entirely fictitious. Nor is it wholly "foreign." It is based on idealized concepts of English culture that the English themselves not only recognize, but also, in a form of "autophilia," actively promote and perpetuate. For, Englishness, like Anglomania, involves the idea of England rather than the reality of England. As Aileen Ribeiro observed in "On Englishness in Dress" (2002), Englishness is a romantic construct, formed by feelings, attitudes, and perceptions, as opposed to Britishness, which is a political construct, based on shared practices and institutions. Indeed, by its very definition, Britishness embraces the diverse, disparate, and diasporic character of the country (or rather countries). Englishness, however, despite social, political, and economic developments, continues to suggest singularity and homogeneity. This image, of course, is a pretense, but Englishness, "enduring Englishness," is maintained by its mythologies, the most powerful being that of timelessness.

Through the lens of fashion, "AngloMania" explored various normative representations of Englishness. Like "Dangerous Liaisons," they were presented in a series of "fictive" vignettes that drew on artistic and literary references. Unlike its flirtatious predecessor, however, the exhibition juxtaposed historical and modern costumes with the intention of revealing a conceptual continuum of the "English imaginary." It is a strategy that The Costume Institute has employed in previous exhibitions and has the tonic effect of the new enlivening the old and the old verifying the new. What was novel, perhaps, was the use of historical and modern clothing to represent "characters," as if in a play or a painting. Apart from a device to engage visitors, such an approach referenced one of the defining features of the English, namely their interest in character and biography. This is reinforced in this catalogue, as it was in the exhibition, by the inclusion of grand manner portraits. Indeed, the show presented the opportunity of highlighting significant paintings from the Museum's holdings, including Thomas Gainsborough's *Mrs. Grace Dalrymple Elliott* (1778, p. 156). One of the most celebrated courtesans of the eighteenth century, Mrs. Elliott was the mistress of some of the most eminent peers of her period, including Lord Cholmondeley. Allegedly, when she became pregnant in her late twenties (following her husband's divorce on the grounds of her infidelity), four men, including the Prince of Wales, stepped forward to claim paternity. English history is alive with such eccentric characters, some real, and some, as in the exhibition, fictitious.

Apart from the novelty of narrative, peopled with ghosts from the past and the present, the show was equally radical in terms of its styling, which in some instances mixed period costumes with modern accessories. Seemingly anachronistic, such juxtapositions were determined by both aesthetic and intellectual criteria. The former usually provided by the creative consultants, Patrick Kinmonth and Antonio Monfreda, and the latter, as stated in the relevant chapters of this catalogue, by the curator. The wigs were another point of departure. Whereas in "Dangerous Liaisons" they were made from hand-knotted human hair and styled after period coiffures, those in "AngloMania," made by Julien d'Ys, were emphatic in their artificiality and exaggeration. The wigs were an exercise in the conceptual historicism reflected in the garments themselves. Most of the modern pieces were selected for their avant-gardism and their self-conscious historicism, two of the defining features of British fashion of the past thirty years (the "modern" time frame of the exhibition, chosen for its developmental Postmodernity). All of the pieces, whether modern or historical, were selected for their relevance to the interiors. This relevance may have been symbolic, metaphorical, or iconographical, but it supplied the exhibition's justification. Like mixing old clothes with new clothes, the presence of costumes in the English Period Rooms provided a contextual relativity that was at once startling and seductive. More poignantly, it presented a vortex for nostalgic and utopian longings, the essence of both Englishness and Anglomania.

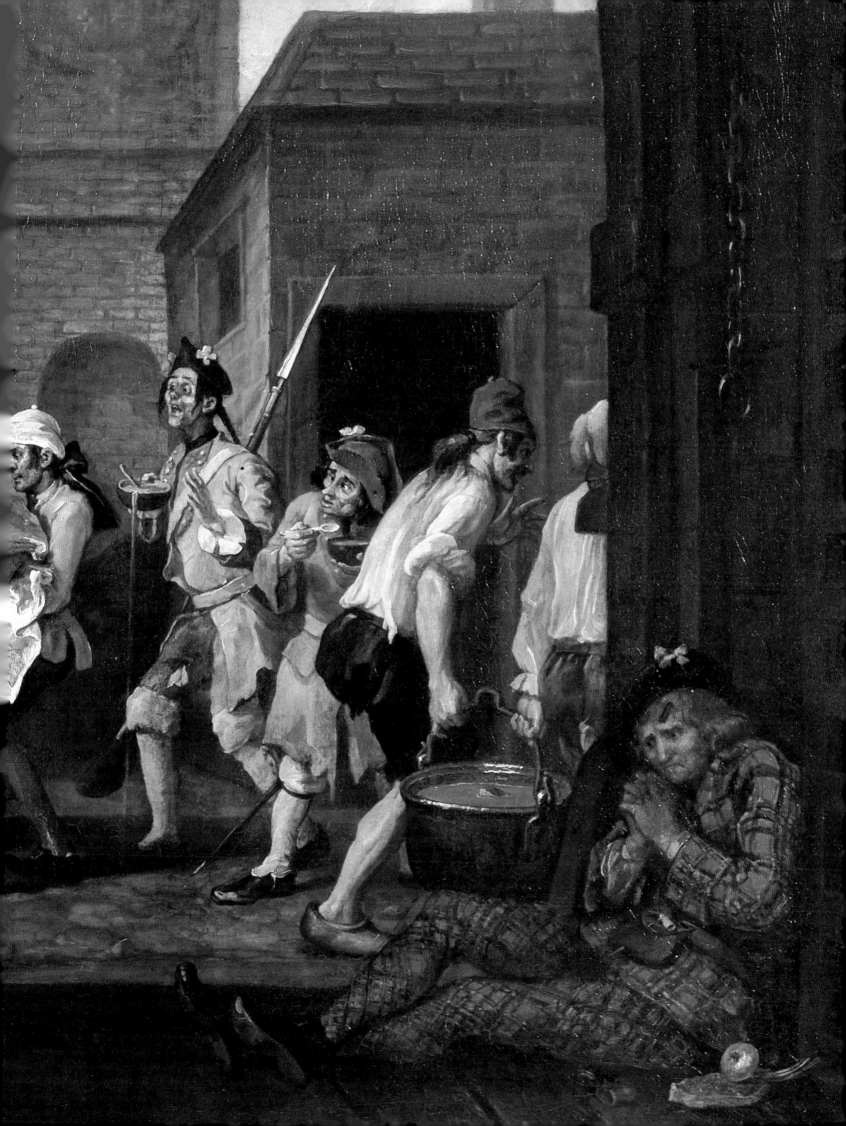

Apart from everything else, Anglomania is about clothes. But clothes can be about many things. Goethe's Werther (1774), the young man whose suicide tickled the morbid impulses of a generation, dressed in an English-style blue frock coat and yellow breeches, thereby setting the tone for dreamy young men all over Europe. The English look, in Werther's case, was associated with high Romantic *lacrimae rerum*, a yearning, sensitive, beautiful melancholy. While the Wertheresque Anglomaniacs contemplated self-destruction in the face of ugly materialism and industrial enterprise, young women sighed over Samuel Richardson's virtuous heroines and dashing men in riding coats.

Several decades before that, Voltaire's Anglophiliac tendencies, acted out in Cirey, his château in Champagne, affectionately known to Voltaire and his mistress Emily du Châtelet as "Cireyshire," were quite the opposite of Wertherism. His infatuation with England was all about Reason and the Enlightenment; not about mooning young Romantics but scientific geniuses like "Sir Newton" and "Mr Loke" (Locke). The cult of reason and freethinking, garbed in simple British elegance, was promoted by Voltaire as a rebuke to the Catholic obscurantism and royal absolutism of France.

Voltaire's view of England was echoed in England. Simplicity, in the eyes of Hogarth, and other boosters of the image of "Roast Beef and Old England," had always been a British virtue, as opposed to the velvet fripperies of France. Voltaire was too French to go in much for roast beef; his tastes were extravagant in clothes and in food. But the notion of British simplicity inspired a new form of Anglophilia in France. In the late nineteenth century, Baudelaire and other Parisian decadents dressed in black, mimicking the English dandies of the Regency. Black, to the French decadents, was the color of aristo-cratic aloofness from bourgeois mediocrity and the new industrial age.

The rise of *gentlemanismo* in Italy, France, or wherever else men dressed in fine tweeds, club ties, pin-striped suits, and other accoutrements of classy Englishness (more than Britishness, I should say), came near the end of the nineteenth century but stretched well into the 1960s. In some places (advertisements in *The New Yorker*, for example, or in Ralph Lauren stores) it still lingers on. The difference between an Italian Anglomane and a real English gentleman can usually be discerned in the Italian's tweeds, which look so much smarter than the cultivated shabbiness of the trueborn Englishman's dress.

Although the style based on that of the English gentleman may strike some as conservative, this is not the whole story. For it, too, shares with the previous phases of Anglomania an element of protest: not just against the mass-produced vulgarity of modern democracy, but, in a way, even against the privileges of birth. The gentleman, like the Regency dandy, does not stand out because of his bloodlines, which may be relatively humble, but by sheer dint of his style. This is why *gentlemanismo* has often appealed to successful men who felt like social outsiders.

Gentlemanismo was followed in the 1960s and 1970s by Pop and Punk. Perhaps—yet again—in protest against the uniformity of mass-produced affluence, young people in London dressed up as Regency rakes, 1920s flappers, or officers in the Crimean War. British fashion was at once romantic and socially subversive. Those who were not born in the working class pretended that they were and adopted Cockney accents, while working-class boys dressed up like toffs. The hedonistic fancy dress of Swinging London was followed by the darker, more violent, more bitter Punk style of "Thatcher's Britain." There was something of the Punk in the Iron Lady herself: the desire to destroy, but also to adopt the class trappings she affected to despise.

Romantics, Enlightenment rationalists, French flaneurs, flower children, Mrs. Thatcher, and Punk rockers may not appear to have anything much in common, certainly nothing traditionally associated with England. And yet they do, and it does have something to do with an idea of Englishness. This idea can be both reactionary and rebellious, liberal and conservative, sober and flamboyant, deliberately classy and a mockery of old class distinctions. What always has been admired, I think, from Voltaire's time to the present, is a peculiarly English (or perhaps here I should say "British") combination of freedom and nostalgia, of tradition and individualism.

Baudelaire was a great admirer of Beau Brummell, the Regency dandy whose last word on how to

starch a shirt or tie a stock was taken as gospel by a small London coterie, which included the prince regent, later King George IV, until he fell out with the famous dandy. Brummell was not from a rich or grand family but behaved as though he were much grander than any aristocrat, or indeed royal personage. The main characteristics of Brummell's circle of fops were a studied air of insolence, even rudeness, and a total disdain for doing anything useful. When the Prince of Wales, who got tired of Brummell's mockery, snubbed him while strolling down Bond Street, Brummell inquired of the prince's companion who his "fat friend" was. Brummell, then, was a climber, while treating the ladder he was climbing with contempt.

Living for nothing but pleasure, taking nothing more seriously than tying the faultless cravat, was seen by Baudelaire as the ideal attitude to emulate in a utilitarian age. As he put it in his *Intimate Journals* (published posthumously in 1930), "A dandy does nothing. Can you imagine a dandy addressing the common herd, except to make game of them?" Baudelaire, like Brummell, loathed the idea of democracy, which he regarded as banal and opposed to individual eccentricity. Which is why both he and his English heroes—"the last champions of human pride"—posed as aristocrats.

And posing is of course what Anglomania, especially of the sartorial kind, is all about: the freedom to be something one is not. This pose can be a reactionary one. Indeed, among Anglophiles, it very often is. But it does demand a particular kind of liberty, the liberty to imagine, to dress up. But it is also related to the history of British class distinctions. Tocqueville was one of many foreign observers in Britain who noted the porous quality of the British upper class. In Germany or Austria, or under the French ancien régime, the nobility was a caste more than a class, inaccessible to upstarts and outsiders. The British nobility was of a more liberal disposition, which allowed men and women with talent or wealth, or even superior style and wit, such as Beau Brummell, to share in its privileges. It allowed for assimilation, as it were, which was one reason, perhaps, why the British upper class managed to avoid a violent revolution, and why it attracted so much admiration among those who lived in more oppressive societies.

The importance of posing, of cutting a dash, through outrage as well as originality, is part of the strong but porous class system. The fact that, traditionally, class was a matter of detailed codes of dress and speech, that each Englishman and woman was instantly readable to anyone familiar with these codes, gave to English life an unusual degree of theatricality. The class system could be oppressive, to be sure, and a reason for some people, who felt excluded in one way or another, to move abroad. But the theatricality of English life, owing to the importance of presentation as well as the fluidity of class, has also been a great source of creativity, even playfulness, in the streets as much as in the theater. In England, more than most places, the world is indeed a stage.

Now that most of the codes and trappings of class have either collapsed or become increasingly confused, people are free to rummage in the vast national storehouse of costumes to pick and choose what they want. Since the English have always plundered their past, often for their own amusement, Postmodernism is quite suited to England. It is no longer subversive for a working-class boy to dress like an Edwardian fop, for an aristocrat to pose as a working man. Dressing up has become a free-for-all.

This eclecticism is not always properly understood by Britain's admirers. Many foreign followers of *gentlemanismo* are disappointed when they visit the actual place of origin. The English gentleman may now be a more common sight in Milan, Philadelphia, or Calcutta than in London. But no matter, Anglophiles never were the same as Englishmen. Imitating the English has provided a great deal of pleasure to many people, who felt that dressing up in English clothes gave them a sense of dash and distinction. But Anglomanes have, over the ages, given at least as much pleasure to the English themselves, who could bask in the sincerest form of flattery, while being reassured of their natural superiority when even the most assiduous foreign mimic managed to get the smallest detail wrong.

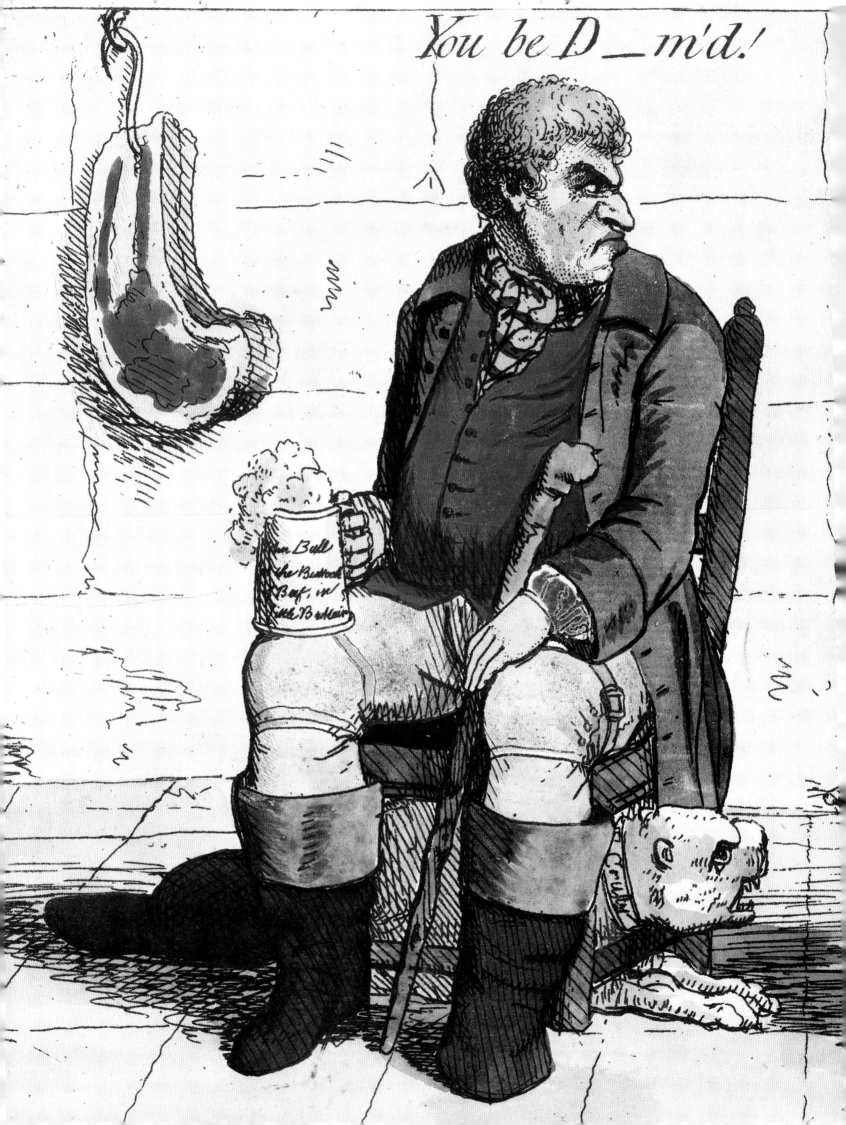

Anglomania, the craze for all things English, gripped Europe during the mid- to late eighteenth century. As perceived by Voltaire, the father of Anglomania, England was a land of reason, freedom, and tolerance, a land where the Enlightenment found its greatest expression. It was a view held by many English writers and artists of the period, such as David Garrick, Henry Fielding, Samuel Johnson, and particularly William Hogarth, whose work reflects a fierce and forthright nationalism. Two of his most patriotic paintings are *The March to Finchley* (ca. 1749–50, pp. 10–11) and *The Gate of Calais* (ca. 1748–49, pp. 14–15). While not painted as pendants, they are united by their jingoism. Filled with noises, tastes, and smells, they are teeming with national symbols. The British flag flies proudly above the melee in *The March to Finchley*, while the English coat of arms basks in the sunlight of *The Gate of Calais*. Originally entitled *O! the Roast Beef of Old England* after a song by Fielding, *The Gate of Calais* features a large joint of beef as an emblem of England.

Beef had long been a bearer of national identity, but in the 1700s it became equated with English liberty and manly virtues, as did other meaty symbols of England, such as butchers, bulldogs, and, particularly, John Bull. Created by the satirist John Arbuthnot in his pamphlet *Law Is a Bottomless Pit; or, The History of John Bull* (1712), this allegorical character was originally depicted as greedy, gullible, and irascible. However, during the eighteenth century, he emerged as a heroic figure, the basic archetype of the freeborn Englishman. When he began to appear in prints in the 1760s, it was often in the form of a bull or a bulldog. From the 1780s, however, he was more usually depicted as a human, often cast as a sailor, farmer, artisan, or merchant (his original occupation). Frequently, he was portrayed alongside other national symbols, as in James Gillray's lively drawing *Politeness* (1779, p. 18), which shows him with a full mug of ale in his hand, a loyal bulldog by his side, and a large joint of beef on the wall behind him. Typically, he is depicted wearing boots, breeches, waistcoat, and frock coat, a loose coat with plain cuffs, a turned-down collar, and minimal side pleats. Defined by its plainness, practicality, and informality, the frock emerged as the supreme sartorial symbol of England, a powerful signifier of its perceived liberties. It is the frock that conveys the English appearance of Goethe's Werther in *Die Leiden des jungen Werthers* (1774).

Patriotic symbols are brought together in a spectacle of nationhood at the entrance to the exhibition "AngloMania." The staging, based on Hogarth's *The Gate of Calais*, includes a large faded Union Jack as a backdrop for two ensembles that represent, respectively, eighteenth- and late-twentieth-century concepts of sartorial freedom. On the left is a three-piece suit from the mid-1700s that echoes a version worn by the figure on the far left of the painting, a depiction of Hogarth himself. Made from wool, a plebeian, relatively inexpensive material that the English elevated to high fashion, its sense of the demotic is expressed through its simplicity. In a reversal of fortune, the bondage suit from the late 1970s, made by Malcolm McLaren and Vivienne Westwood, asserts its liberalism through its very complexity. For while the suit's zips and straps, taken from fetishistic and sadomasochistic clothing, are worthy of a Houdini challenge, they liberate the wearer through the language of street style, more specifically, that of Punk and its freewheeling, self-expressive vocabulary.

Made from tartan, the suit evokes the figure on the far right of *The Gate of Calais*, probably a veteran of the Jacobite Uprising (1745). Tartan is a potent (albeit romanticized) symbol of Scotland, as is the unicorn, which along with the lion, a symbol of England, appears in the Royal Standard as a supporter, a carved, painted, and gilded version of which hangs above the entrance to the exhibition. In terms of its political complexity, the history of the Royal Standard parallels that of the Union Jack, the design of which is based on the crosses of Saint George, Saint Andrew, and Saint Patrick, respectively the patron saints of England, Scotland, and Ireland. Its strong graphic impact and its ability to serve as a vehicle for national identifications have guaranteed the Union Jack's co-option by the fashion industry, as seen in the frock coat designed by David Bowie and Alexander McQueen. Although based on a jacket worn in the 1960s by Pete Townsend, the lead singer of The Who, its style is more redolent of John Bull. Ruined yet precisely tailored, the coat is a pastiche of patriotism, a Postmodern reworking of Hogarth's "Roast Beef of Old England."

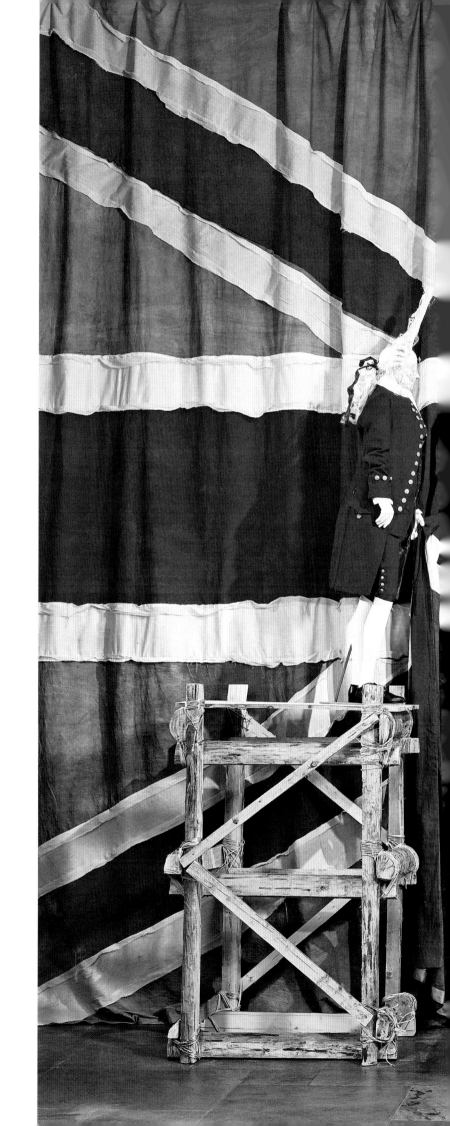

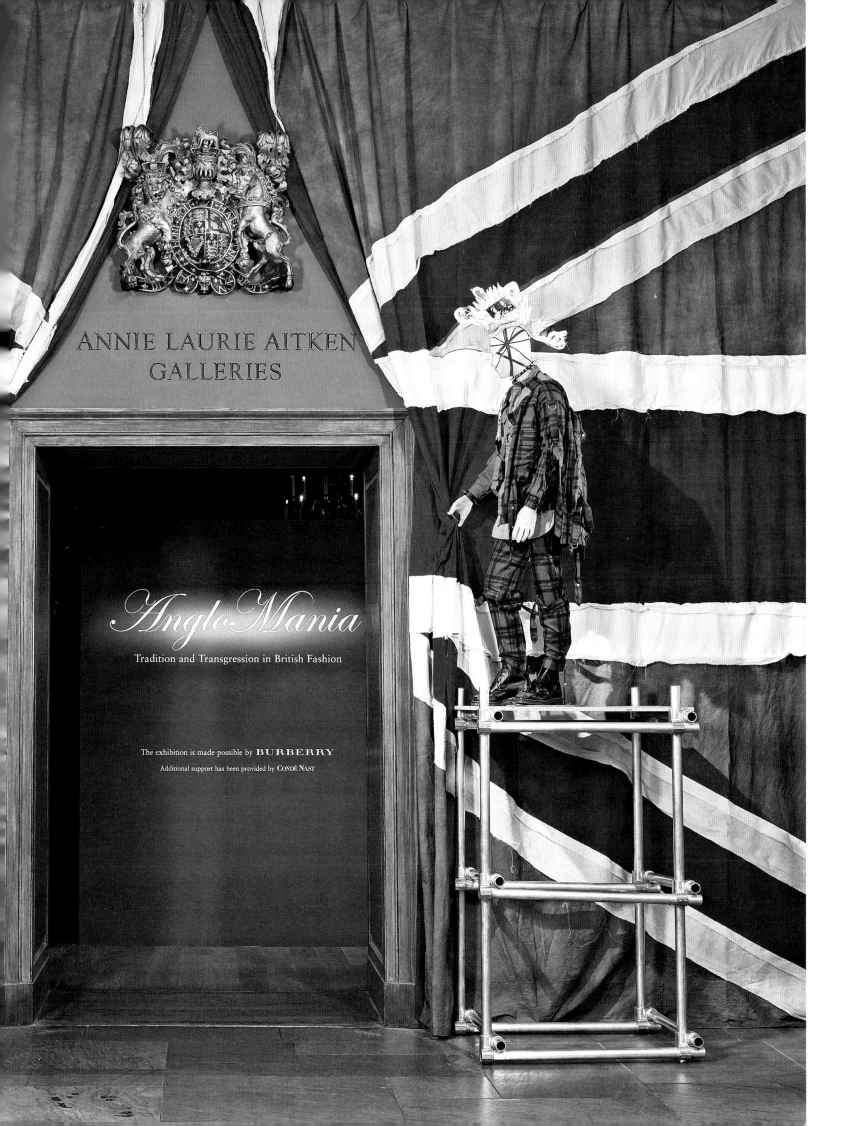

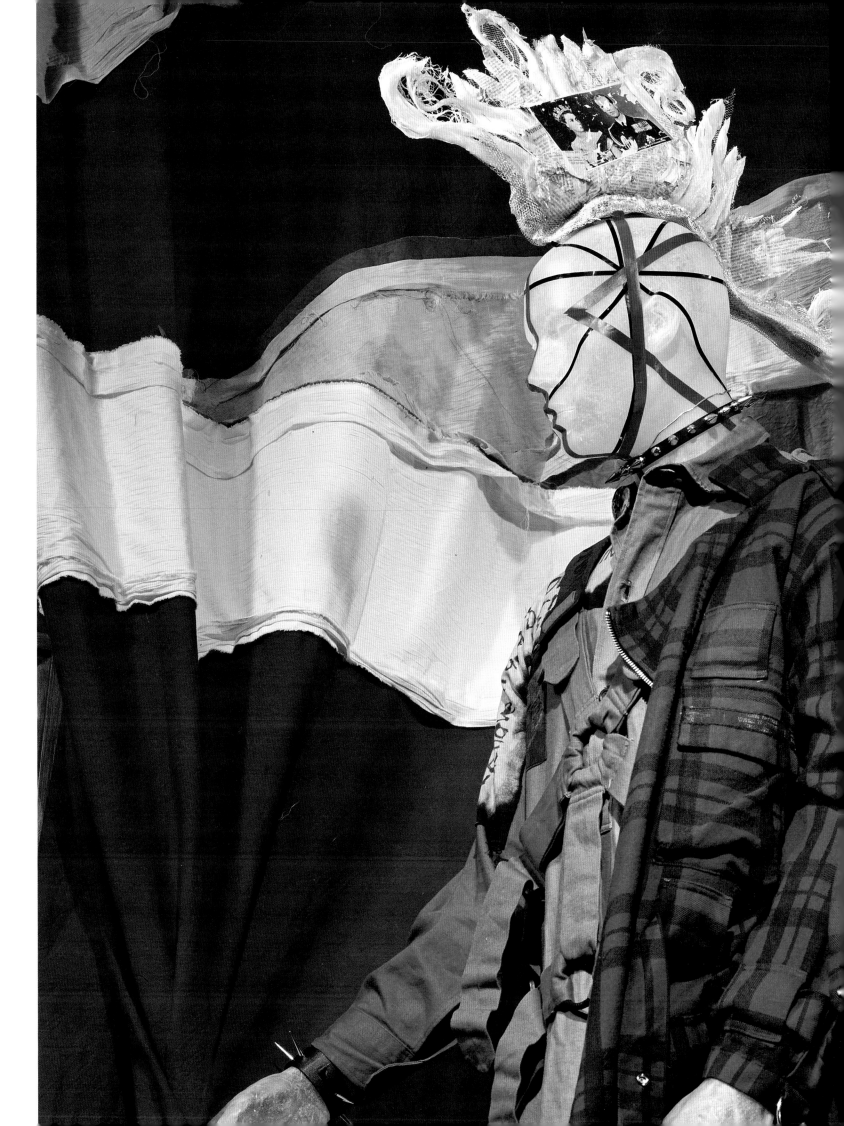

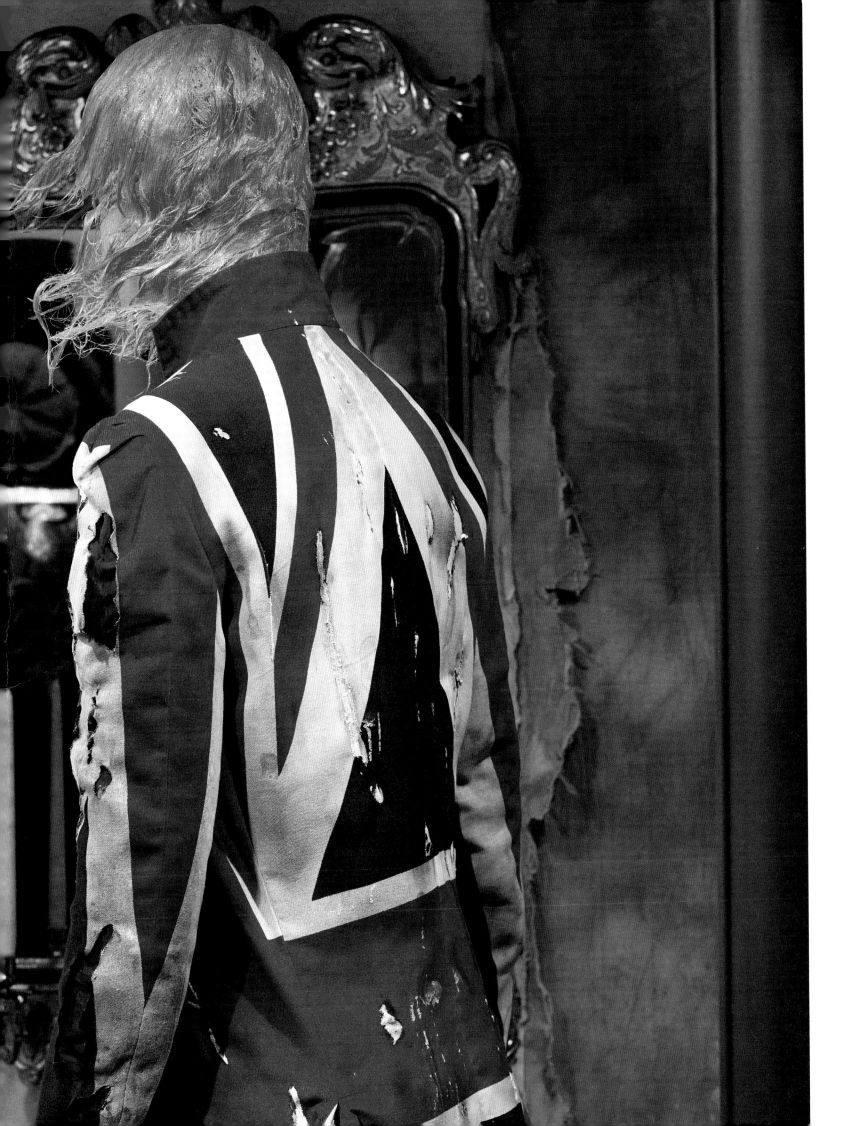

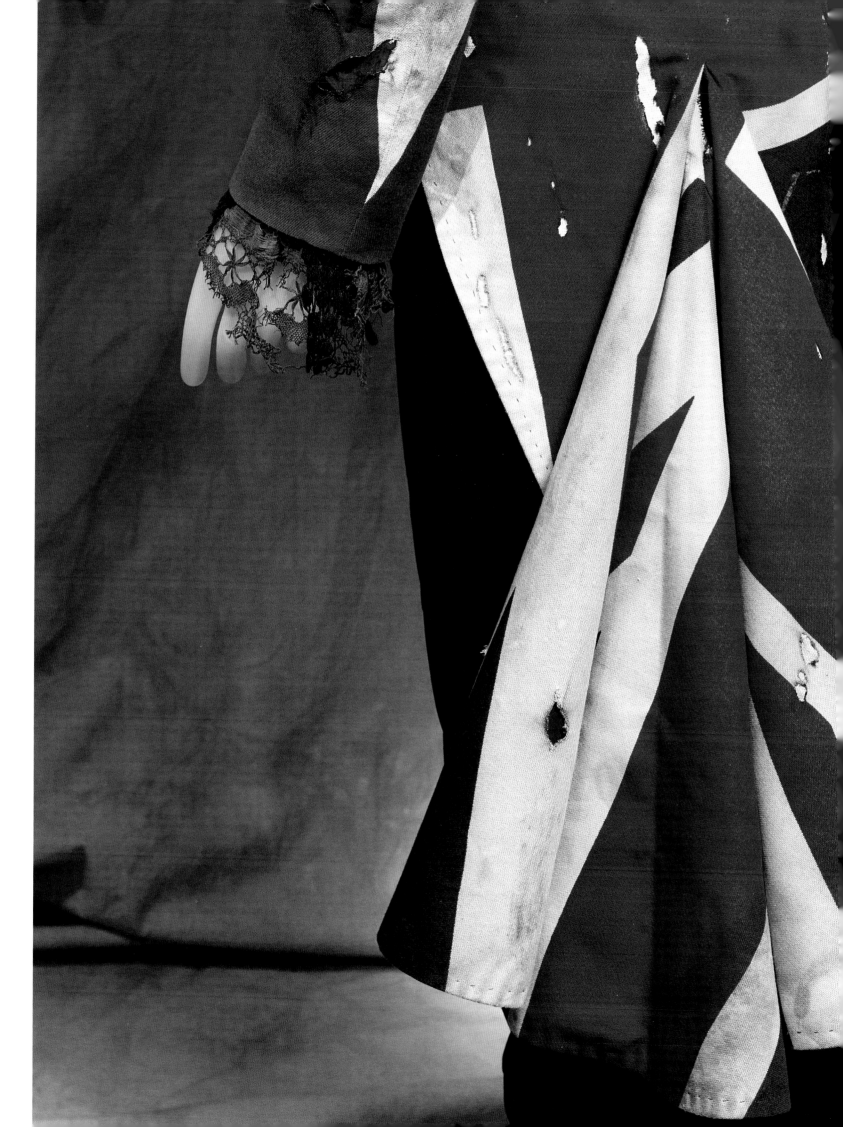

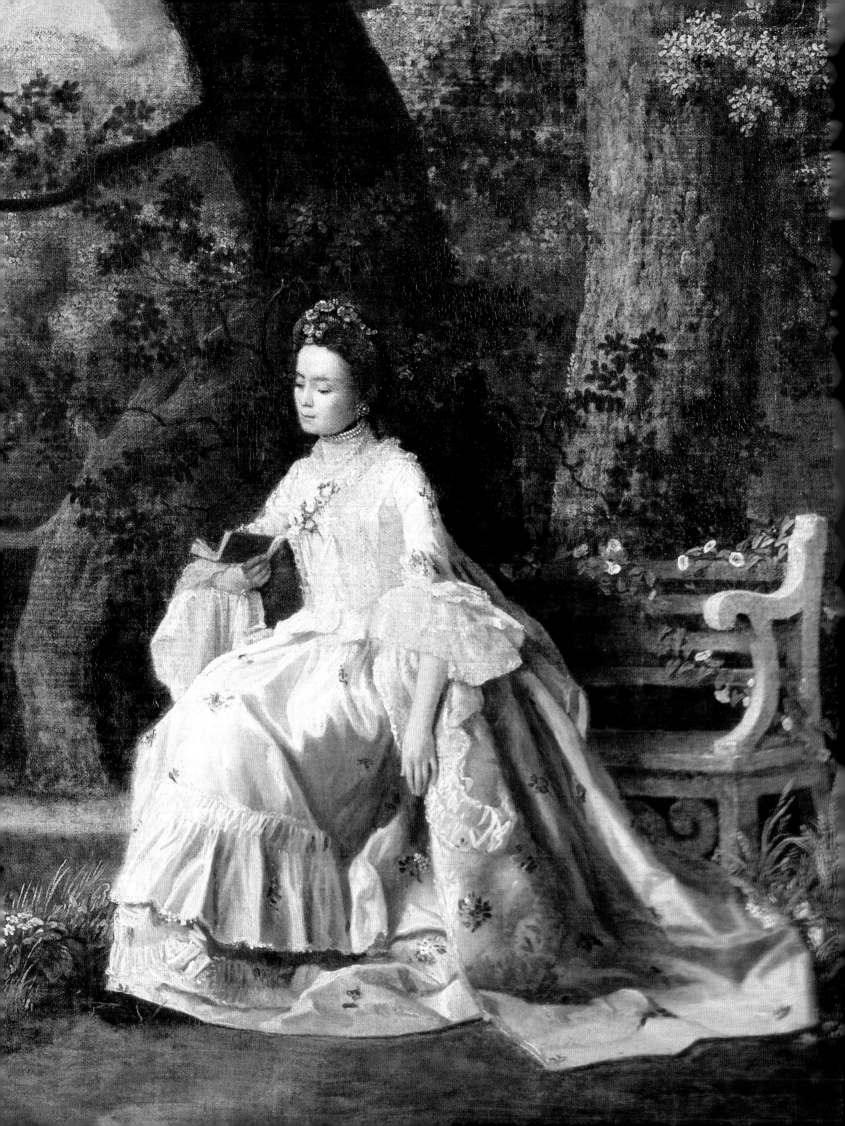

The vast parks that surround the grandest country houses of the nobility are among Britain's greatest artistic achievements. Writing in 1780, Horace Walpole commented, "We have discovered the point of perfection. We have given the true model of gardening to the world; let other countries mimic or corrupt our taste; but let it reign here on its verdant throne, original by its elegant simplicity, and proud of no other art than that of softening Nature's harshness and copying her graceful touch." While these parks seem to represent the English landscape at its most unaffected, they are the result of careful planning and cultivation. A product of the Age of Reason, they emerged out of a desire for improvement (particularly agricultural improvement) and reflected the belief in the logic, harmony, and equanimity of Nature.

Unlike the formal, enclosed gardens of the seventeenth century, they attempted to subsume the entire visible landscape, a concept developed by the French landscape designer André Le Nôtre. This "ideal of extent" was most fully realized in the gardens of Lancelot "Capability" Brown, whom the poet William Cowper described as "Th'omnipotent magician." Brown strove to show the English countryside to advantage, exploring its expressive possibilities and presenting an idealized picture of Nature. His Utopian landscapes, typically comprising extended prospects, informal tree plantings, winding watercourses, and smooth rolling lawns, were copied in France, in Germany, and even in Russia. In a letter to Voltaire, who often boasted of having introduced *le jardin anglais* to France, the Russian empress Catherine II (the Great) wrote, "I passionately love gardens in the English style, the curved lines, the gentle slopes, the ponds pretending to be lakes, the archipelagos on solid ground, and I deeply disdain straight lines . . . should say my anglomania gets the better of planimetry."

The dining room at Kirtlington Park in Oxfordshire, commissioned by Sir James Dashwood, overlooked one of Brown's idyllic landscapes. Designed by the architect John Sanderson, the room's naturalistic stuccowork, with its scheme of the Four Seasons on the ceiling and its trophies of fruit and flowers on the walls, seems to be an extension of Brown's Claudian landscapes. This impression is underscored by the integration in the overmantel of John Wootton's painting, a genre scene in the manner of Claude Lorraine. Depicting moments of perfection and grandeur, Lorraine's landscapes had a conscious influence on noblemen like Dashwood, who had been on the grand tour, a compulsory component in the education of any gentleman. Addressing these "blest youths" in his poem *The English Garden* (1772), William Mason wrote, "And scenes like these, on memory's tablet drawn Bring back to Britain: there give local form To each Idea; and if Nature lend Materials fit of torrent, rock and shade, Produce new *Tivolis*."

If the room's exuberant plasterwork is a counterpart to Brown's Utopian gardens, so are the dresses made from silks woven and designed by a specialized, principally Huguenot workforce in Spitalfields during the eighteenth century. Ranging from the "bizarre" designs of the early 1700s to the Rococo patterns of the 1740s and 1750s, they reveal a variety of flowers that have been given three-dimensional form through Philip Treacy's "orchid" hats. While orchids appear in the designs of Spitalfields silks (notably those by Anna Maria Garthwaite, known for her use of exotic flowers), the affinity between Treacy's floral tributes and those seen in the dresses, especially from the 1730s and 1740s, is established through their scale, their fresh coloring, and, most importantly, their botanical naturalism. In art history, realism, as Nikolaus Pevsner has noted in *The Englishness of English Art* (1964), is a decidedly English characteristic. It is evident in the work of various English artists, including George Stubbs. In his *Lady Reading in a Park* (ca. 1768–70, p. 28), Stubbs points to the interplay between realism in art and in fashion by painting his poised beauty in a robe of Spitalfields silk. The pink tulle dress by Hussein Chalayan, however, seems to denounce, or at least destabilize, the notion of naturalism. Made from hundreds of nylon rosettes shaved to resemble topiary, it recalls the formal gardens of the seventeenth century with their complex geometry of clipped hedges. Chalayan's inspiration, however, was the erosive and tectonic forces that create all kinds of shapes in nature, an inspiration that, ultimately, points to the futility of man's attempt to master nature.

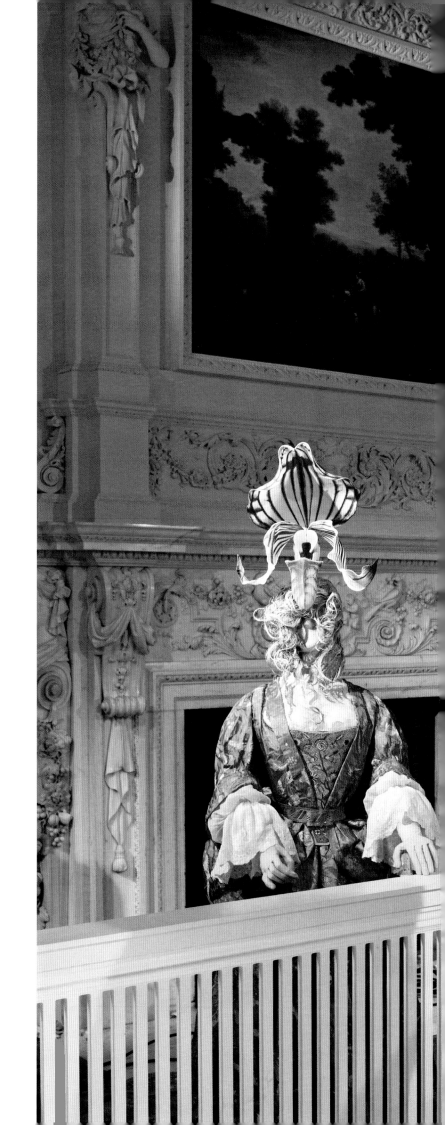

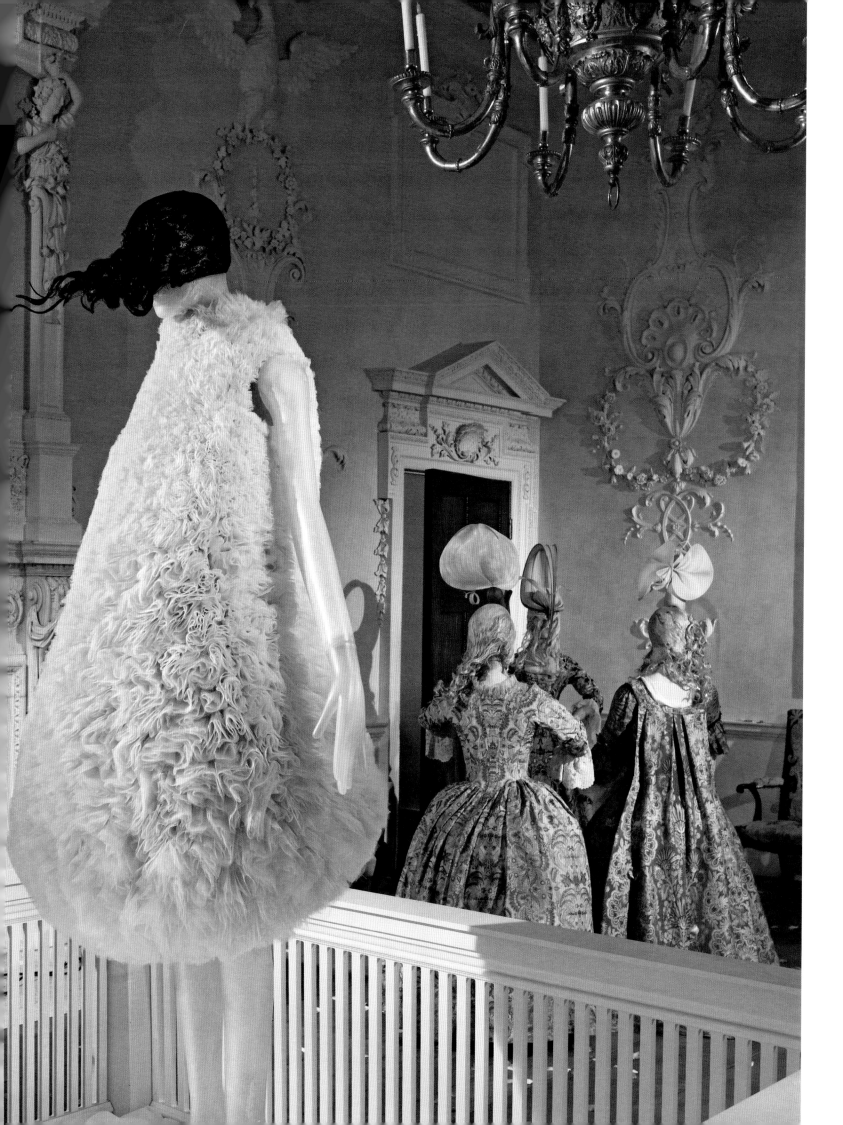

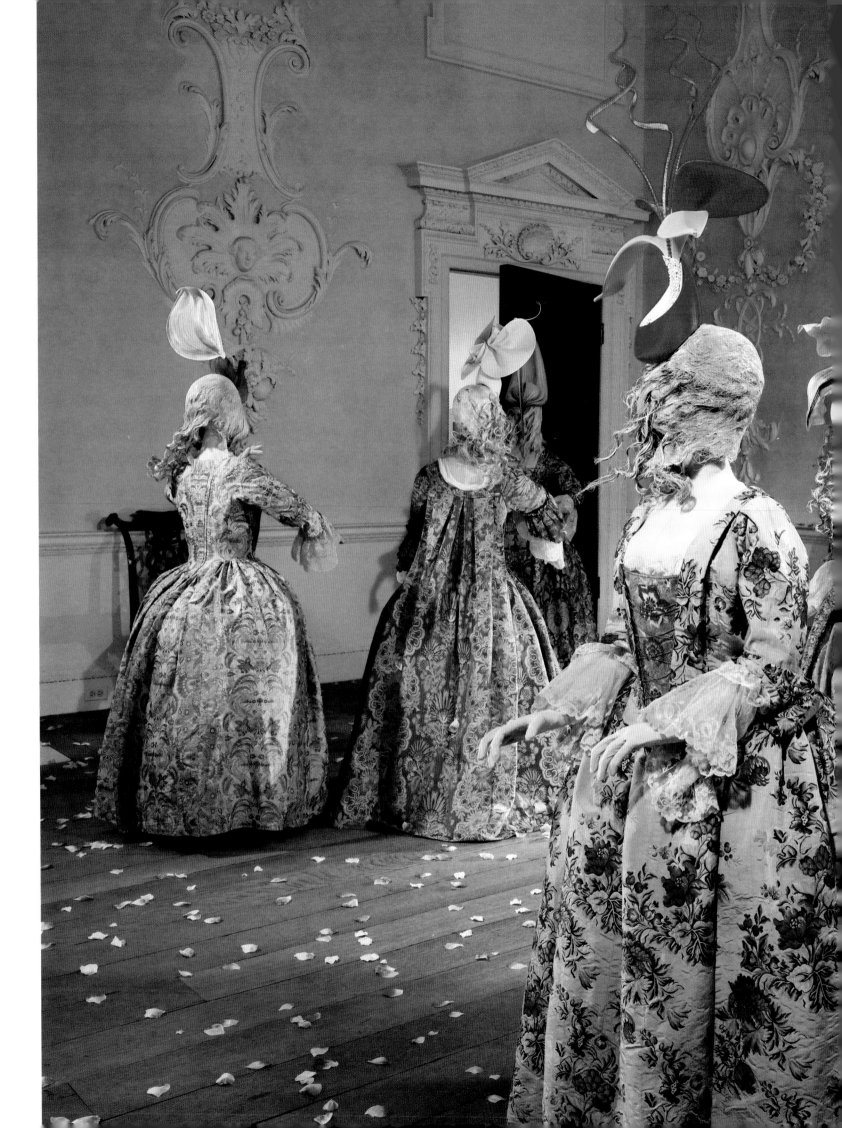

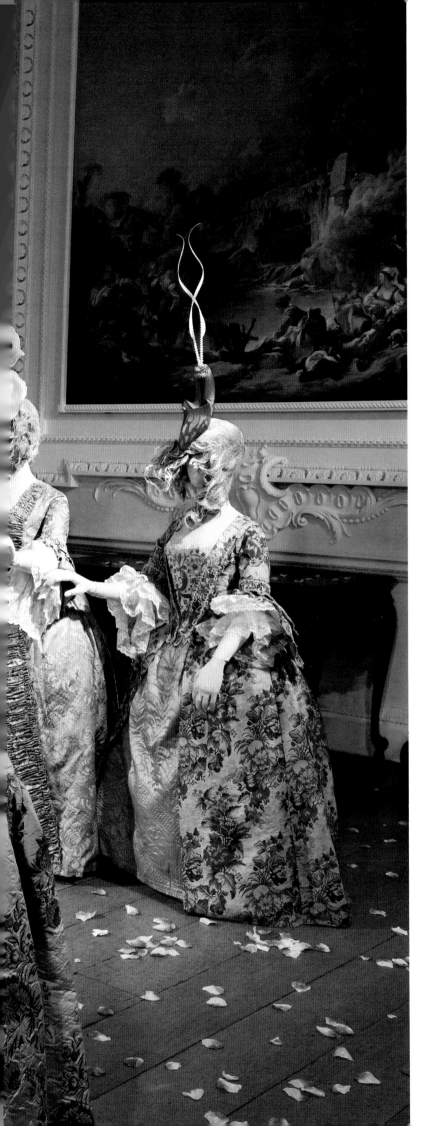

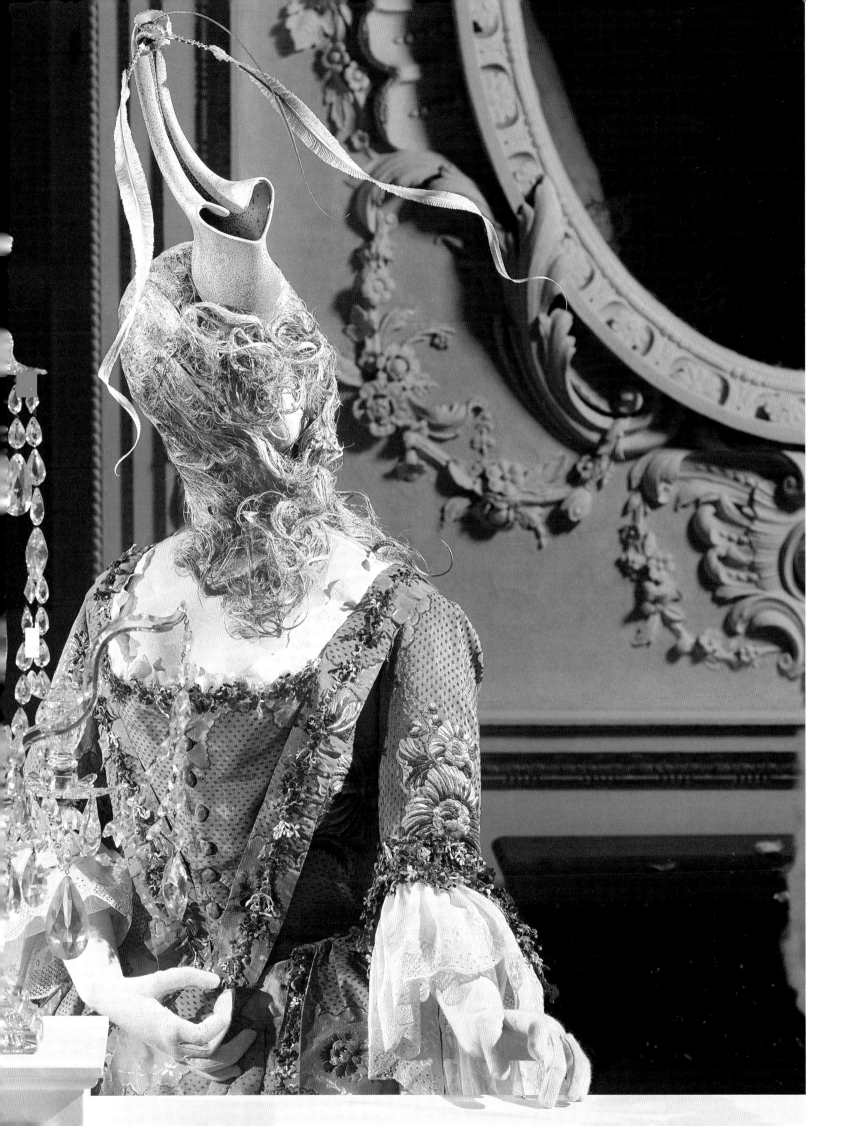

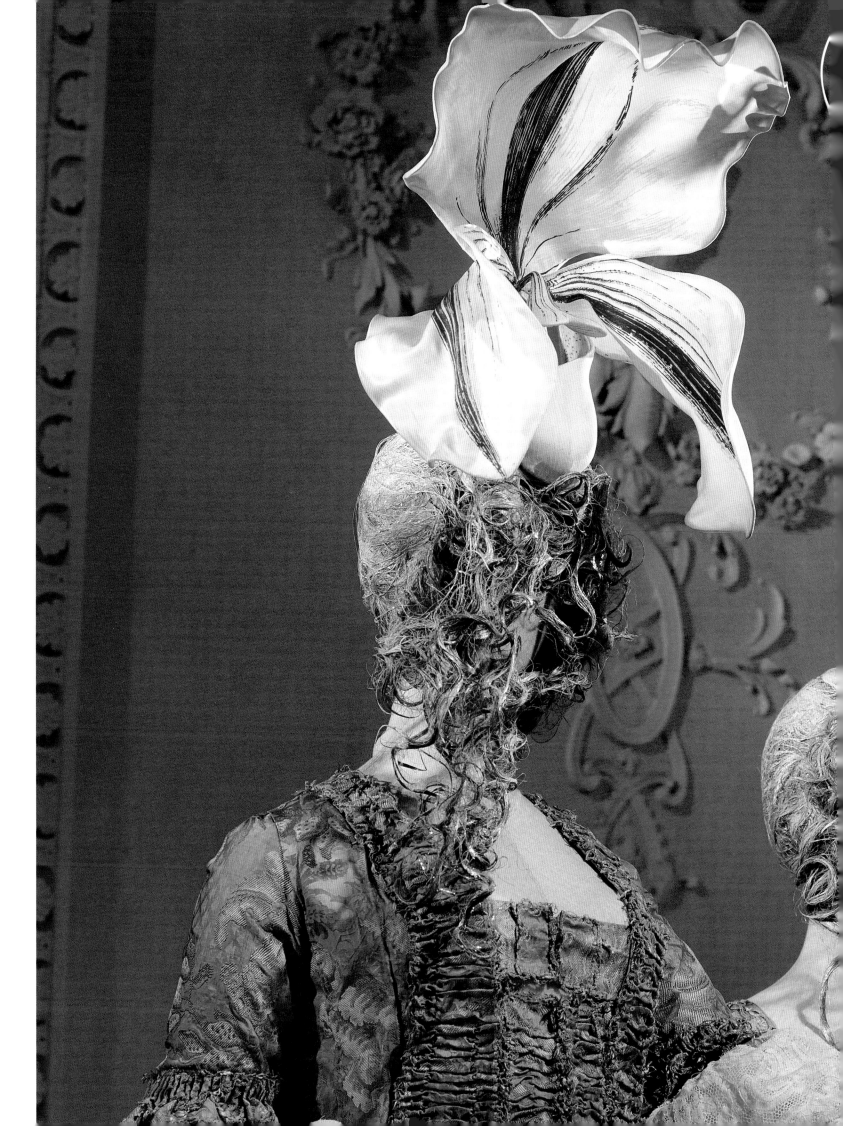

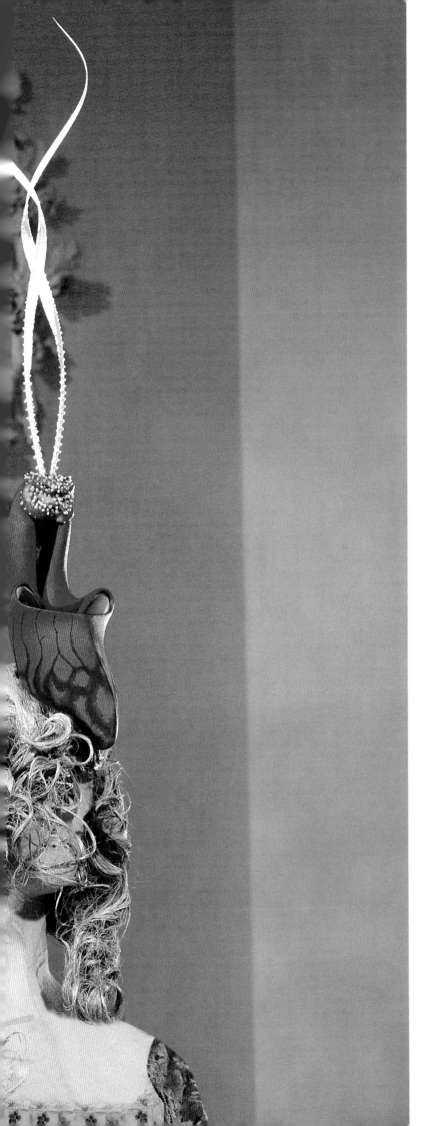

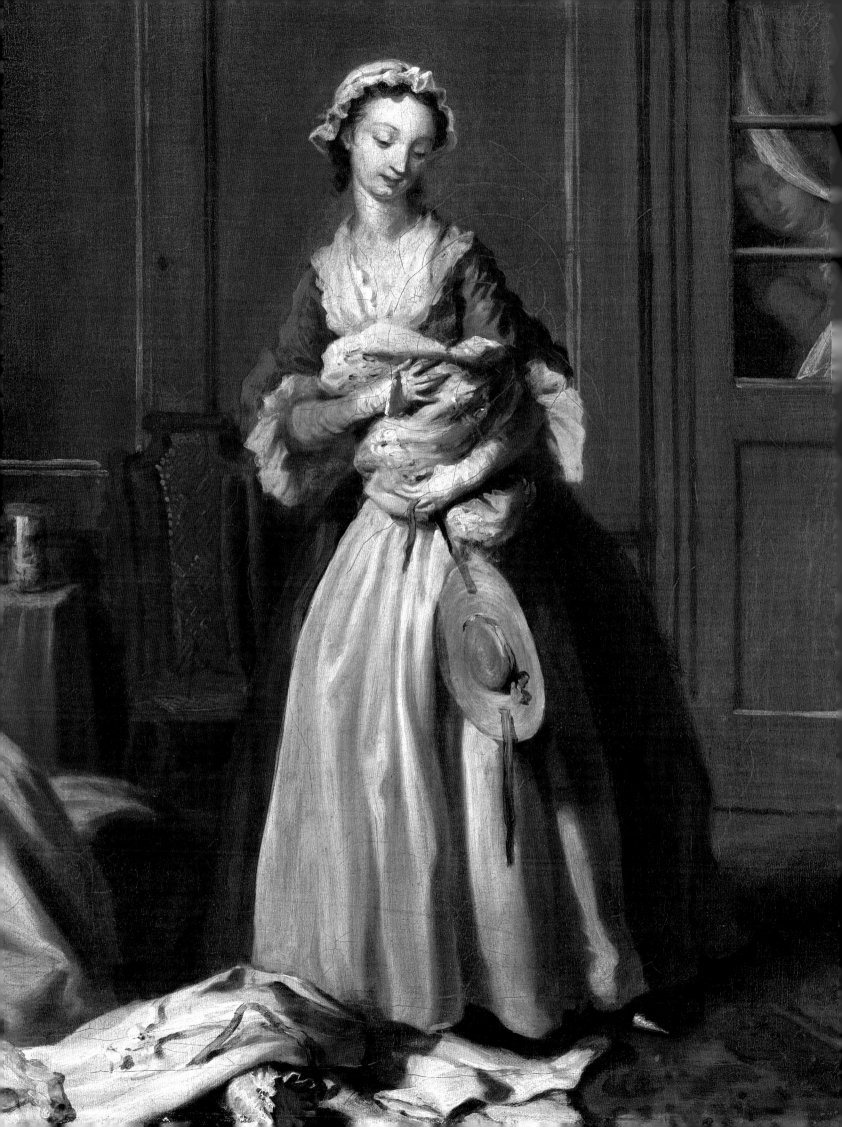

The English country house, like the English country garden, is equated with a fundamental Englishness. This association is partly owing to its social structure, which, until as late as World War II, was defined by the master-servant relationship (a creation and a recreation of Britain's distinctive hierarchical organization). The word "servant" was not in general use until the eighteenth century, a period in which the demand for servants increased dramatically. At this time, as Giles Waterfield has observed in *Below Stairs* (2003), employers usually looked upon their employees with coldness and contempt. Maids were often seen as sexual targets, a theme that was explored by Samuel Richardson in *Pamela, or Virtue Rewarded* (1740). One of the earliest and greatest British novels, it tells the story of a virtuous maidservant, whose resistance to the repeated attempts at seduction by her employer, Mr. B., finally leads to their marriage. With its themes of romance, sexuality, and class conflict, the novel became an immediate best seller not only in Britain but also on the Continent. The writer and intrepid traveler Lady Mary Wortley Montagu commented, "It has been translated into French and Italian; it was all the fashion at Paris and Versailles, and is still the joy of chambermaids of all nations." So successful was *Pamela* that several artists, most notably, Joseph Highmore (p. 38), created a series of scenes from the novel for the print market, thereby extending its appeal to an illiterate audience.

The theme of domestic service informs the vignette enacted on the staircase from Cassiobury Park in Hertfordshire, which contrasts a lavish court gown by the House of Worth with a group of ragged, tattered dresses by Hussein Chalayan. Worn by Esther Chapin, whose great-great-granduncle was George Washington, probably when she was presented at an afternoon court of Queen Victoria in the late 1880s (the climax of the Season and a debutante's coming-out), the gown serves as the ultimate symbol of the wearer's social standing. While its origins are French, the gown's colors and pattern of lilies, rendered realistically, owe more to the British Aesthetic Movement of the late nineteenth century. This love of naturalism, as we have seen in "The English Garden," has a strong tradition in Britain and is evident in the scrollwork balustrade of the staircase, which depicts acanthus flowers and bursting seed or pea pods. (This sculpture in wood is attributed to Edward Pearce for Sir Henry Capel, first Earl of Essex, whose family portraits hang on the walls of the staircase.) Although the style of the gown reflects popular fashions of the period, the train is a vestige of earlier court styles. Equally antiquated is the man's court suit of coat, breeches, and waistcoat. Worn by men who did not have a prescribed uniform, its sartorial paralysis was an avowal of tradition and formality. A deliberate solecism as well as archaism is reflected in the servant's livery, made by Henry Poole & Co., which aped court dress of the early 1700s.

Status was as important downstairs as it was upstairs, and liveried employees, such as footmen and coachmen, belonged to the category of lower servants. At the bottom of the hierarchy of female employees were "bunters," usually identifiable by their torn and patched clothing. In terms of their aesthetic, Hussein Chalayan's layered and shredded garments (actually inspired by voodoo and the sorceress Medea) recall the abject poverty of these lowly maids. However, in terms of their production, which reflects the handcrafted, labor-intensive processes of the haute couture, they are more likely to appear in the wardrobes of mistresses than of maidservants. In the eighteenth and nineteenth centuries, upper female servants often inherited or were given the cast-off clothes of their mistresses, usually stripped of their trimmings. In Richardson's novel, we learn that Pamela, during the two or three years that she worked for her mistress, received several gifts of clothing. Upon the death of her "good lady," Pamela is given additional garments from her mistress's son and new employer, Mr. B. In a letter to her parents she reports of the first gift, "He has given me a suit of my late lady's clothes, and half a dozen of her shifts, and six fine handkerchiefs, and three of her cambric aprons and four holland ones. The clothes are fine silk, too rich and good for me to be sure." This practice of receiving an employer's hand-me-downs is referenced in Chalayan's ensembles. With the skill of the most imaginative and resourceful of maidservants, Chalayan combines secondhand garments with elements from his own repertoire (such as fabrics buried with iron filings to imbue them with a false patina of age) to create poetic collages that suggest the sartorial stratagems of servitude.

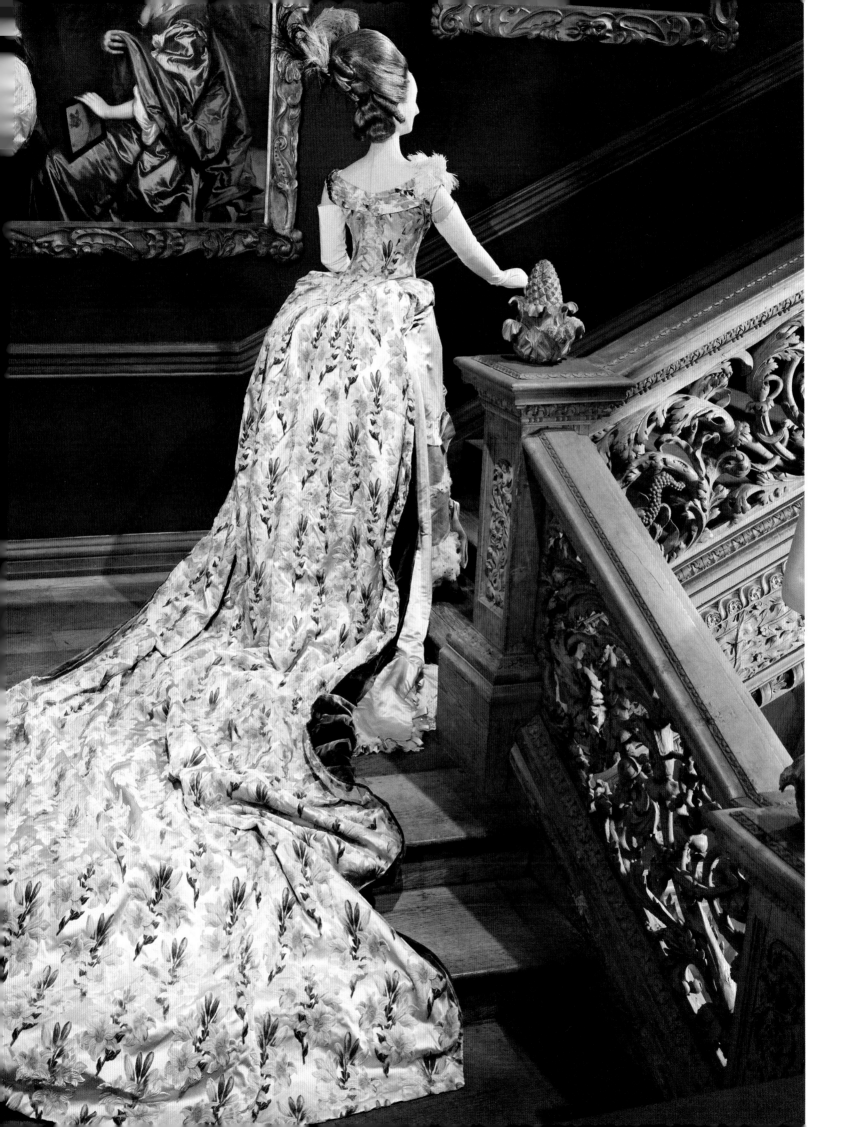

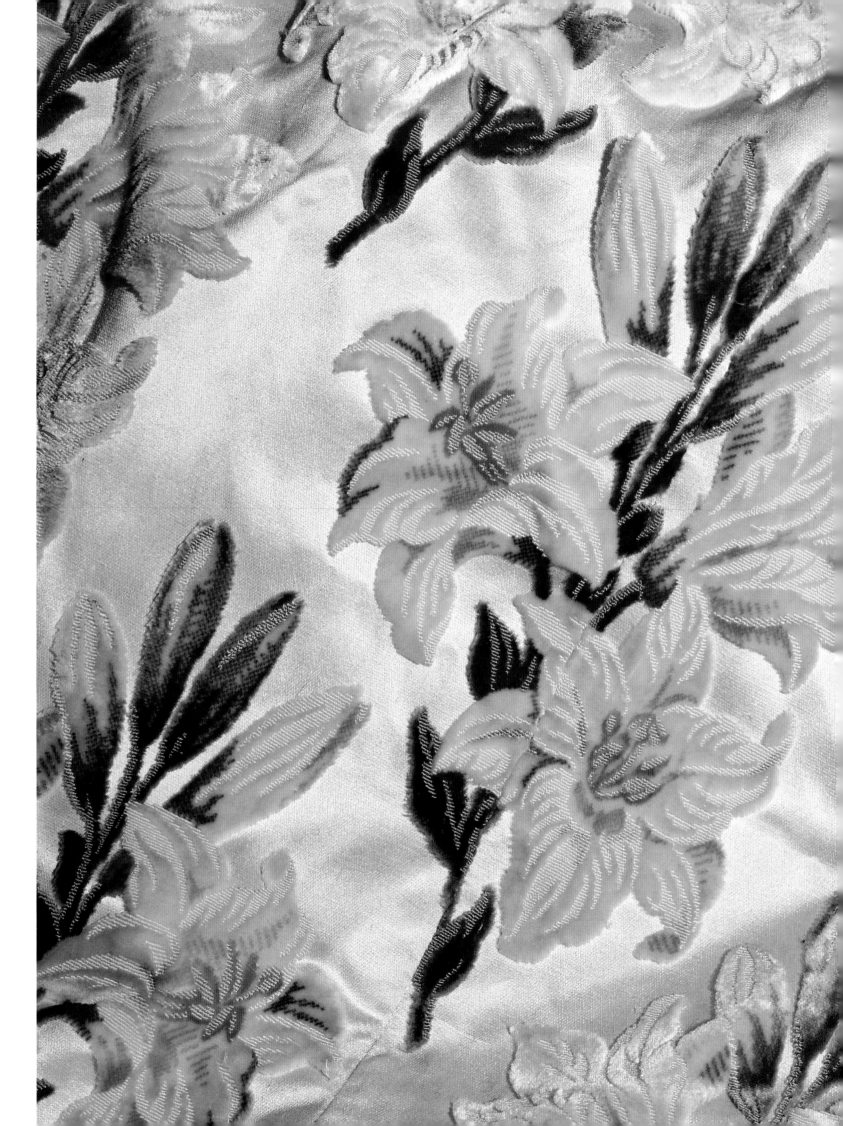

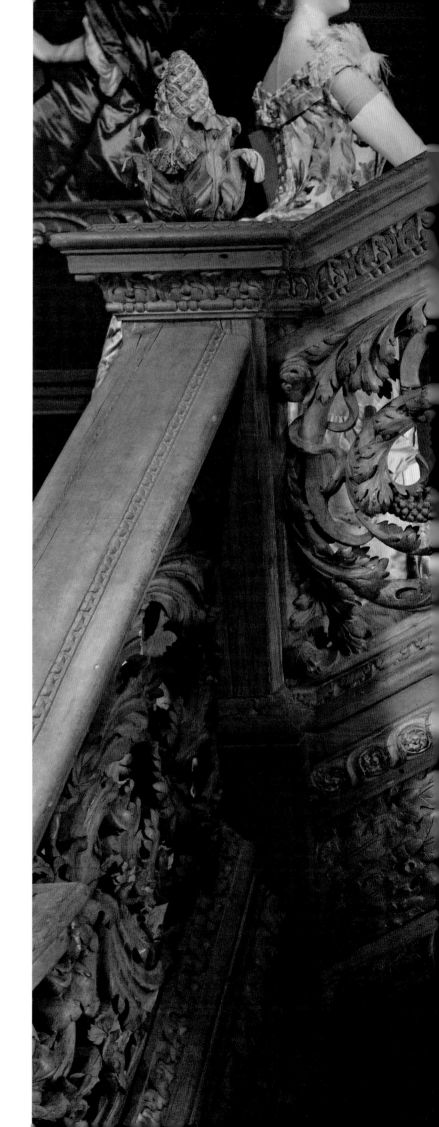

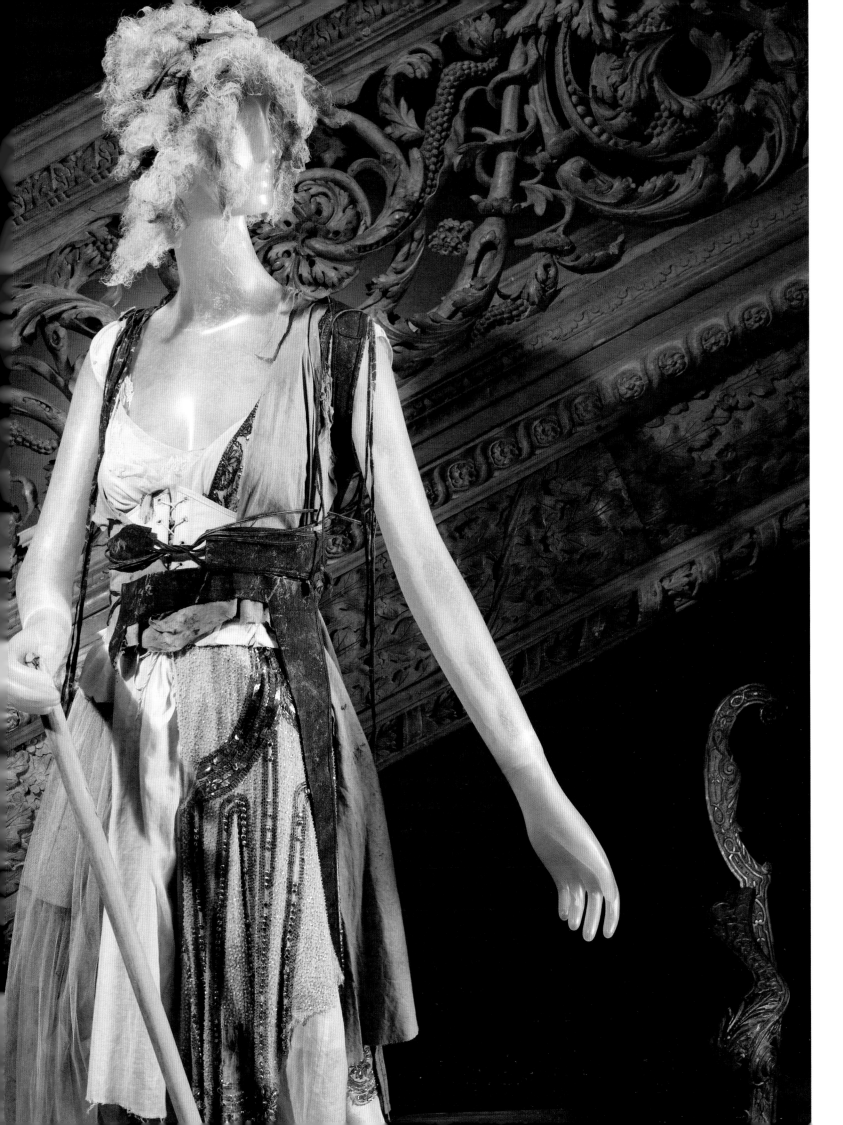

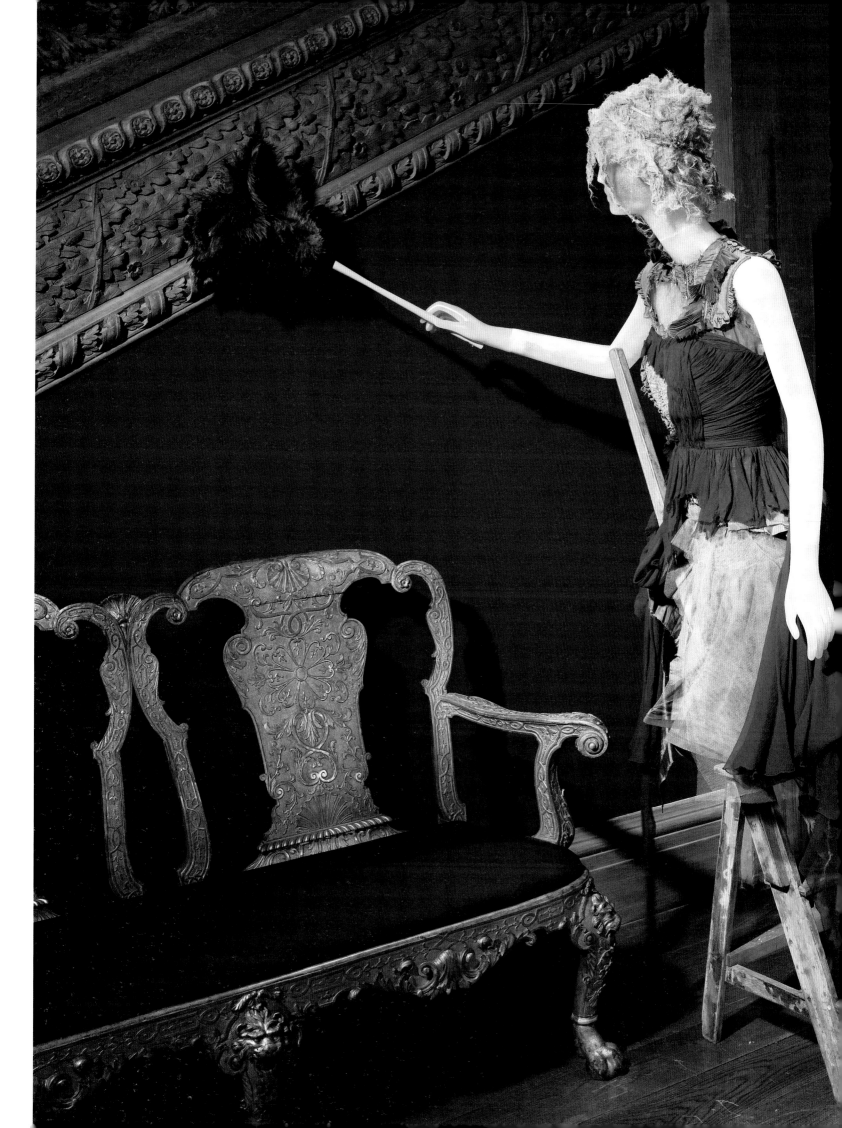

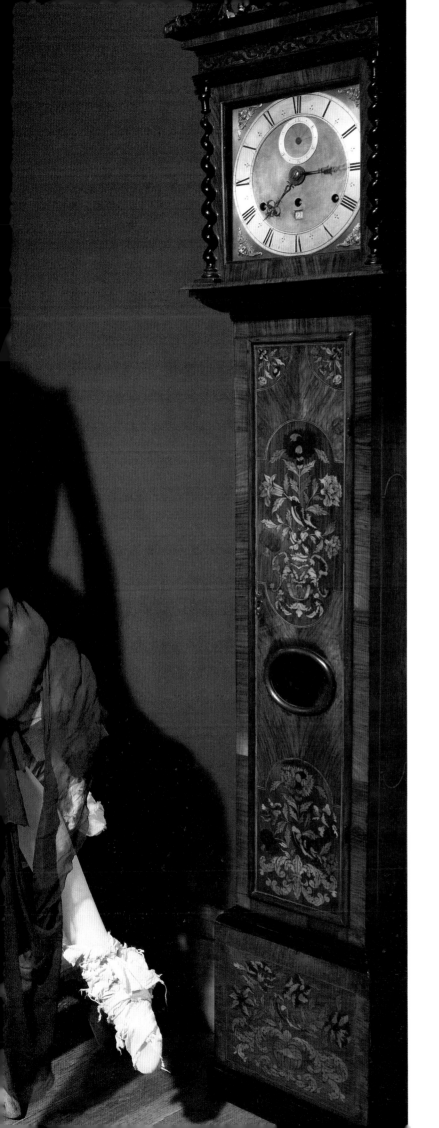

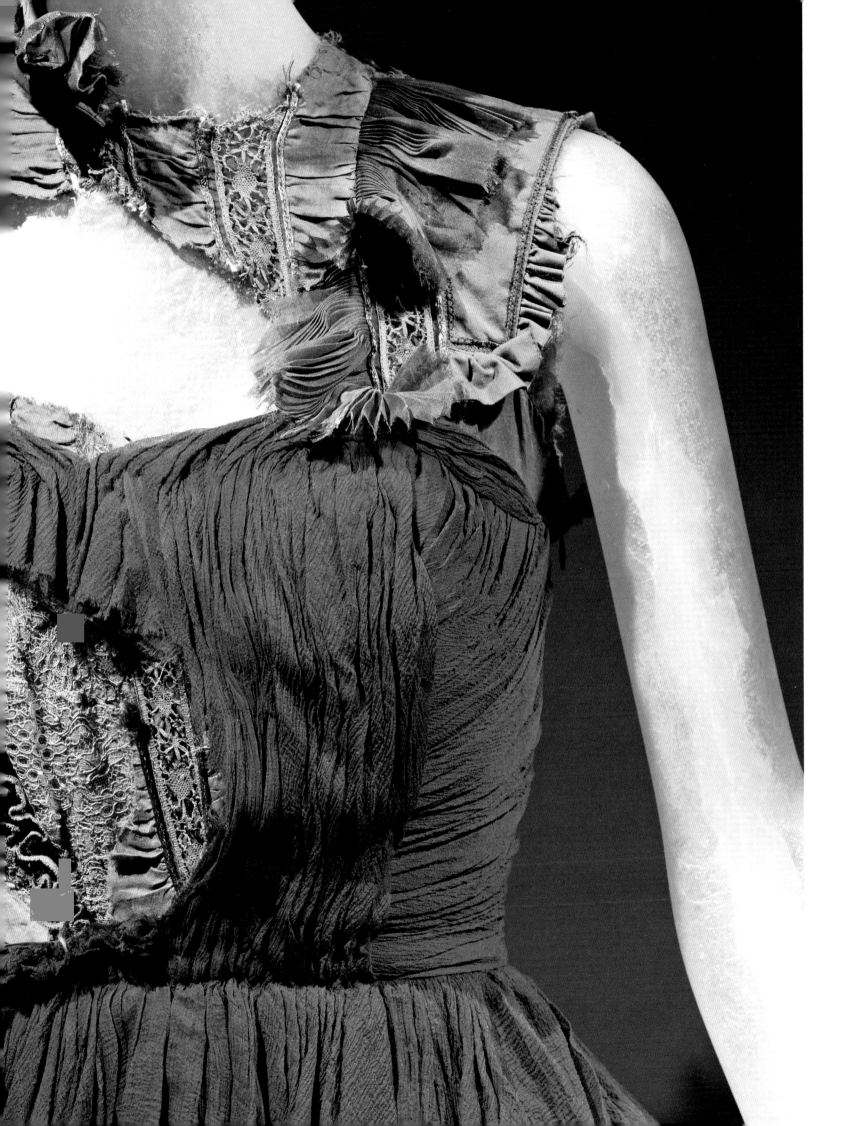

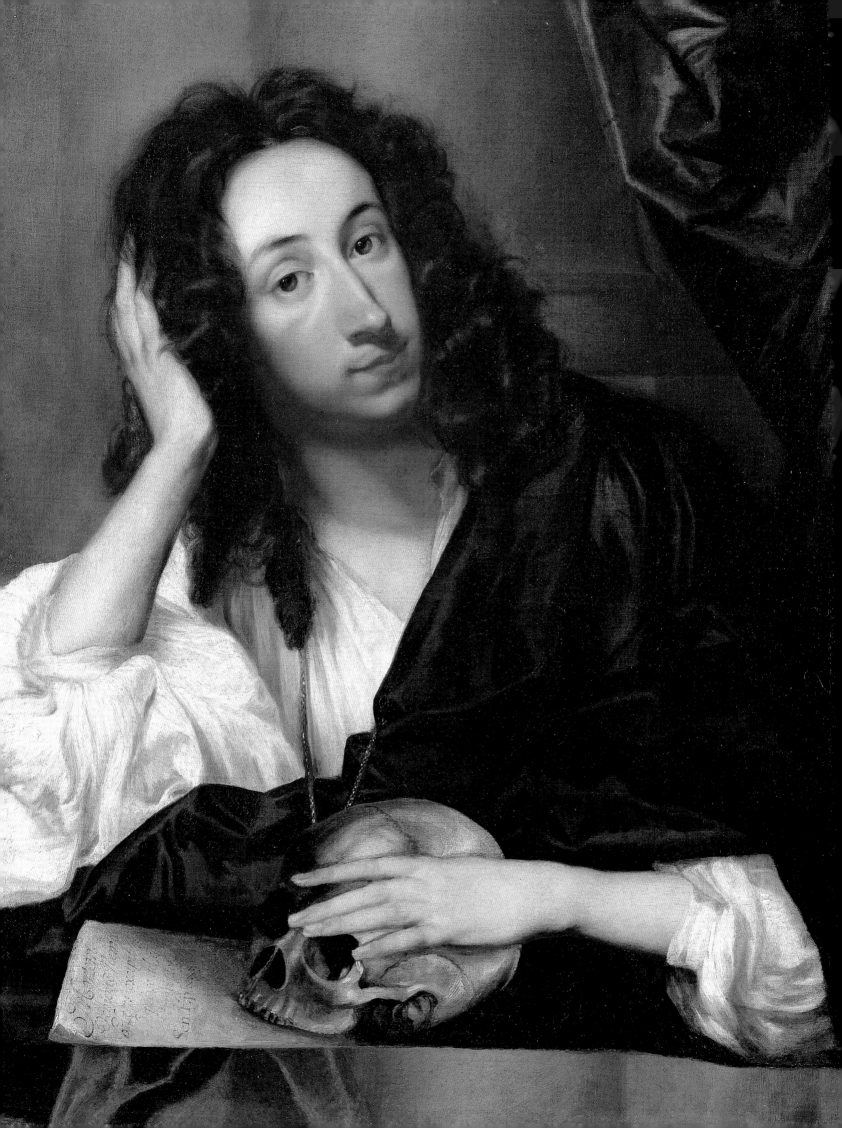

For centuries the country house or estate has served as a highly visible symbol of wealth and status. This is true, especially, from the late seventeenth and early eighteenth centuries, when families built new houses or rebuilt old ones to assert their financial standing against the backdrop of an emerging capitalist economy. Often, such architectural vainglories were undertaken by recently elected, or as in the case of Thomas Coningsby, the owner of Hampton Court in Herefordshire, recently elevated members of the nobility. Coningsby was created Baron of Clanbrassil in 1690 for his loyalty to King William III during the Battle of the Boyne (earlier he had supported William's claim to the English throne during the Glorious Revolution of 1688). Almost immediately, he set about remodeling and lavishly refurbishing Hampton Court, which had been built in 1435 and had passed to his family in 1510. While the house's exterior received a romantic medieval facelift, the interior, in keeping with prevailing fashions, received an assertive Baroque makeover.

Typical of the baron's extravagance and the Baroque's exuberance is this state bed, one of two Coningsby ordered in 1697 or 1698, in the opulent style of William III's French architect-designer Daniel Marot. Triumphs of the skills of weavers, upholsterers, and the makers of trimmings, state beds were the focus of the state apartment, a suite of rooms, including bedchamber and antechamber, at the center of any grand scheme of interior decoration. Bloated symbols of prestige, they were reserved for noble and royal visitors or for formal family receptions following births and marriages. Upon the death of a senior member of the household, the apartment was hung in black, and the corpse lay in state in the bedchamber.

Such a practice is reflected in "The Deathbed," which features a mourning dress worn by Queen Victoria after the death of her consort, Prince Albert, from typhoid fever in 1861. In the nineteenth century, mourning clothing became an outward signifier of gentility and respectability, since only the rich could afford the minutia of its etiquette. Black was worn for full mourning, which, for a widow, usually lasted two years, and gray, white, violet, mauve, and lavender for half mourning, which usually lasted six months. Queen Victoria's dress, almost entirely covered by black crepe, indicates that she was in the early stages of full mourning. More than any other material, crepe was associated with bereavement, imposing upon the wearer a rigid convention. Its lifeless, lusterless surface achieved the desired optical effect of mourning, namely the abolition of reflection. While Queen Victoria gradually abandoned her wrappings of widowhood, she never fully emerged from her eclipse, remaining in black for most of the rest of her life (earning her the sobriquet the "Widow of Windsor"). Her majestic mourning for the prince was in the tradition of the Romantic obsession with Love and Death, concepts that have dominated the fashion sensibility of several British designers, especially that of Alexander McQueen.

The language of Romanticism is invoked in his black mesh top and black silk skirt, the hem of which has been ravaged as if to suggest the violent passions that fueled the Romantic cult of the heart. A poetic morbidity is imposed upon the ensemble by pairing it with a hat by Philip Treacy. Encrusted with crystals imitating jet (the jewelry of sentiment par excellence), it recalls Queen Victoria's Mary Stuart widow's cap, so-called because it came to a peak on the forehead *à la Marie Stuart*. Explicit references to death and transience inform the brooch made from a rabbit skull by Simon Costin and the aluminum "spine corset" by Shaun Leane, both of which draw on the tradition of the memento mori, as depicted in John Evelyn's portrait (p. 50). So does the aluminum "jawbone," also by Leane, worn with an ensemble by McQueen that includes a pair of trousers made from tartan (of his own clan). Tartan is a fabric that the British monarchy, including Queen Victoria and Prince Albert, has long co-opted. In the 1840s and 1850s, the royal couple helped generate a craze for tartan, or "tartanmania," as part of their wistful romance with Scotland. McQueen's employment, however, often has darker implications, as in his "Highland Rape" collection (autumn/winter 1995–96), which took the theme of the Jacobite Uprising. Its aggressive styling, including staggering, blood-spattered models wearing torn and shredded garments trimmed with McQueen tartan, was intended to counter fanciful and idealistic notions of Scottish history such as those held by Queen Victoria and her beloved husband.

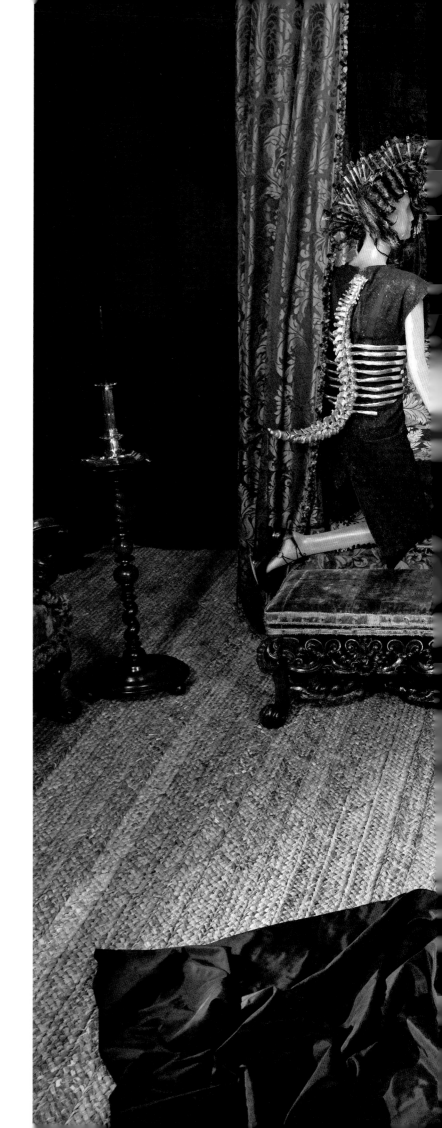

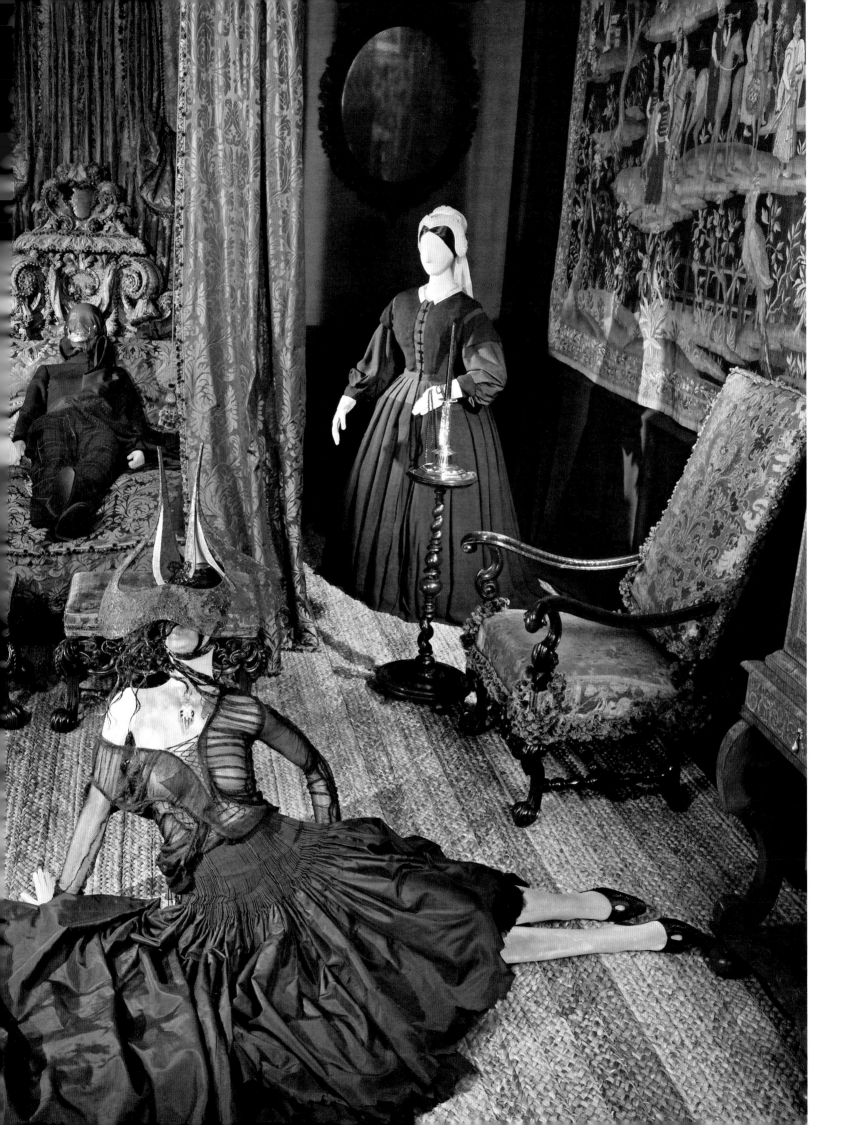

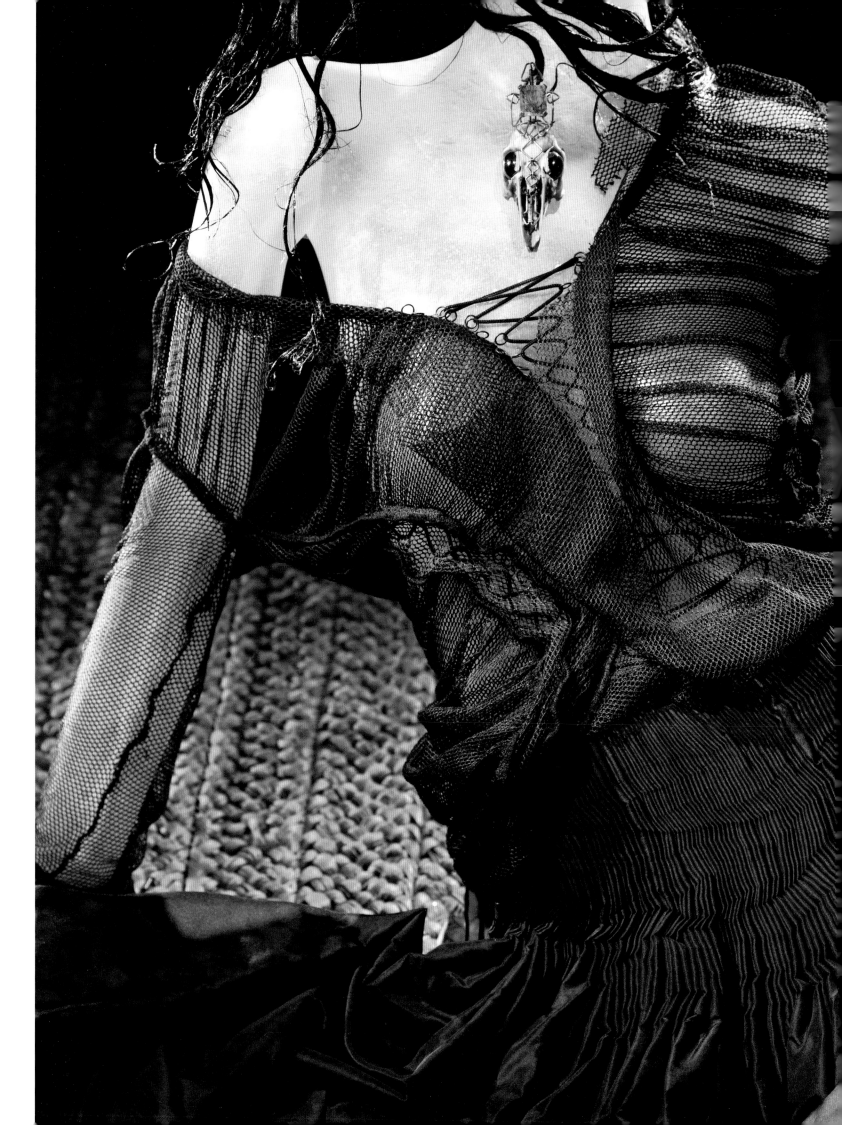

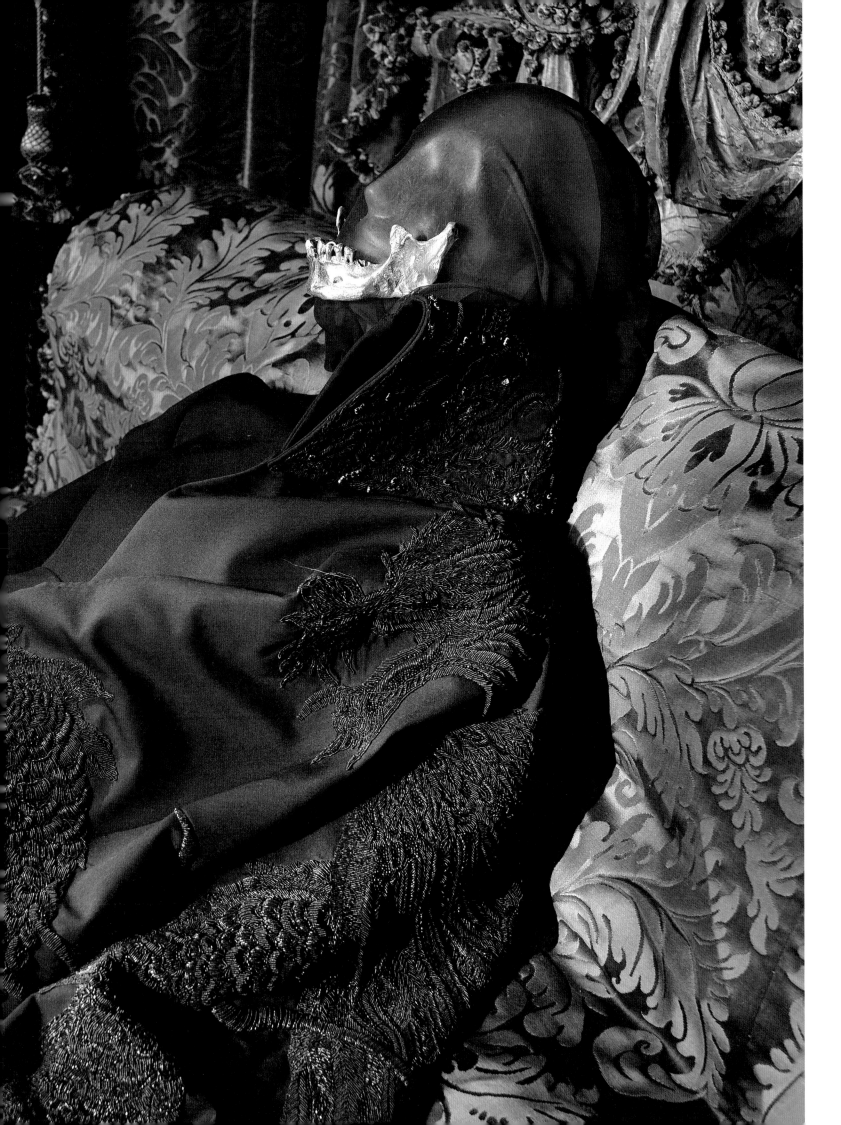

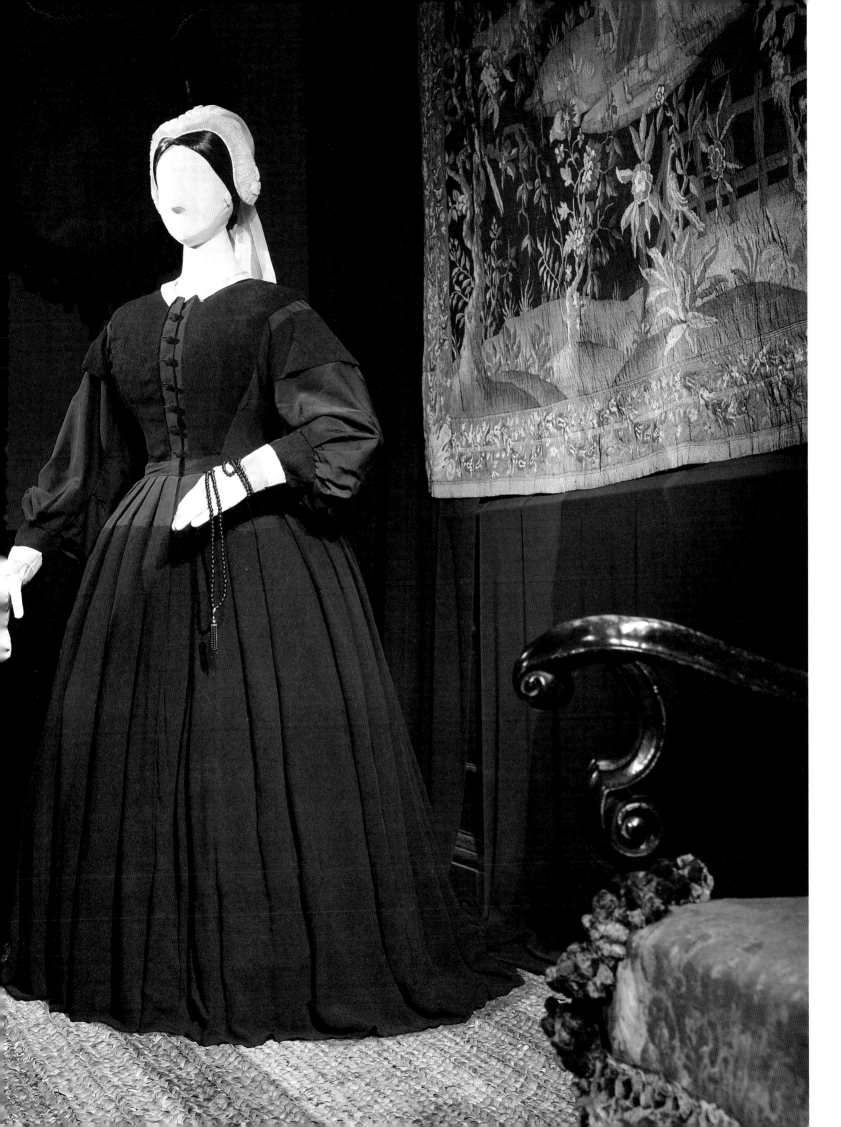

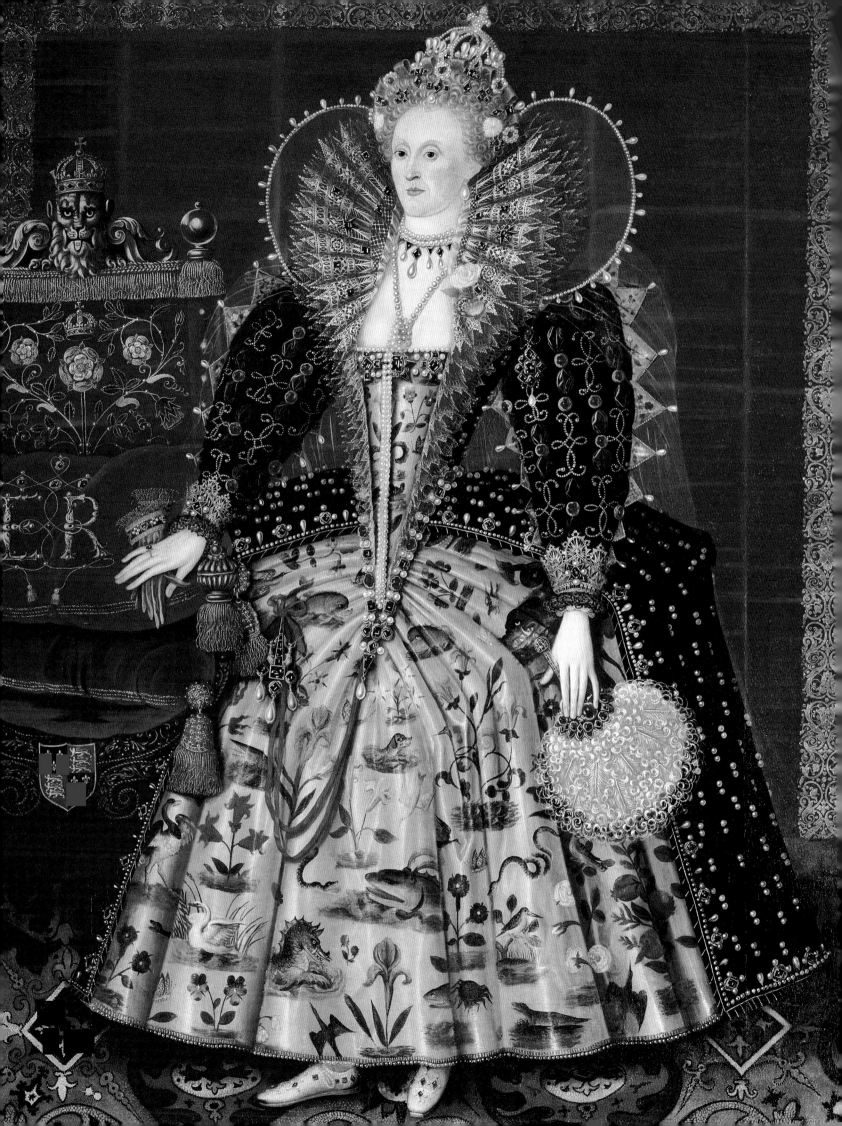

The British have always found portraiture appealing. It is congruent with their conviction, stemming from a deep-rooted puritanism, that art, like dress, should be useful. For the nobility, the functional relevance of portraits, not unlike the country houses or estates for which they were commissioned, has long rested on their value as propaganda. Traditionally, portraits, that is to say grand public portraits, have served to affirm wealth and status and reaffirm pedigree and ancestry. This function is true, especially, of the state portrait, the primary impulse of which is political. As Andrew Wilton has noted in *The Swagger Portrait* (1992), it invokes the right to rule and, as such, places a great emphasis on the outward trappings of authority. This accent is seen clearly in the portrait of Queen Elizabeth I (ca. 1599, p. 62) from Hardwick Hall in Derbyshire, in which the figure is depicted full length, fully frontal, and from a low viewpoint, devices employed in portraiture to enhance the grandeur of the subject.

As is typical of the queen's later portraits, when all hopes of a marriage had been abandoned, she is depicted as an icon, whose pallid masklike face is invested with a saintly idealization. The bejeweled magnificence of her costume and coiffure embodies the glory and riches of the queen's sacred and secular imperial kingdom, presenting a dazzling impression of "the admired Empresse through the worlde applauded." With its symbolic profusion and complexity, the portrait has a heraldic quality, made all the more explicit by the presence, in the chair's carving and upholstery, of heraldry relating to Elizabeth. Indeed, with its bold central figure placed against what appears to be a scarlet velvet curtain with a border of gold thread embroidery, the portrait serves as an ornate coat of arms, pointing to the strong alliance between royal arms and portraits and their function as expressions of sovereignty.

Given such cultural significance, it is perhaps not surprising that portraiture has proved a critical source of inspiration for several British designers, most notably Vivienne Westwood, who, as part of her autumn/winter 1997–98 collection, "Five Centuries Ago," created a facsimile of the costume represented in the portrait from Hardwick Hall. It forms the focal point of the Elizabethan Room from Great Yarmouth in Norfolk. The entrance to the room has been constructed to resemble a picture frame, above which hangs a carved depiction of the royal coat of arms. This framing device is employed throughout "AngloMania," specifically in instances whereby garments are transformations of canonical artifacts from the fields of painting and photography to that of fashion, like the ensemble by Westwood of tweed crown and fake ermine tippet (frontis), a parody of the robes and insignia of office depicted in royal images for more than five hundred years. Even the corset, based on those worn in the 1700s, and her "mini-crini," a hybrid of the 1960s mini-skirt and the 1850s crinoline (a garment associated with the overblown opulence of Empire) evoke regality through their color (scarlet) and their material (silk velvet).

In the Elizabethan Room, the painterly origins of Westwood's costume are underscored through its juxtaposition with a portrait of a noblewoman (late 16th century), whose face, like many women of her status, was made up or "painted" to resemble Elizabeth's unwrinkled smoothness of countenance (the ideal of female beauty). While the shape of Westwood's dress resembles the fashionable Elizabethan silhouette, achieved through a corset and an underskirt, or farthingale, the bodice is only lightly boned and the skirt's volume is attained primarily through pleating and the relative stiffness of the material, a sumptuous duchesse satin. The design of the fabric is a faithful rendering of that in the portrait from Hardwick Hall. Although printed, the clarity and vibrancy of the motifs, including birds, flowers, and sea monsters, makes them appear to have been painted, as they may have been originally (equally, they may have been embroidered). The brooch, pinned to the black velvet jacket with a high "ruff" collar, is a vestige of the gorgeous bombast of jewelry adorning the jacket in the queen's portrait, as is the necklace, invoking the dark sensibility of Elizabethan literary imagery. Made by Simon Costin and entitled the "Incubus Necklace," it incorporates five glass vials of human semen, from which dangle creamy baroque pearls. The vials are set against a filigree of copper wire with snaky silver sperm entwined over its surface. Surmounted by a small silver plaque engraved with the words "Vice and Virtue," the "pearl necklace" serves as an ironic commentary on Elizabeth's assumed status as a semidivine immortal, the widely hailed "Virgin Queen."

That fiend that goth a-night
Women full oft to guile,
Incubus is named by right;
And guileth men other while,
Succubus is that wight.

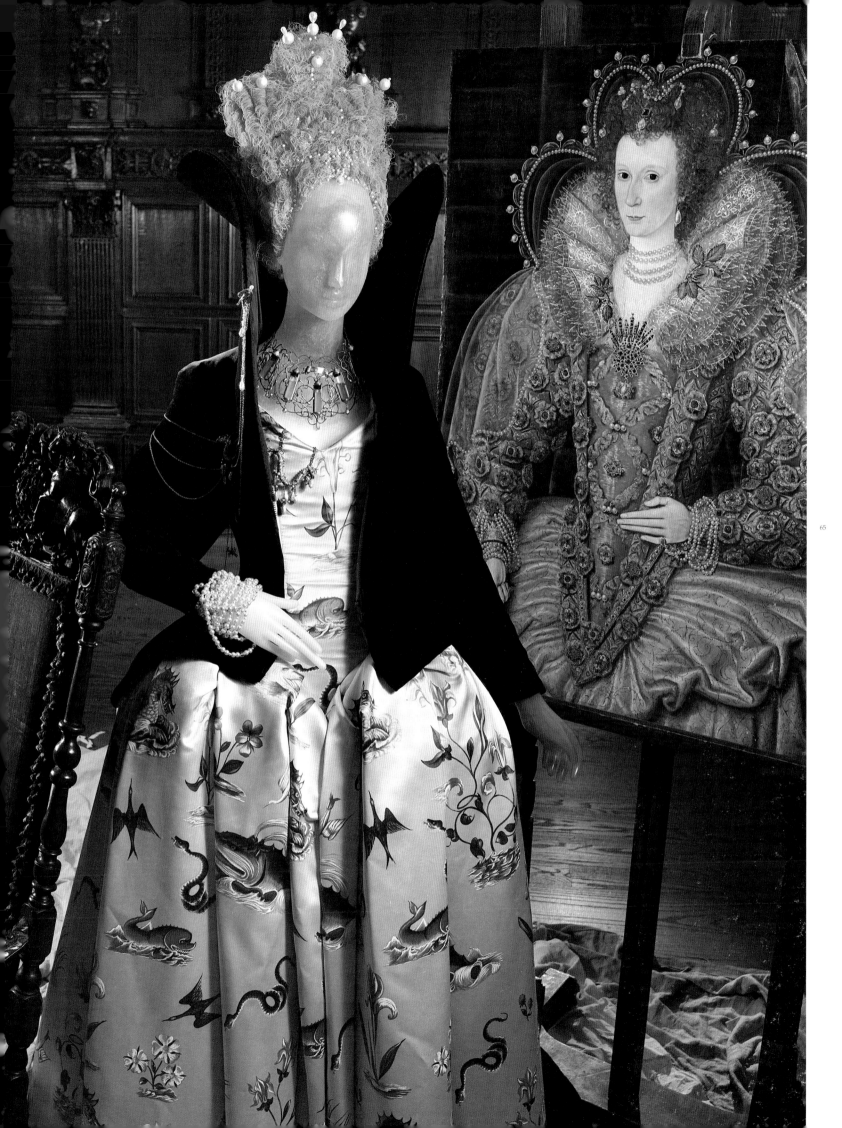

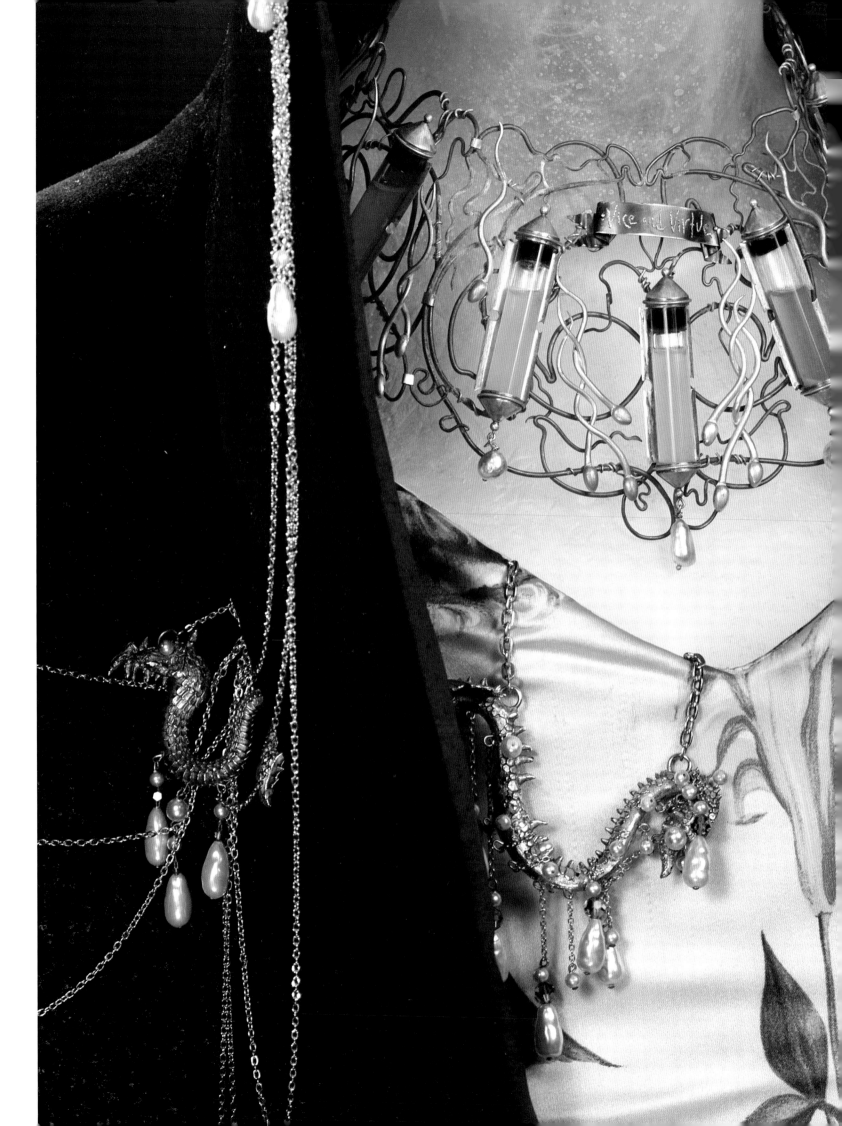

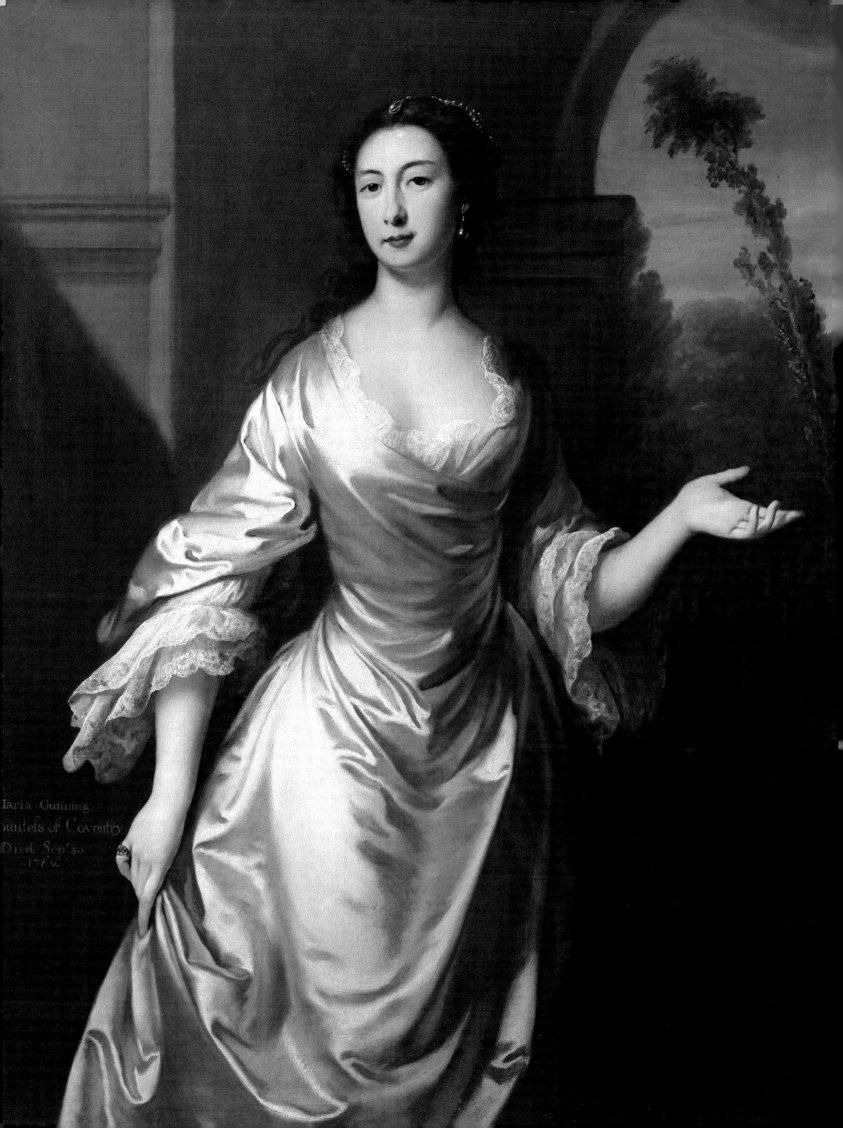

Maria Gunning
Countess of Coventry
Died Sep.r 30
1760

At the same time that France was in the grip of Anglomania, England was in the thrall of Francomania. Commenting on this interchange of influences, Horace Walpole noted, "Our passion for everything French is nothing to theirs for everything English. The two nations are crossing over and figuring in." Francomania was principally an aristocratic predilection, and one that was not specific to the eighteenth century. As indicated in the writings of Samuel Pepys, the English nobility's fondness for French goods and services was much in evidence a century earlier. However, whereas in the 1600s French tastes in art, music, fashion, and furniture were channeled through the court, in the 1700s they were disseminated through the great Whig grandees who ruled the country. This proclivity was a source of irritation among patriots lower down the social scale, who regarded the Gallic tastes of the upper classes as distinctly unpatriotic.

At least until the French Revolution (1789–99), the English nobility remained thoroughly Francophile. Typical of men of his class, George William, sixth Earl of Coventry, spent much of his wealth decorating the interiors of Croome Court, his seat in Worcestershire, with French paintings, porcelain, and furniture. After the Treaty of Paris (1763), which ended the Seven Years War (1756–63), the earl indulged his passion for French luxuries by ordering a set of tapestries from the Royal Gobelins Manufactory in Paris for one of three rooms at Croome Court designed by the architect Robert Adam. The acme of the earl's Francophilia, the tapestries, like wallpaper, cover the four walls from cornice to chair rail. Designed with borders resembling gilded wood frames, they are composed of medallions featuring allegories of the Four Elements by François Boucher, that most French of French painters.

It seems that the earl's aesthetic perspicacity extended to women, for in 1752 he married the actress Maria Gunning. She along with her sister Elizabeth were considered "the handsomest women alive." Walpole recorded that the "Beauties" caused a furor wherever they went, noting, "they make more noise than any of their predecessors since the days of Helen." Many artists attempted to represent Lady Coventry's comeliness, including Francis Cotes and Sir Joshua Reynolds, but none seem to capture her surpassing loveliness quite as well as Sir Joseph Highmore (p. 68). In his painting of 1745, she wears a silk robe without a pannier, a hooped underskirt responsible for the wide-hipped, flat-fronted silhouette fashionable throughout the eighteenth century. While a typical convention of portraiture intended to convey a timeless classical beauty, it appears to be a style the countess favored. Recalling a visit to her house by Lady Coventry, Mrs. Delany, that indefatigable commentator on dress and etiquette, observed, "Her dress was a black silk sack made for a large hoop which she wore without any, and it trailed a yard on the ground." Mrs. Delany also noted that "she had a thousand prettiness in her cheeks," a reference, perhaps, to the countess's penchant for powder. Indeed, her makeup was her downfall, for she died at twenty-seven from consumption aggravated by the cosmetic use of white lead.

Lady Coventry's "death by vanity" informs the vignette in Croome Court, in which the figure, wearing a headdress by Stephen Jones in the form of a raven (a Romantic symbol of death) reaches to touch her mirrored reflection. Similar to the Meissen birds on the pier table, the headdress is a three-dimensional representation of the birds in the tapestry surrounds. The dress, in color, material, and long train, evokes that worn by Lady Coventry when visiting Mrs. Delany. Made by John Galliano for Christian Dior, it is an unabashed expression of his long-standing Francophilia, apparent as early as his 1984 graduation collection, inspired by the Incroyables and Merveilleuses of post-Revolutionary France. Based on Dior's 1947 collection, dubbed the "New Look" by *Harper's Bazaar* editor Carmel Snow, the dress, in its references to eighteenth- and mid-nineteenth-century French styles, reveals the genesis of Dior's remarkable silhouette that combined rigorous shaping with wanton drapery. With the acuity of a dress historian and the vision of a creative maestro, Galliano, in one dress, outlines the history of French fashion, as well as the history of the House of Dior. Galliano stands in a long line of British designers, beginning with Charles Frederick Worth (p. 146), working in the tradition of haute couture. Like Worth, Galliano's ideas of French fashion are informed by his ideals of French culture. It is his status as an outsider that enables him to articulate the "Frenchness" of French fashion so discerningly. As with Lord Coventry, Galliano's Francomania is a fantasy that merges fact with fiction, imitation with variation.

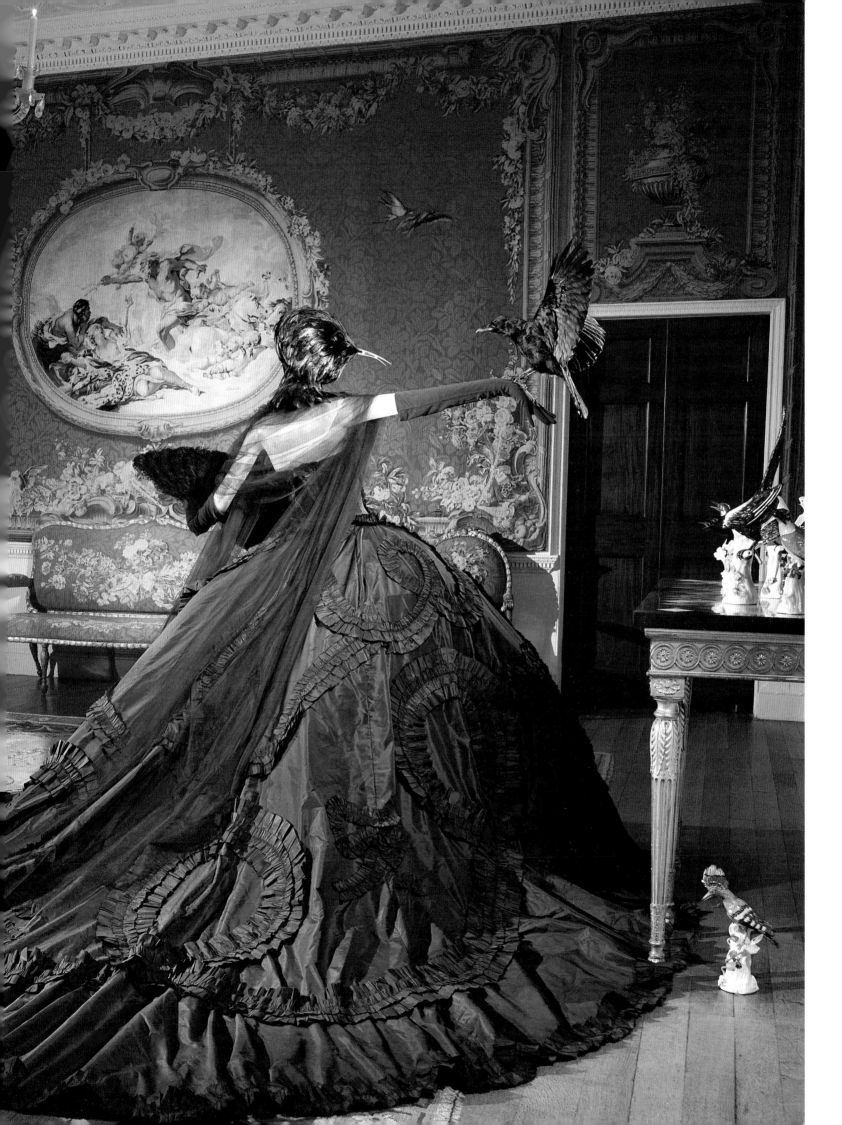

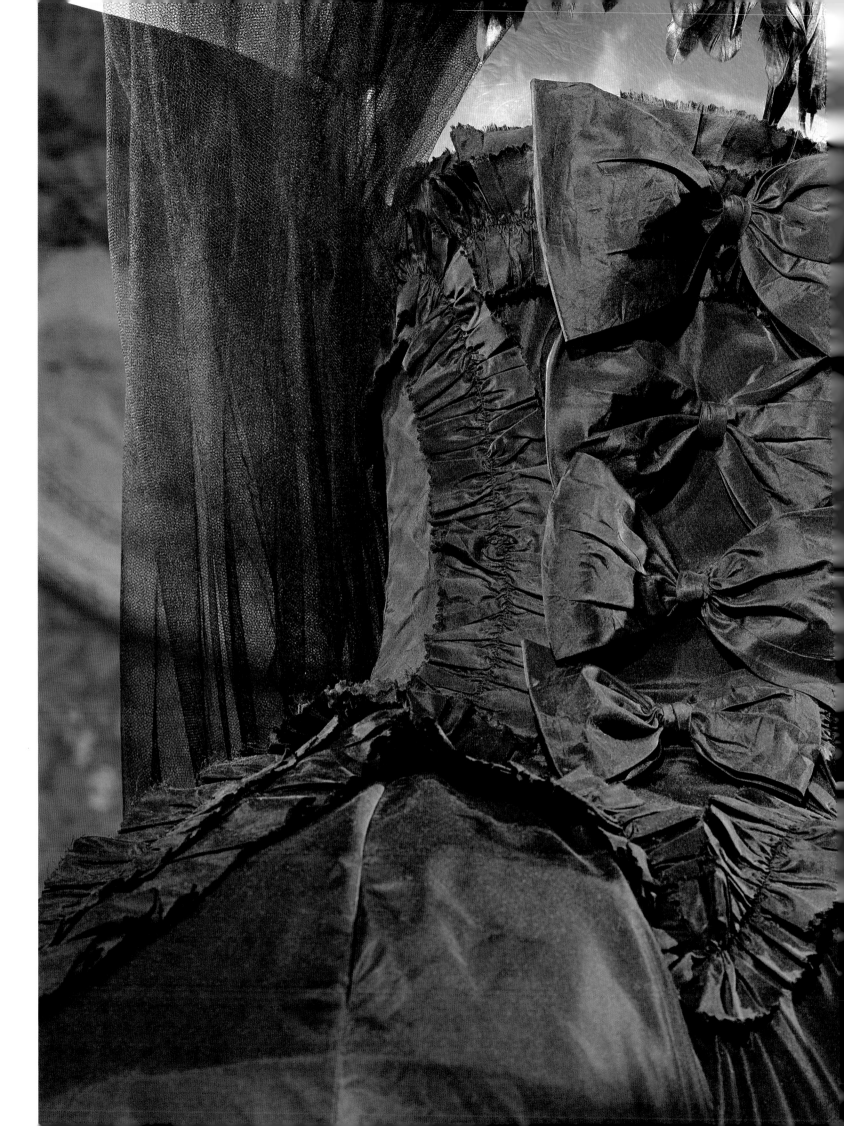

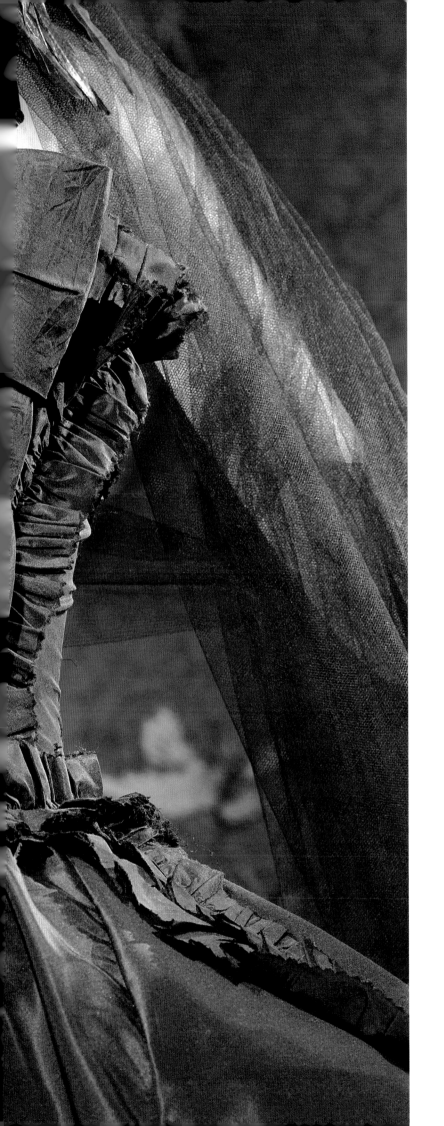

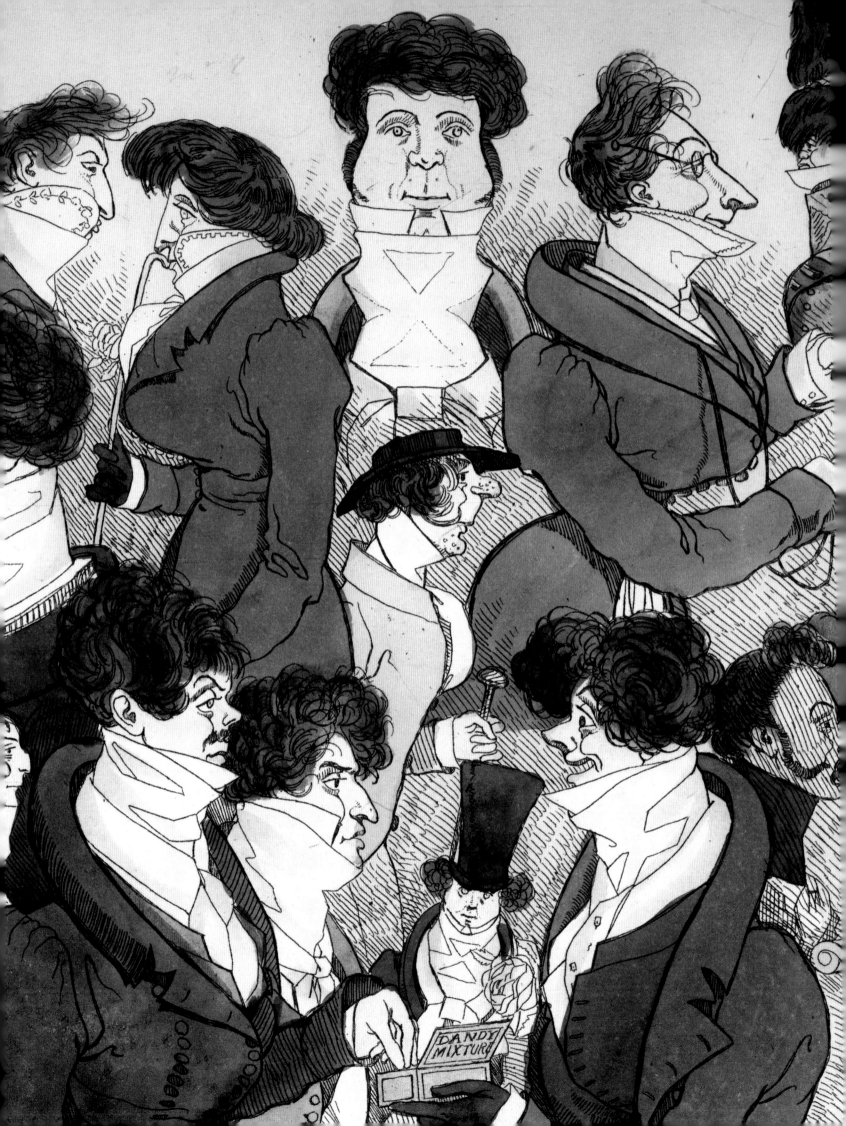

In his *Journey to England and Ireland* (1833), Alexis de Tocqueville noted, "'Gentleman' and 'gentilhomme' evidently have the same derivation, but 'gentleman' in England is applied to every well-educated man whatever his birth, while in France *gentilhomme* applies only to a noble by birth." It was an astute observation, for while ancestry was an important component in the definition of an English gentleman, a more decisive factor was that of character, defined by a code of conduct based on such medieval concepts as loyalty, chivalry, and courtesy. He thrived in England because of the nation's unique social system, the porous quality of which could facilitate the ambiguity and mutability of his identity.

As an indicator of his character, an English gentleman's appearance was paramount. Guy Miege wrote in *The Present State of Great Britain* (1691), the title of "gentleman" was conferred upon those who distinguished themselves by "a genteel dress and carriage." In Miege's day, this sartorial gentility was beginning to be associated with notions of restraint and modesty, ideals that became more entrenched in the 1700s and that were to achieve their ultimate expression in the figure of the Regency dandy. Although from the 1830s dandyism became increasingly associated with a foppish exhibitionism, taken to its extreme in the fin-de-siècle aesthete, it was originally associated with a rigorously disciplined asceticism. George Bryan "Beau" Brummell, whose emphasis on a relaxed, effortless appearance (achieved through arduous dressing rituals) was central to the dandy creed, is commonly regarded as the greatest exemplar of Regency dandyism. "His chief aim," wrote his biographer Captain William Jesse in 1844, "was to avoid anything marked; one of his aphorisms being that the severest mortification that a gentleman could incur was to attract observation in the street by his outward appearance." Brummell's meticulous minimalism was, however, conspicuous by its inconspicuousness.

More interested in refinement than innovation, Brummell exploited late-eighteenth and early-nineteenth-century developments in tailoring techniques to achieve his studied but stunning simplicity. Cut and line, as well as quality of fabric, were forefronted to accomplish an emphatically masculine silhouette (although taken to extremes, it could have the reverse effect, as highlighted in Richard Dighton's *The Dandy Club* (1818, p. 74). Indicative of Brummell's emphasis on "naturalness," the cut of his clothes followed the lines of Greek statuary, reflecting concurrent decorative preoccupations with Neoclassicism. Such concerns are expressed in the dining room from Lansdowne House in London. Designed by Robert Adam, it includes nine niches for classical statues. The use of sculpture as decoration was a typical feature of Adam's interiors of the 1760s and is accented in "AngloMania" by the inclusion of a white muslin dress by John Galliano that evokes the sculptural characteristic of "wet drapery" and references the fashionable Neoclassical silhouette of the late eighteenth and early nineteenth centuries.

Taking as its theme "The Gentlemen's Club," the Lansdowne dining room pitches Punks in designs by Malcolom McLaren and Vivienne Westwood against gentlemen in bespoke suits by Richard James, Richard Anderson, Timothy Everest, Henry Poole & Co., and H. Huntsman & Sons, and ready-to-wear suits by Kilgour, Burberry, Paul Smith, and Ozwald Boateng. Reflecting the tribal identities that exemplify British fashion and culture, this scene of Hogarthian propensity is presided over by a group of dandies, including figures dressed in evening suits by Alexander McQueen and Anderson & Sheppard. McQueen trained at Anderson & Sheppard, the eponymous founders of which served their apprenticeship with the formidable Frederick Scholte, principal tailor to the Duke of Windsor from 1919 to 1959. The Duke of Windsor is represented in "The Gentlemen's Club" by an evening suit in midnight blue, a color that was promoted by Brummell and favored by his royal descendant for its photogenic possibilities (blue, in terms of black and white photography, allowed for the recognition of such tailoring details as lapels, pockets, and fabric-covered buttons). Like the Duke of Windsor, late-twentieth-century Punks and early-twenty-first-century gentlemen are, in very different ways, inheritors of the tradition of Brummellian dandyism, the former through their political posturings and the latter through their sartorial sublimity. For, in spite of, or rather because of its exquisite propriety, Brummell's self-presentation was, fundamentally, oppositional, an antifashion statement that mocked the sartorial superiority of the aristocracy and the sartorial mediocrity of the bourgeoisie. In essence, Brummell was a Punk disguised as a gentleman.

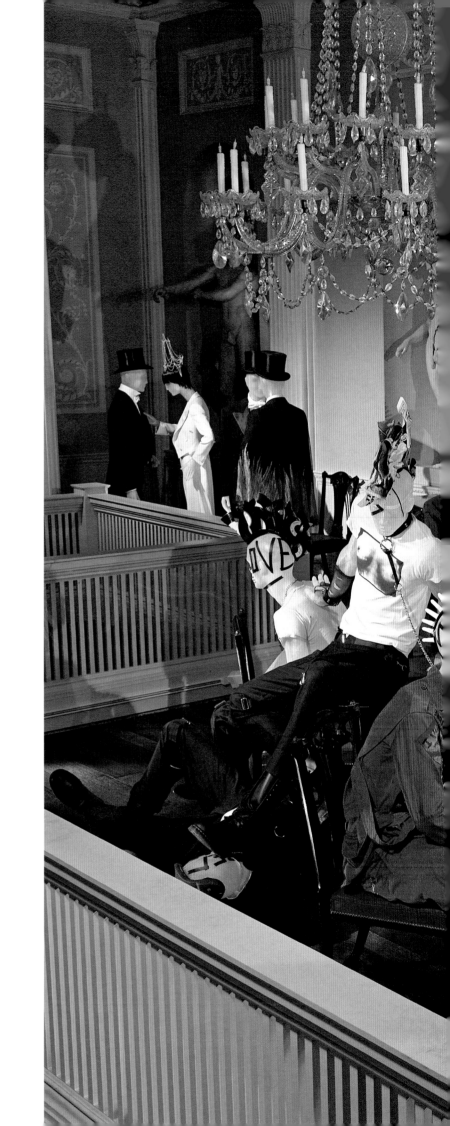

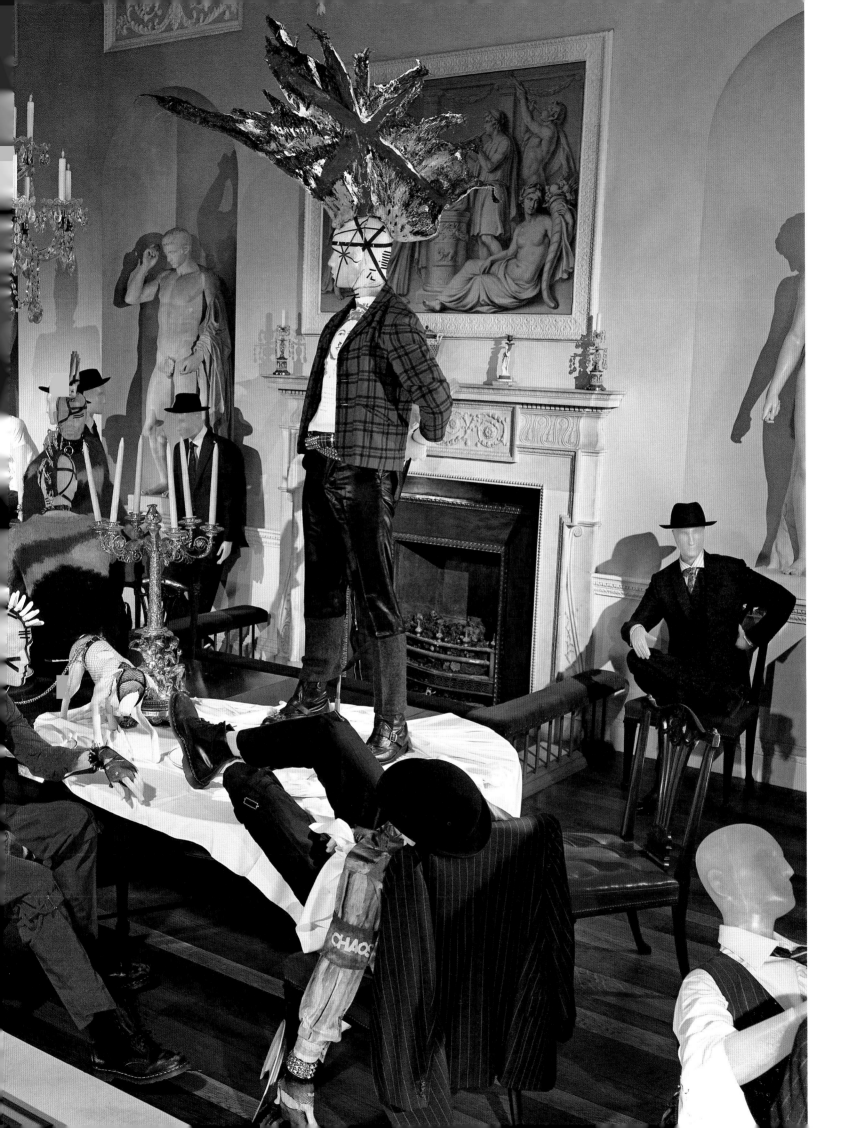

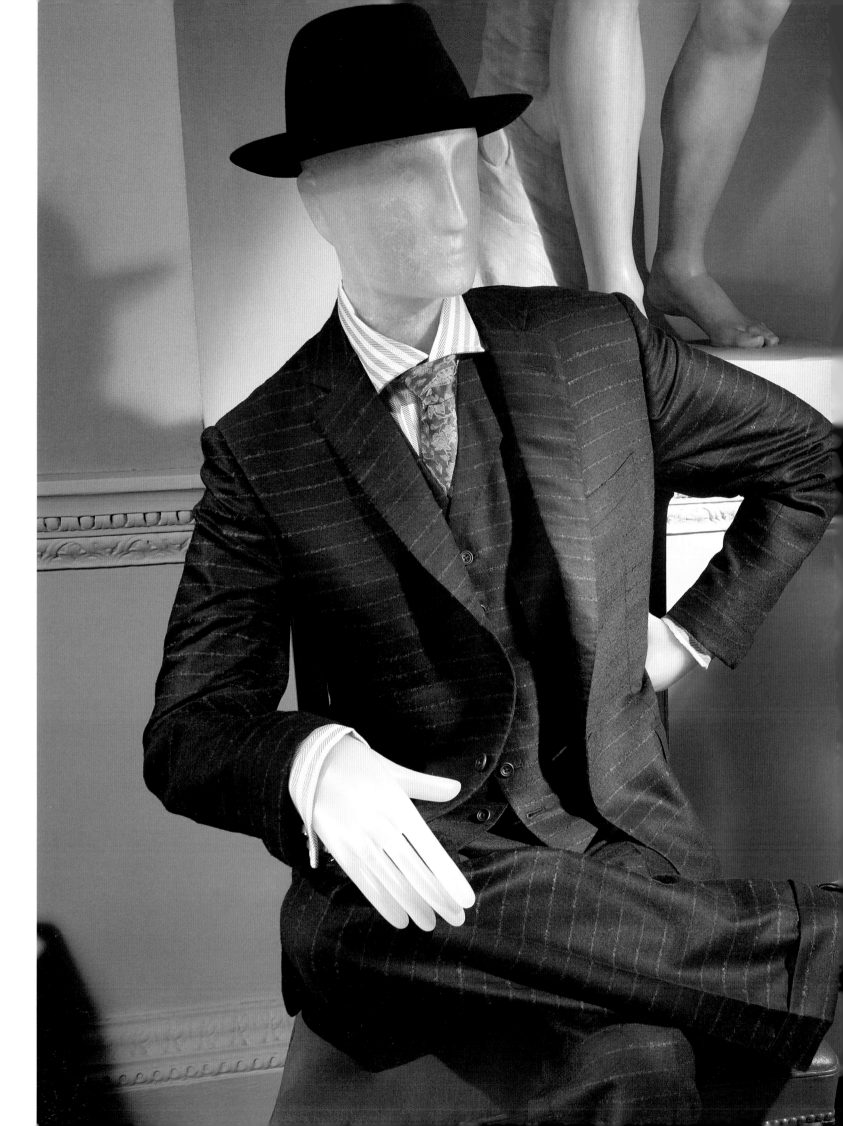

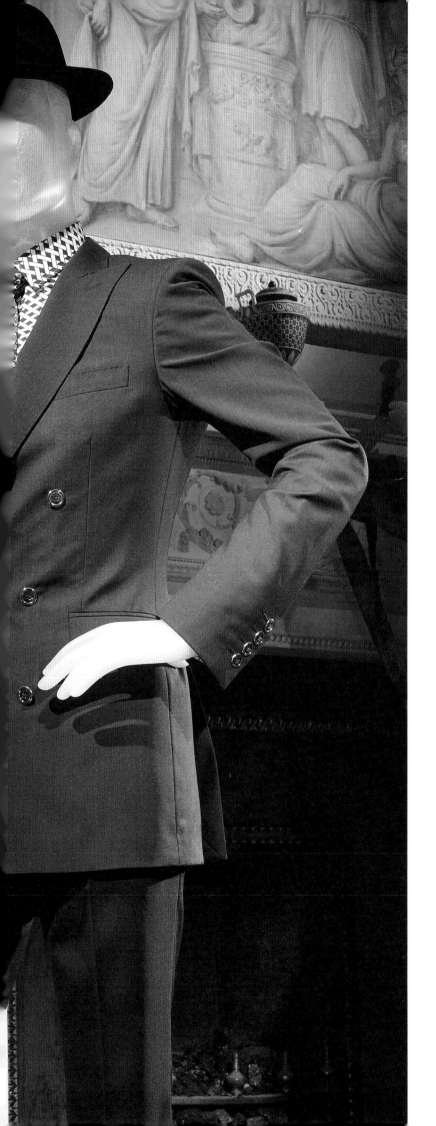

gonna wake up
and *know* what
you've been lying

The Liberal Party/John Betjeman/
s Forte/Sat nights in Oxford
logan + Robert Carr)/Park
s that treat their
/BRUT for their
ce for —

/The Play
ded first thi
or/Michael Rober
vid Essex/Rober
ce/Elton John —
shopping/s...

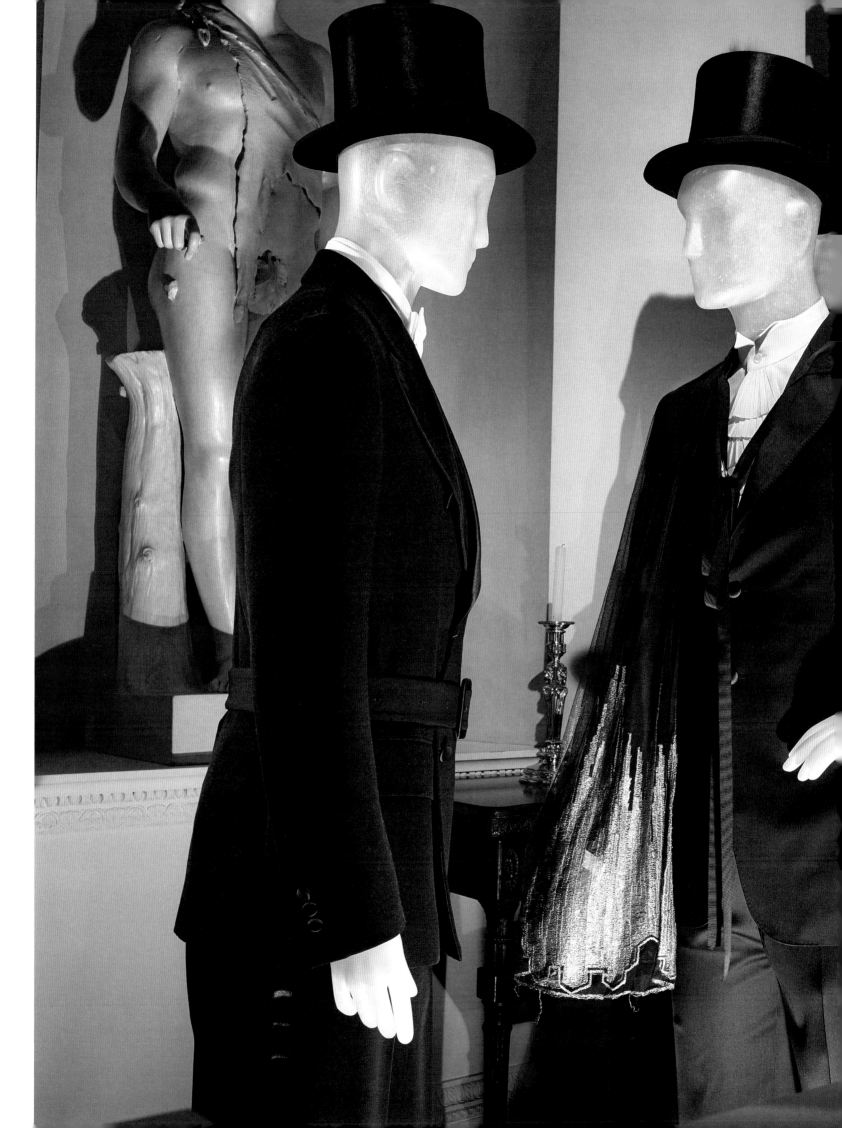

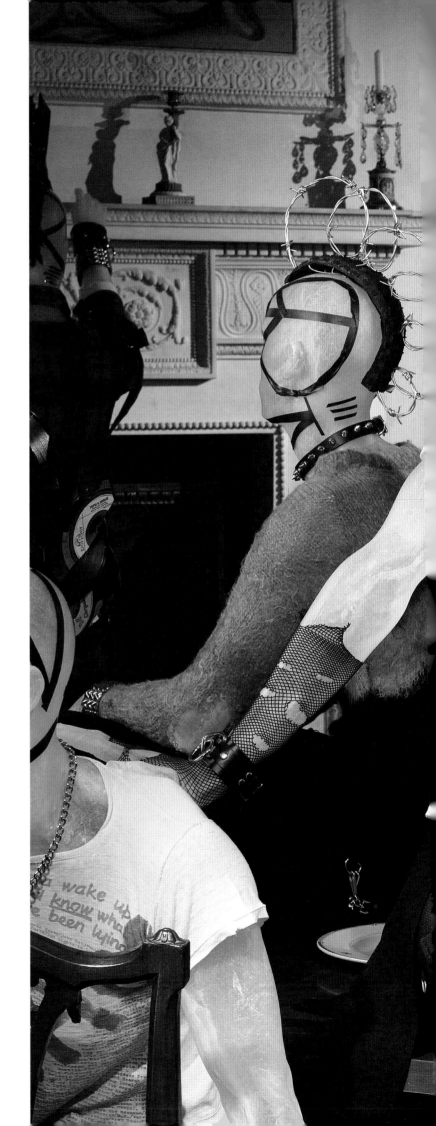

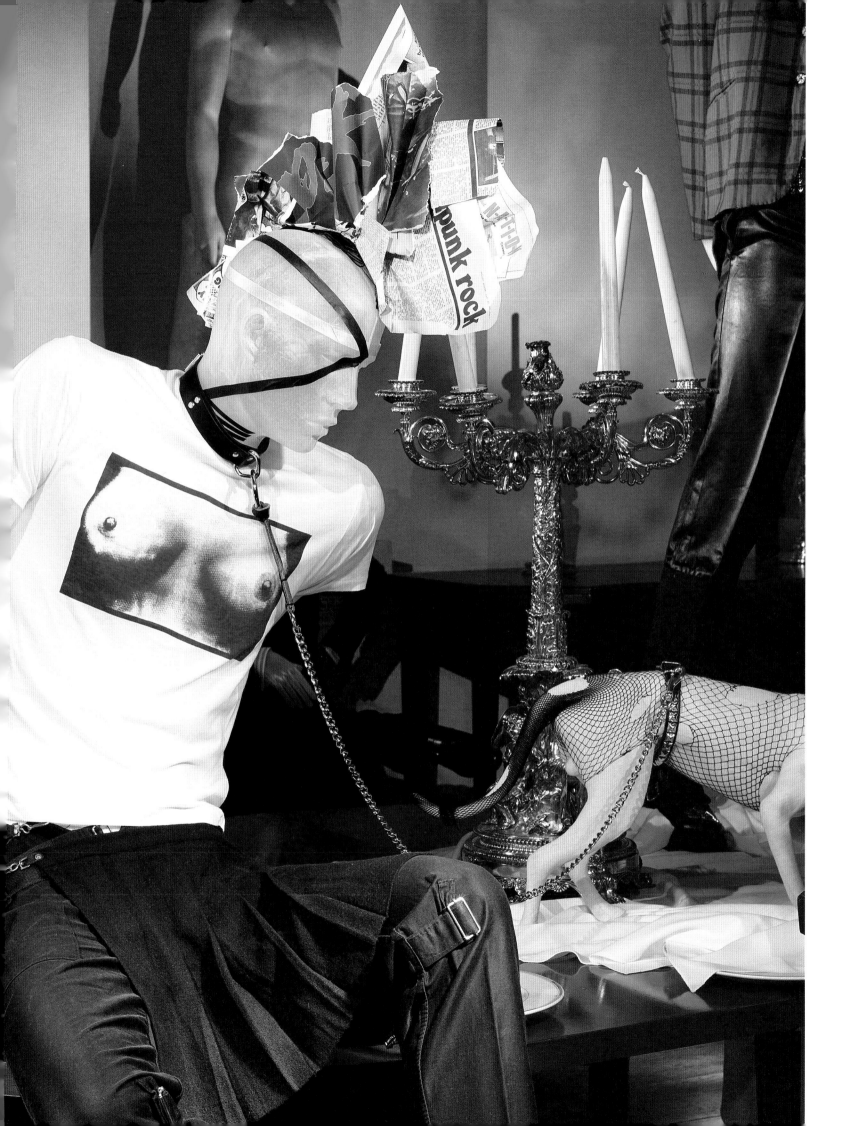

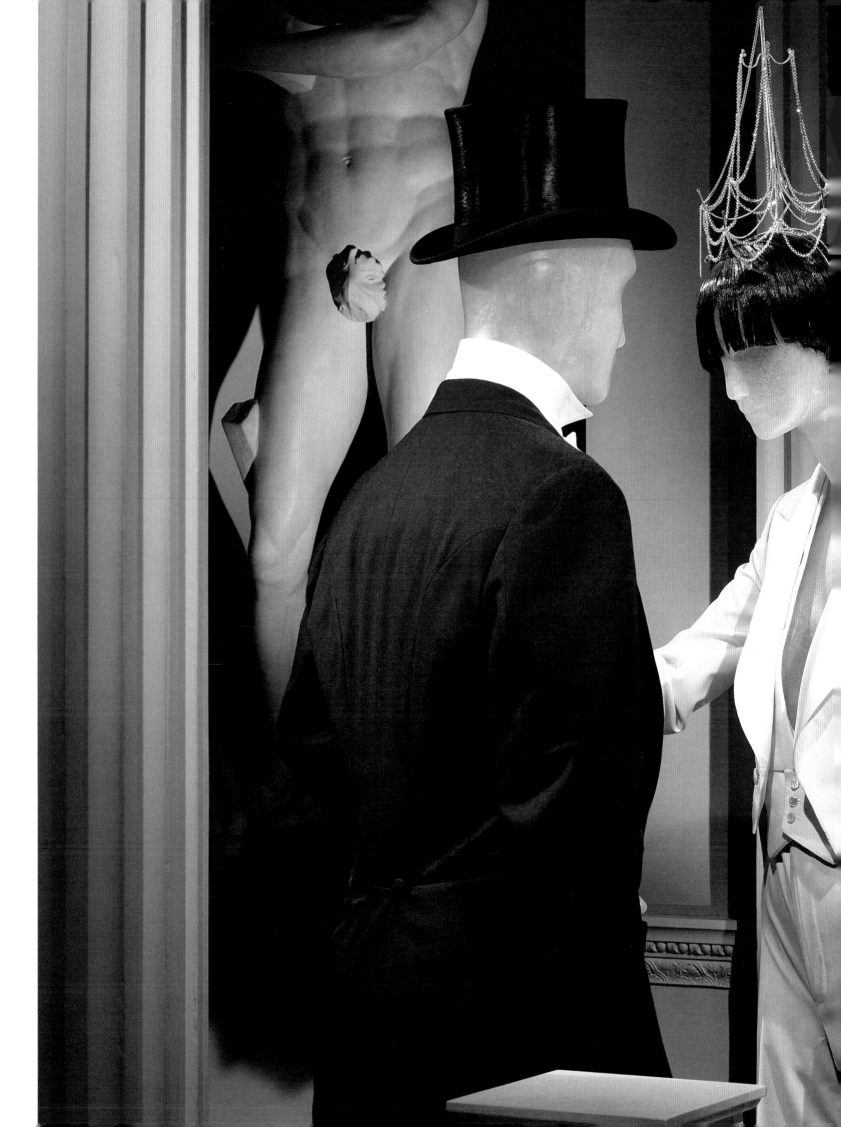

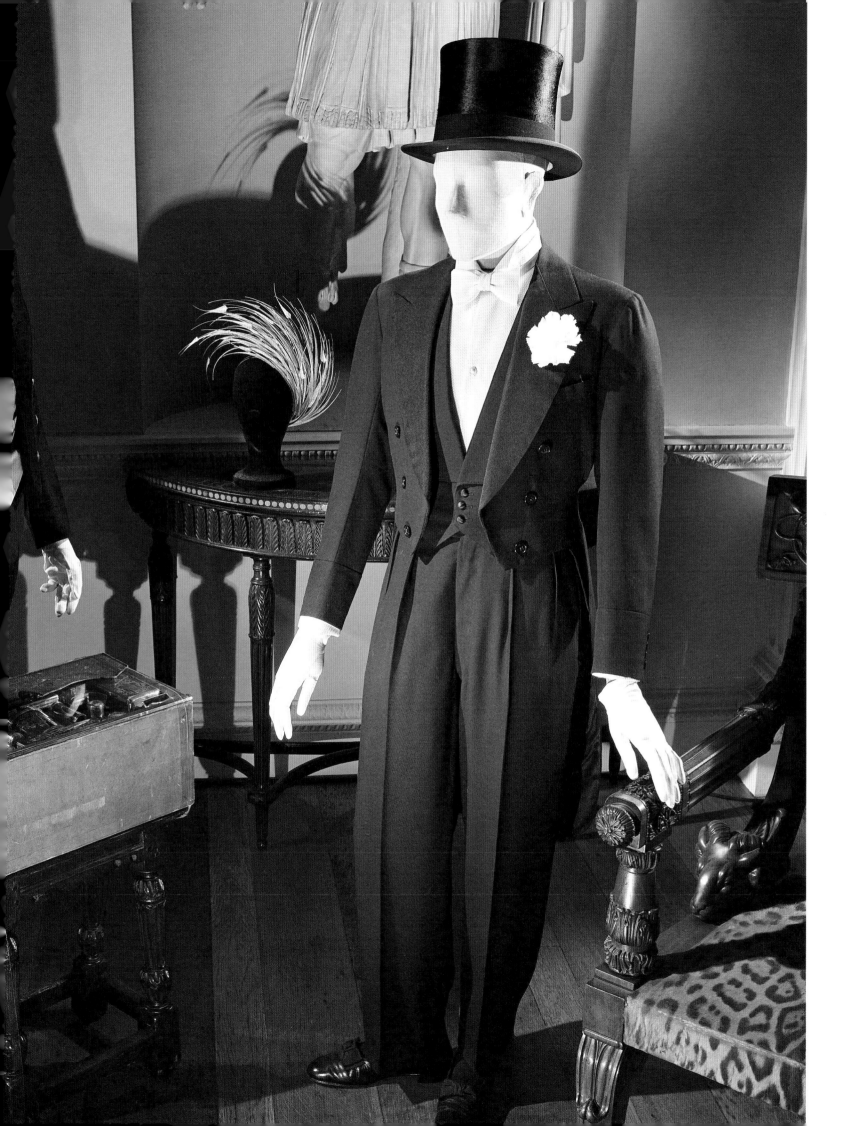

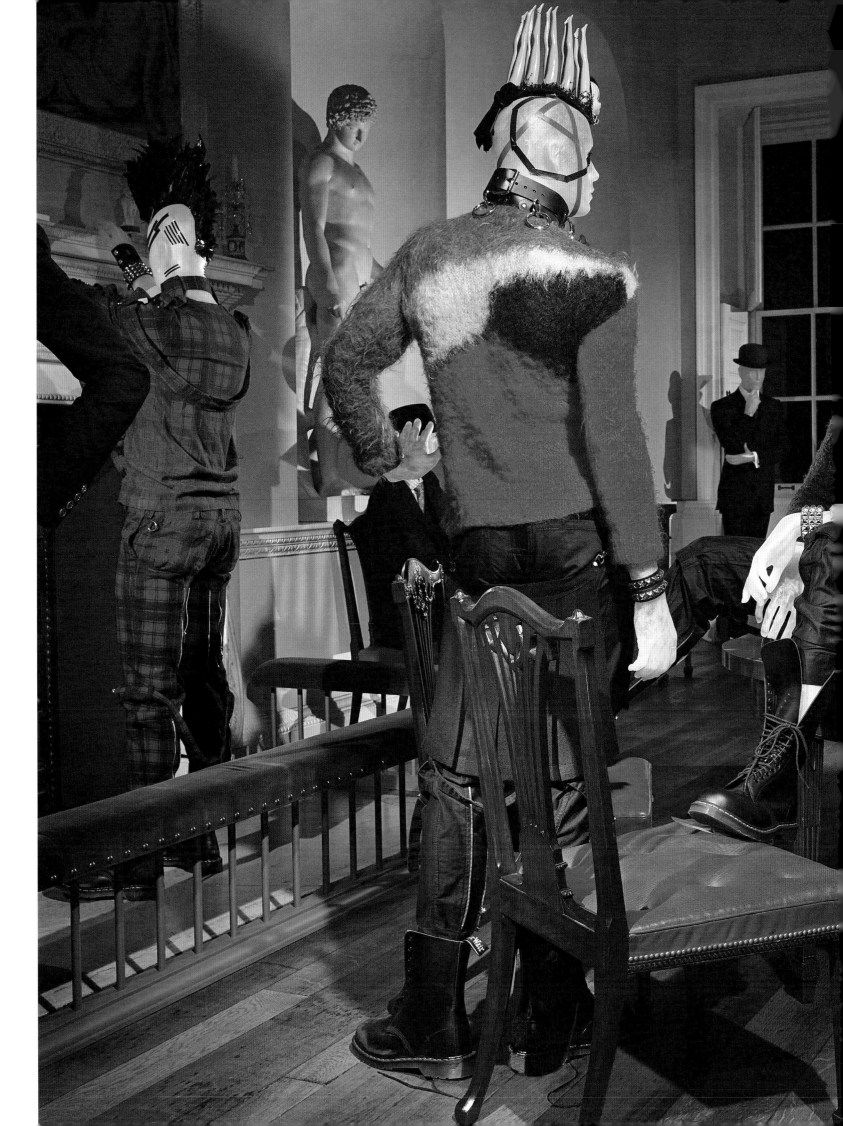

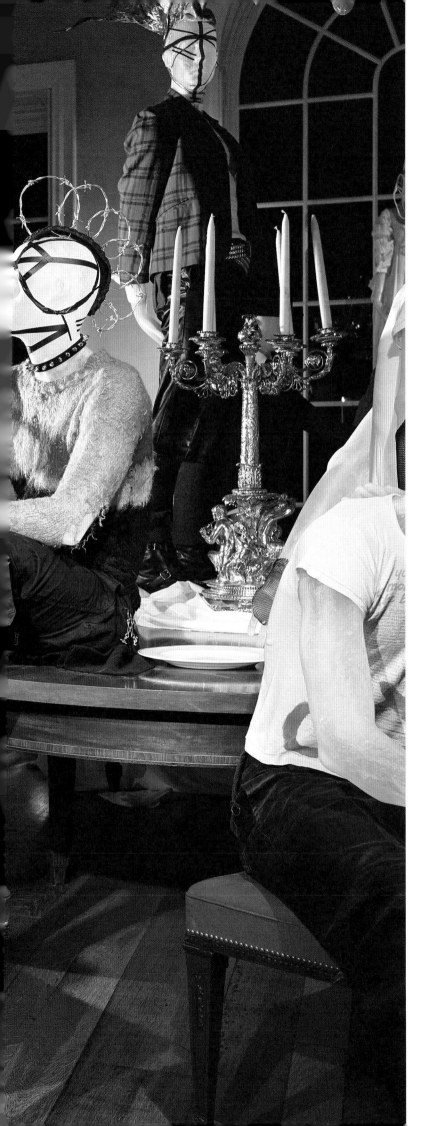

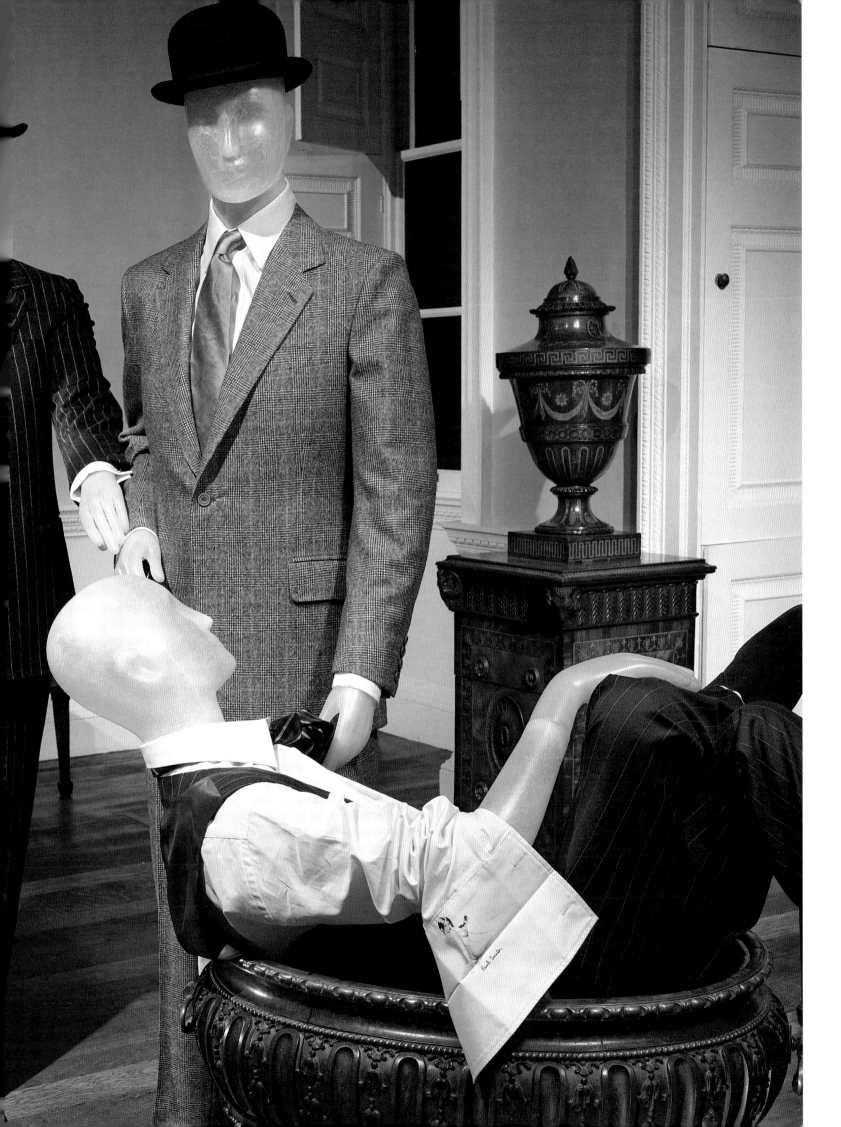

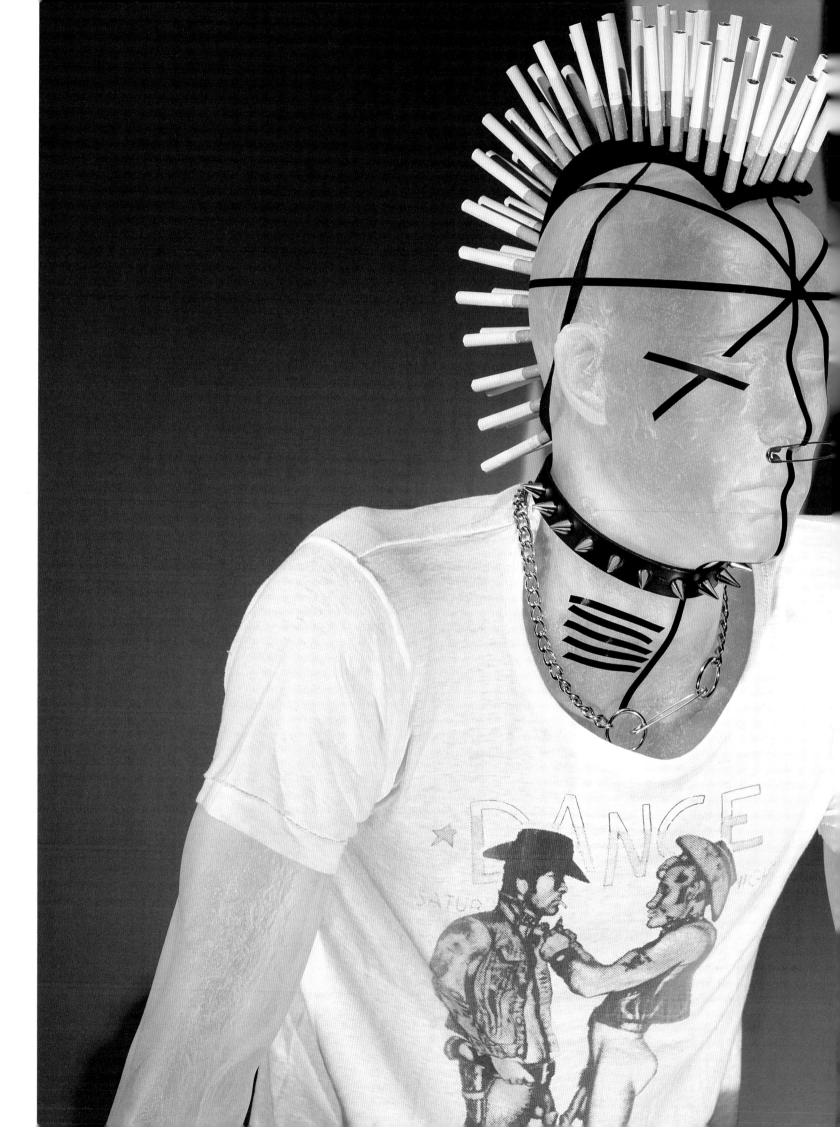

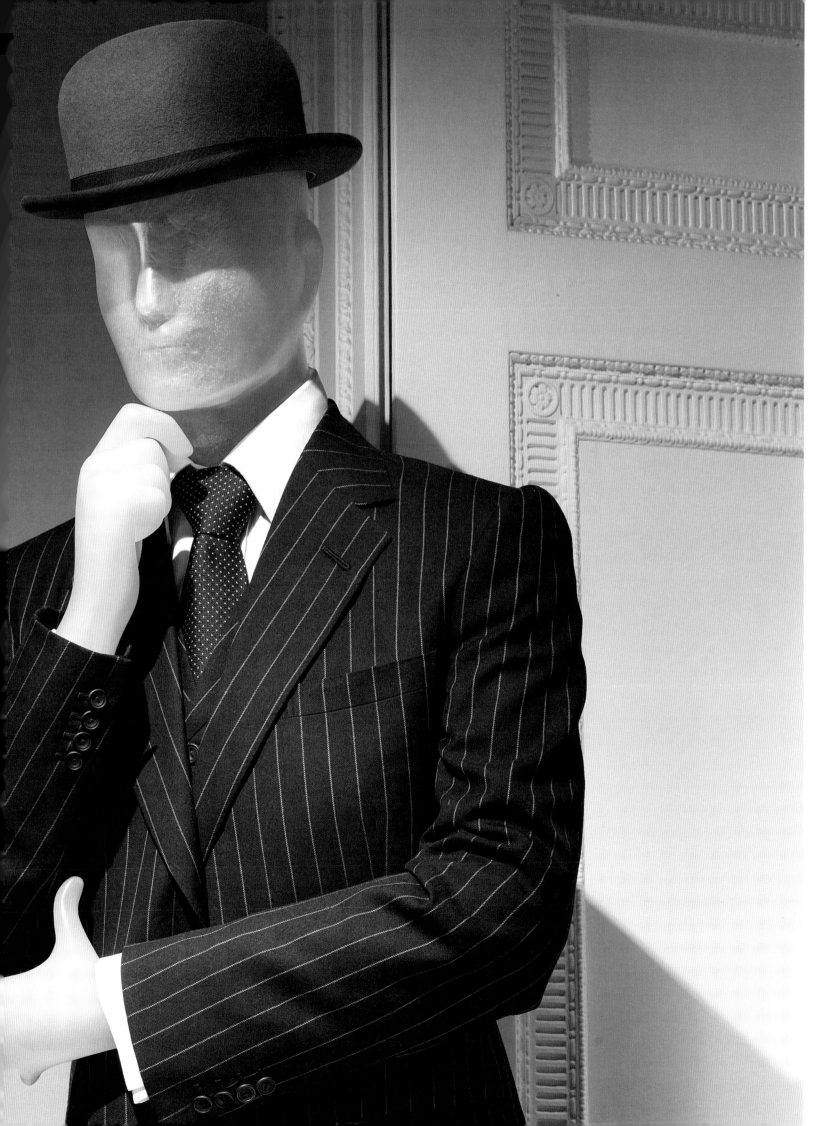

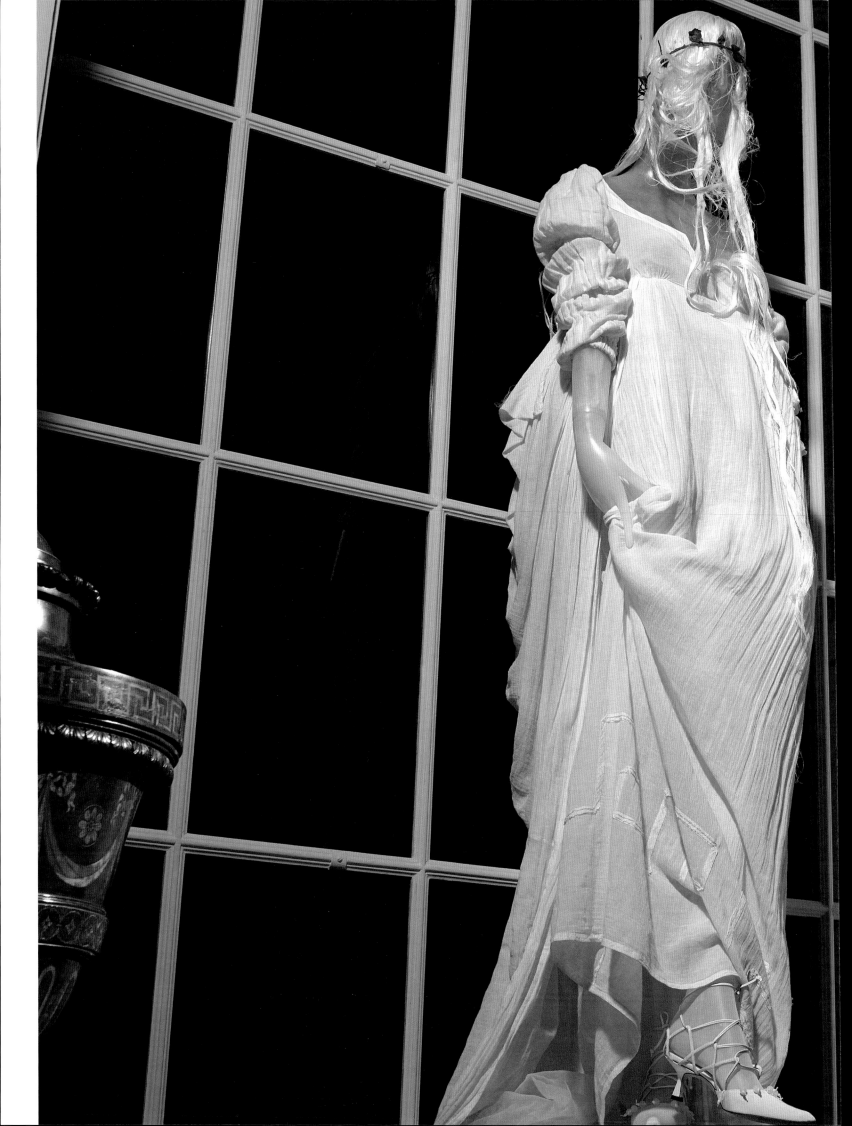

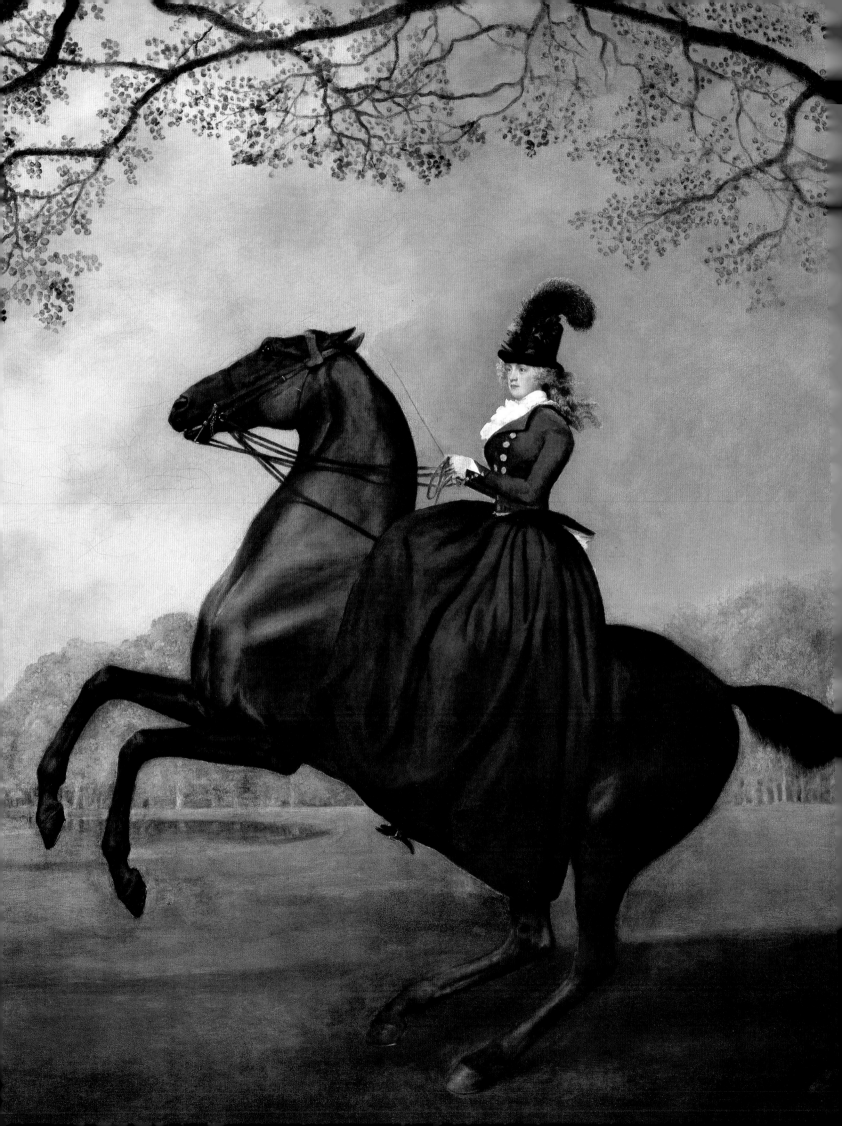

Few sports seem more English than fox hunting. Originally the private informal recreation of country squires and farmers, it emerged as a highly organized, influential, and fashionable institution in the late eighteenth century (largely through the efforts of Hugo Meynell, who, from the 1750s, helped realize the potential of breeding hounds fast enough to keep up with a fox, thereby enhancing the excitement of the chase). From the outset, fox hunting embodied what Voltaire and many other Anglophiles, most notably Montesquieu and Pierre de Coubertin (whose romantic concept of the English gentleman as sportsman prompted the founding of the modern Olympic Games), regarded as the defining features of British culture, namely elitism and egalitarianism. For while fox hunting, at least in the eighteenth and nineteenth centuries, was a sport of the gentry and the aristocracy, it was also a sport of the people. This image of fox hunting, its magnanimity, helped to maintain the traditional deferential relationships on which not only the sport but also rural life in general depended.

During its golden age, usually regarded as 1800 to 1870, fox hunting developed a reputation for boldness and recklessness and became associated with a truculent masculinity. In his biography of Thomas Asherton Smith, one of the most revered horsemen of the early nineteenth century, Sir John Eardley-Wilmot, wrote that fox hunting "gives hardiness, and nerve, and intrepidity to our youth, while it confirms and prolongs the strength and vigour of our manhood." Asherton Smith, who Napoleon described as *le premier chasseur d'Angleterre*, was the epitome of the virile, manly British sportsman. Master of the Quorn in Leicestershire from 1806 to 1817, Asherton Smith was considered unequaled as a horseman. Always ready to take a risk, he rode to hunt, as opposed to many bloods who hunted to ride. He had a very light hand on the rein, which Nimrod, the famous sporting journalist, said he held like silk. Equally as well known for his pugnacity, Asherton Smith was never afraid to resort to the "noble art" of fisticuffs. "Except for my father," he once noted, "I am the worst tempered man in England."

There were also heroines of this Corinthian Age. Most notable, perhaps, was Lady Laetitia Lade, who, in 1796, was said to be the best woman riding to the hounds in England. The wife of the prince consort's honorary racing manager, Sir John Lade, she was originally a servant in a London brothel and formerly the mistress of the notorious highwayman Sixteen String Jack (so-called because he wore a cluster of sixteen colored strings at the knees of his breeches). She was a favorite of the Prince of Wales, who, in 1793, commissioned an equestrian portrait of her by George Stubbs (p. 106). Shown skillfully controlling a rearing horse, she is depicted in her hunting costume of dark blue jacket and petticoat. Like the clothes of her equestrienne predecessors of the seventeenth century, Lady Lade's costume, in terms of its simplicity of tailoring and ornamentation, is adapted from stylish menswear. Indeed, apart from her petticoat, the only concession to feminine fashionability appears to be her hat, decorated with provocative plumage that would, no doubt, have amused the prince.

In "The Hunt" this tradition of sartorial transference from fashionable menswear to equestrian womenswear can be seen in the trench-coat dress by Christopher Bailey for Burberry. Developed by Burberry in 1914 for British officers serving in World War I, the trench coat, like fox hunting itself, has become one of the most potent badges of Englishness. In his trench-coat dress, Bailey substituted the traditional gabardine with an opulent silk faille, the lining of which echoes the scarlet riding coat by Bernard Weatherill, the company that has supplied equestrian clothing to the royal family since 1912. Traditionally, scarlet coats are worn by the master of the foxhounds, the huntsman (who "hunts" the hounds), the whipper-in (who keeps the pack together), and members of the hunt entitled to wear a hunt button. Such archaic formalities are parodied in the hunt ensemble by Vivienne Westwood, which displays her love of history and sexuality through its 1880s-style bustle, 1890s-style sleeve, and black leather fetish boots. Westwood's fondness for English tailoring, however, is asserted through the cut and line of her coat, showing the perfection equaling that of any Savile Row tailor. In contrast, John Galliano's vastly oversized coat upends the tailoring finesse of traditional hunting clothing. At the same time, his outfit of fur headdress, like Burberry's trench coat with fox-fur skirt, cuffs, and collar, is symbolic of the grisly realities of the hunt, which in 2005 resulted in an act of Parliament banning the sport that Oscar Wilde once referred to as "the pursuit of the uneatable by the unspeakable."

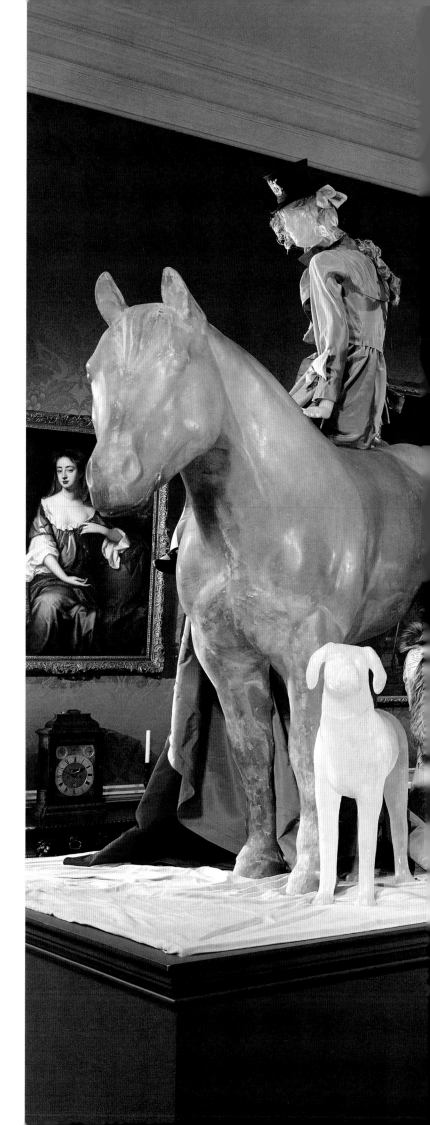

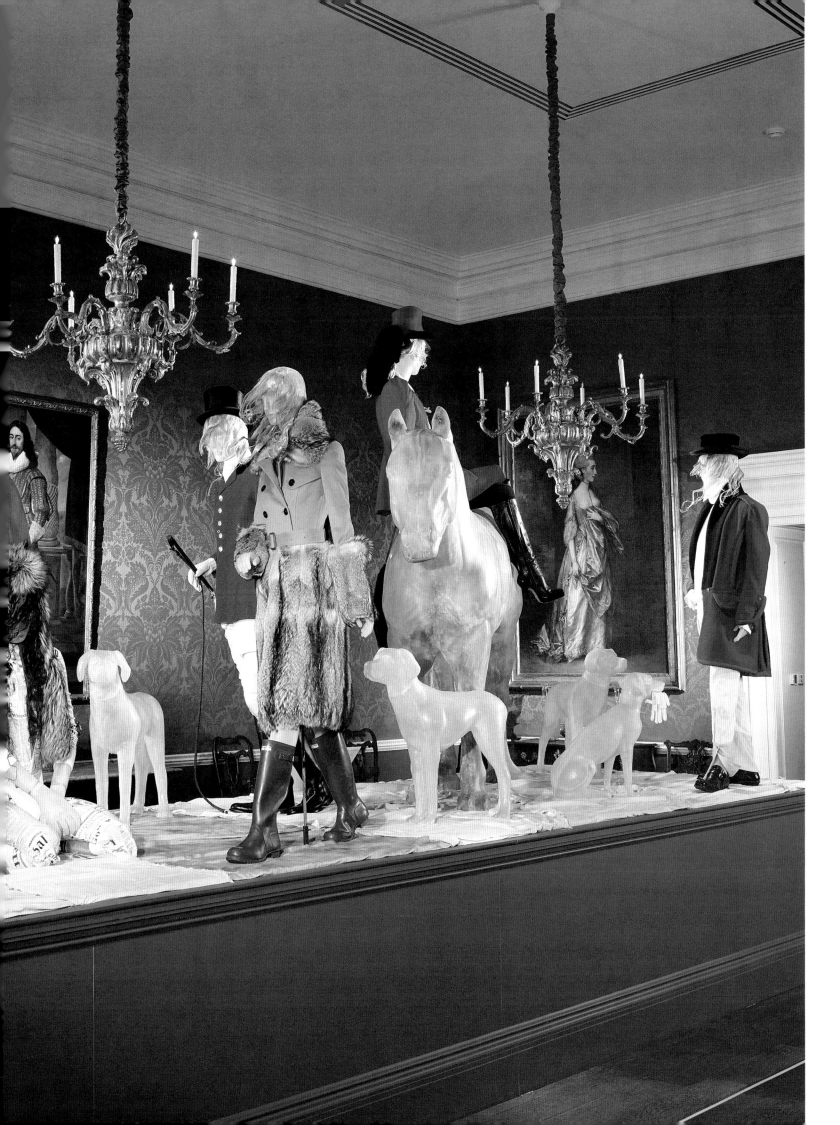

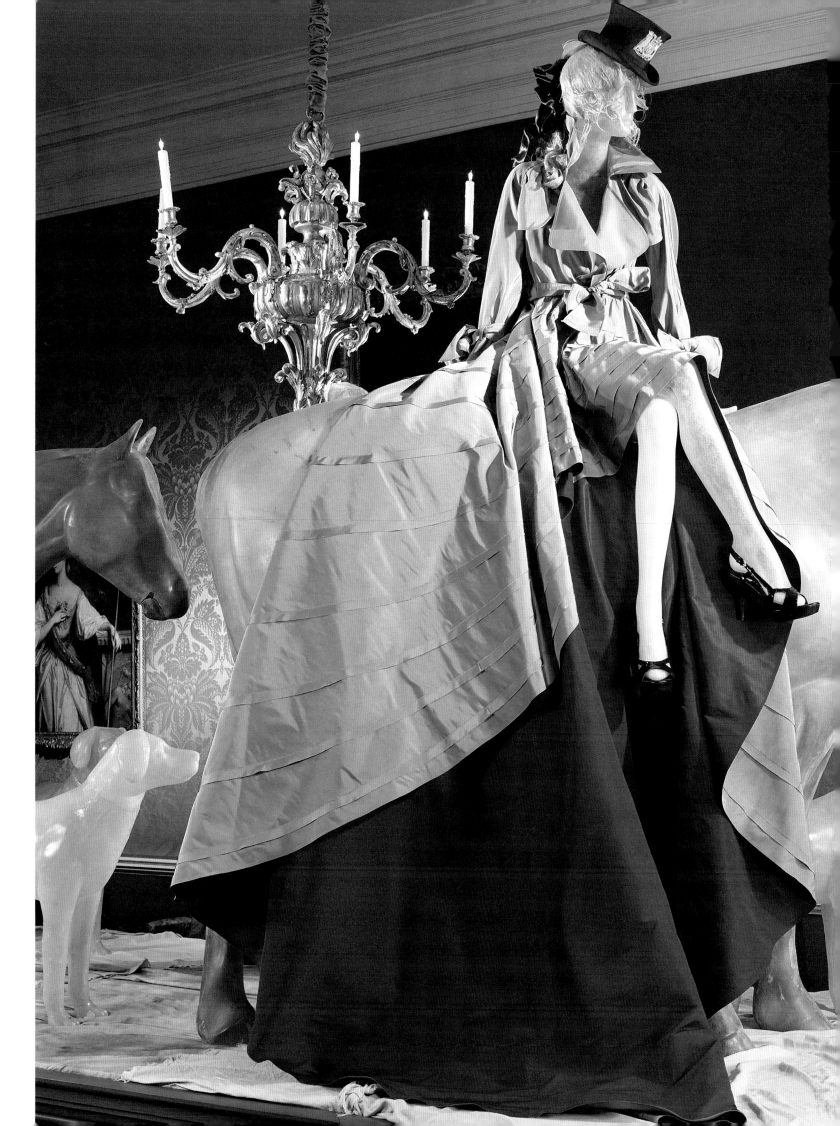

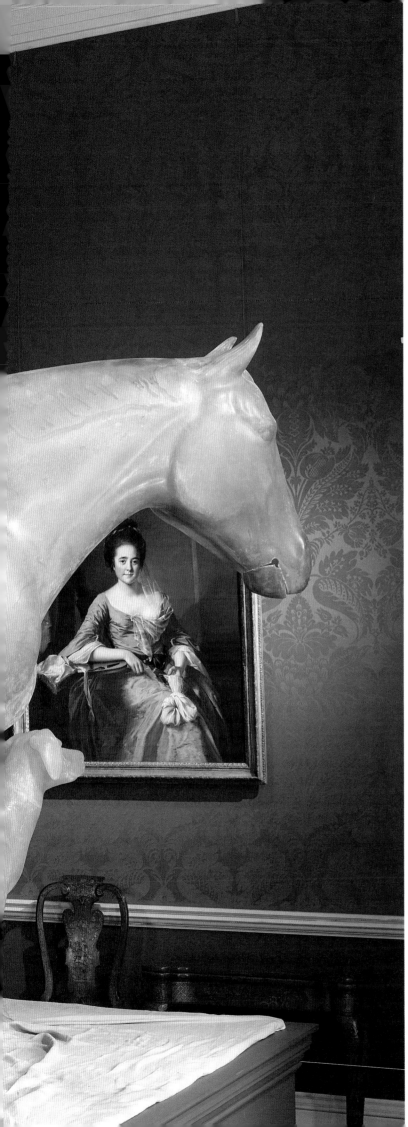

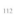112

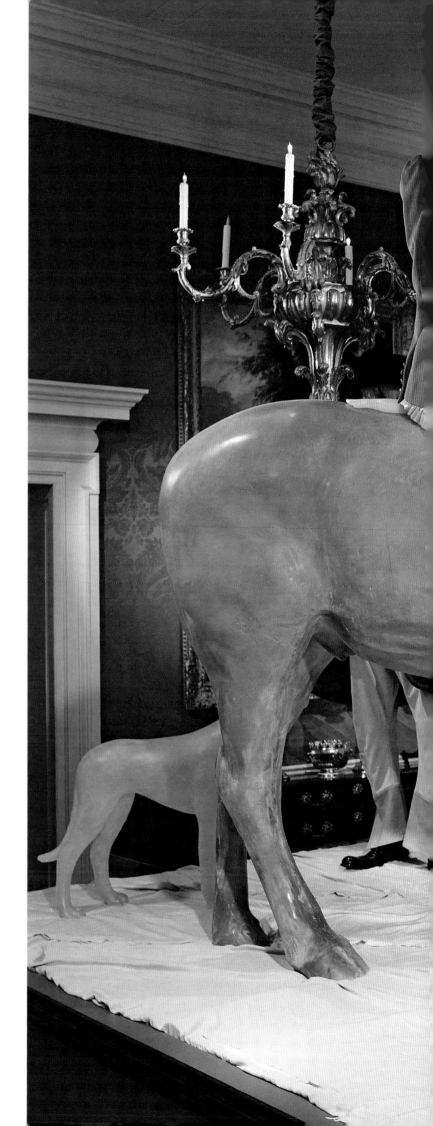

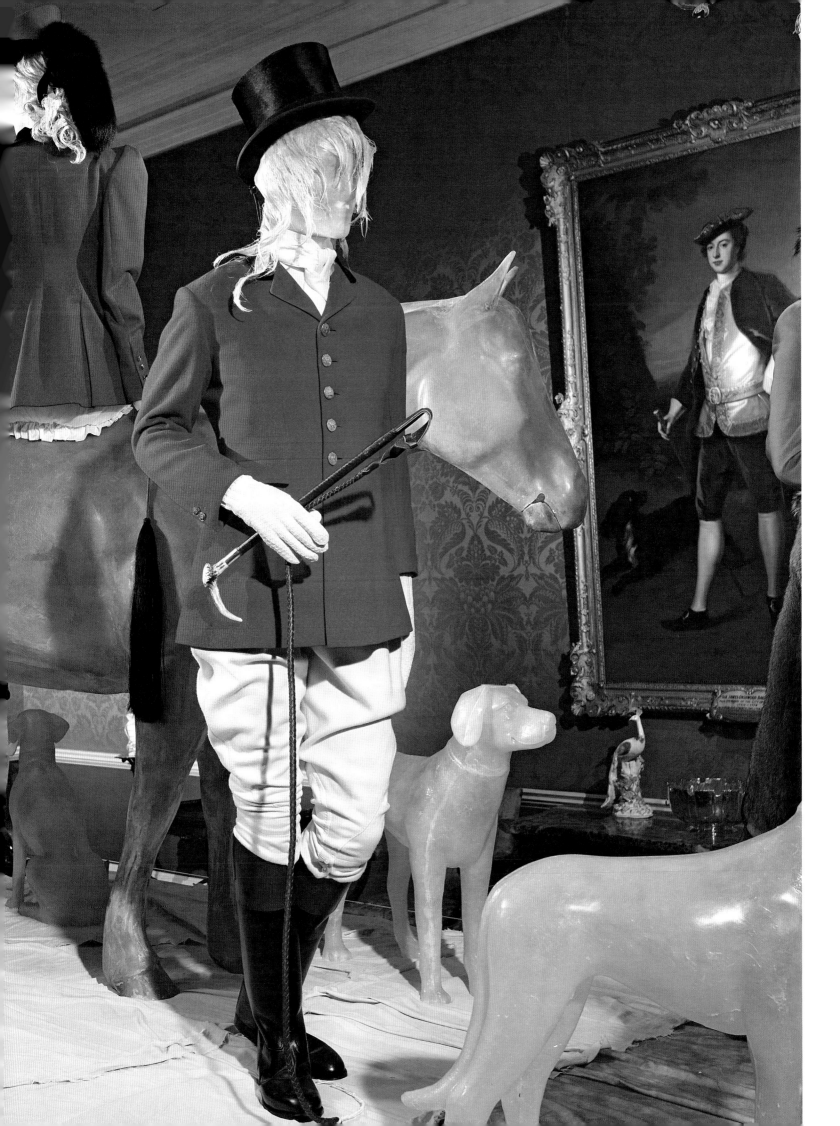

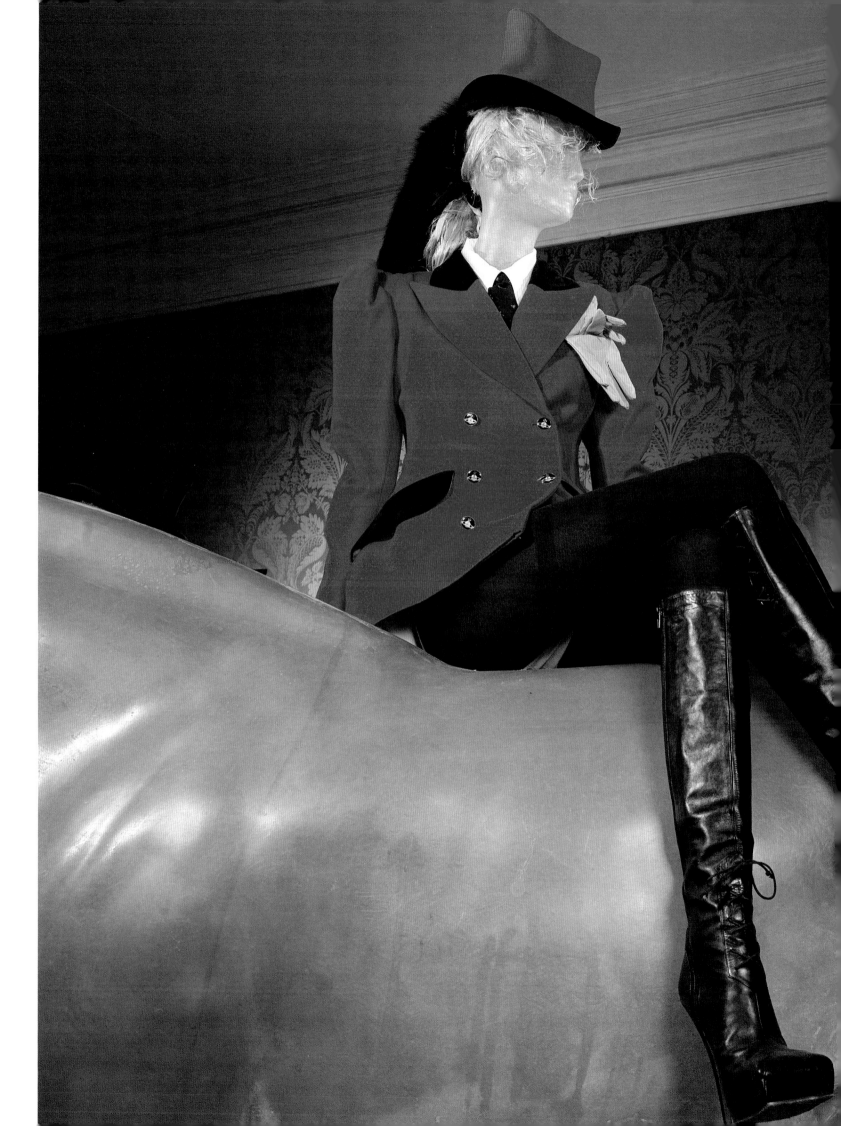

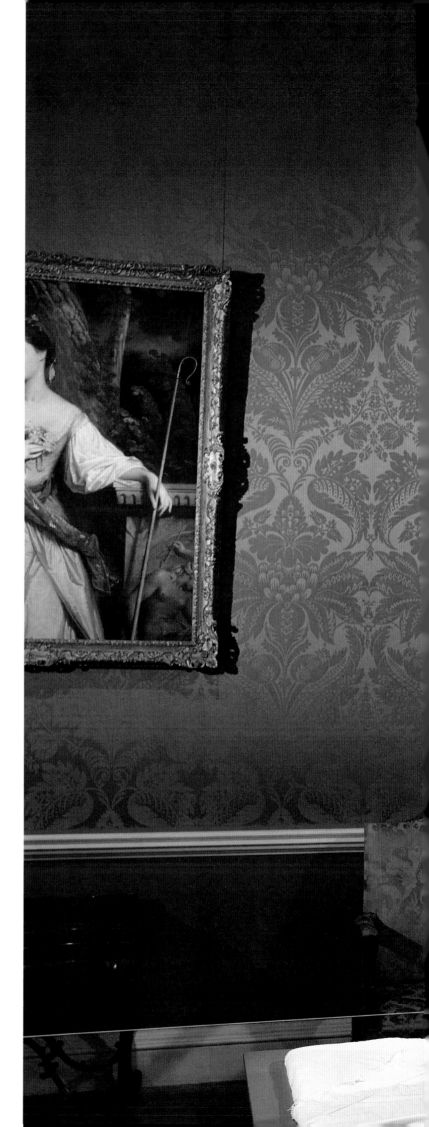

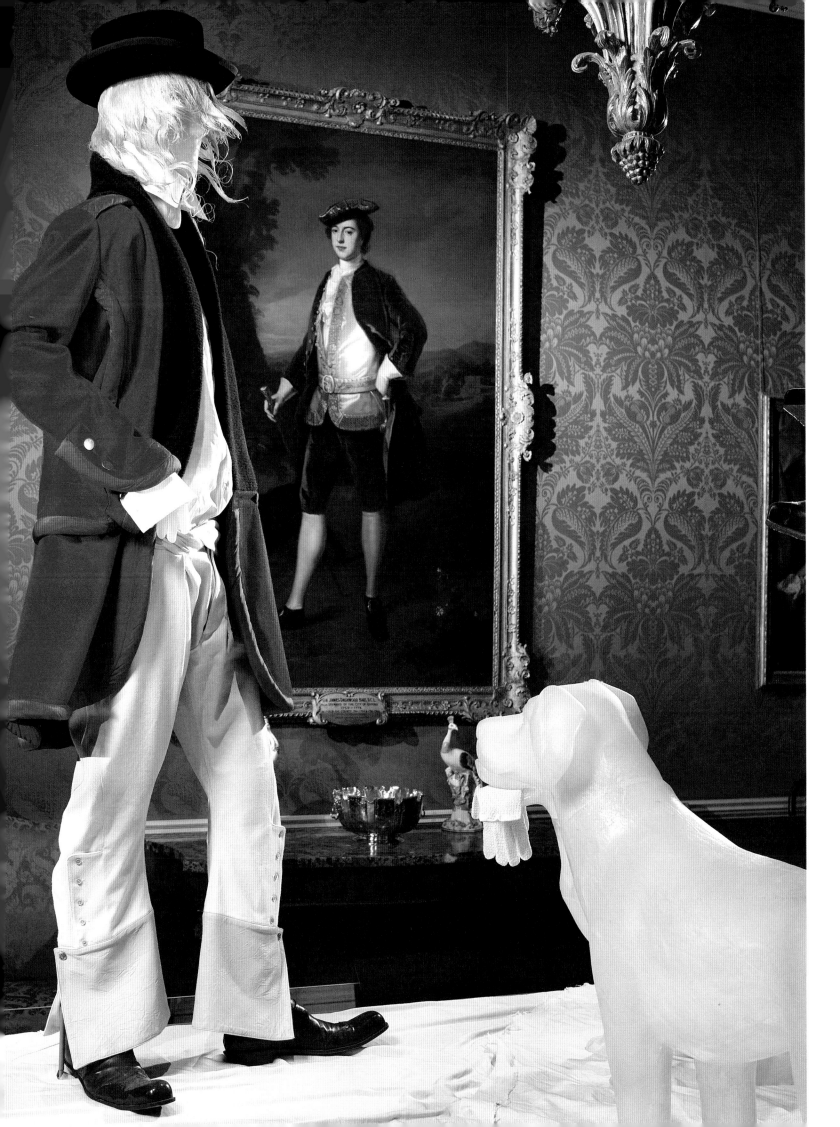

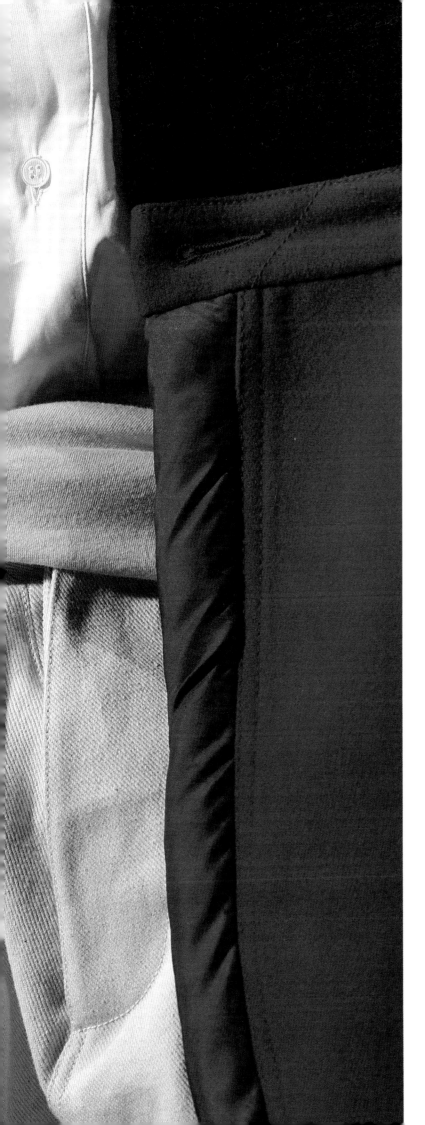

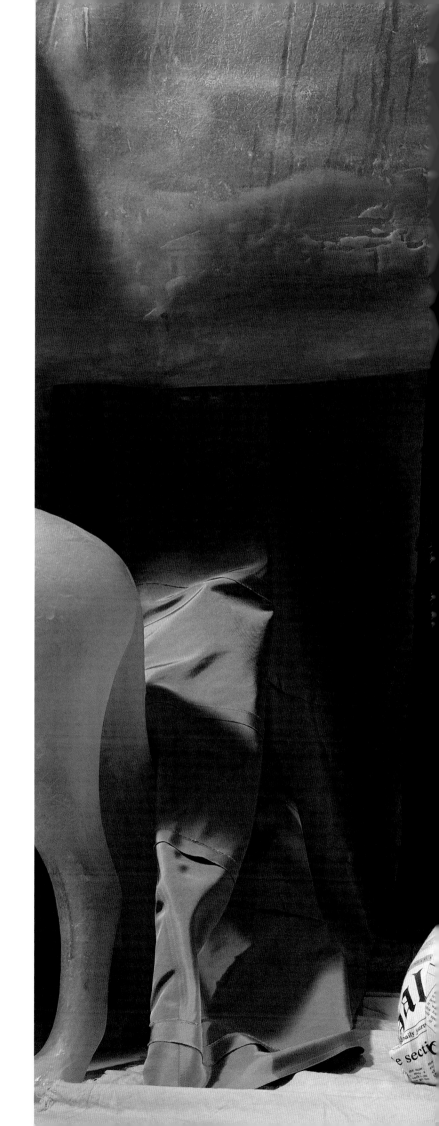

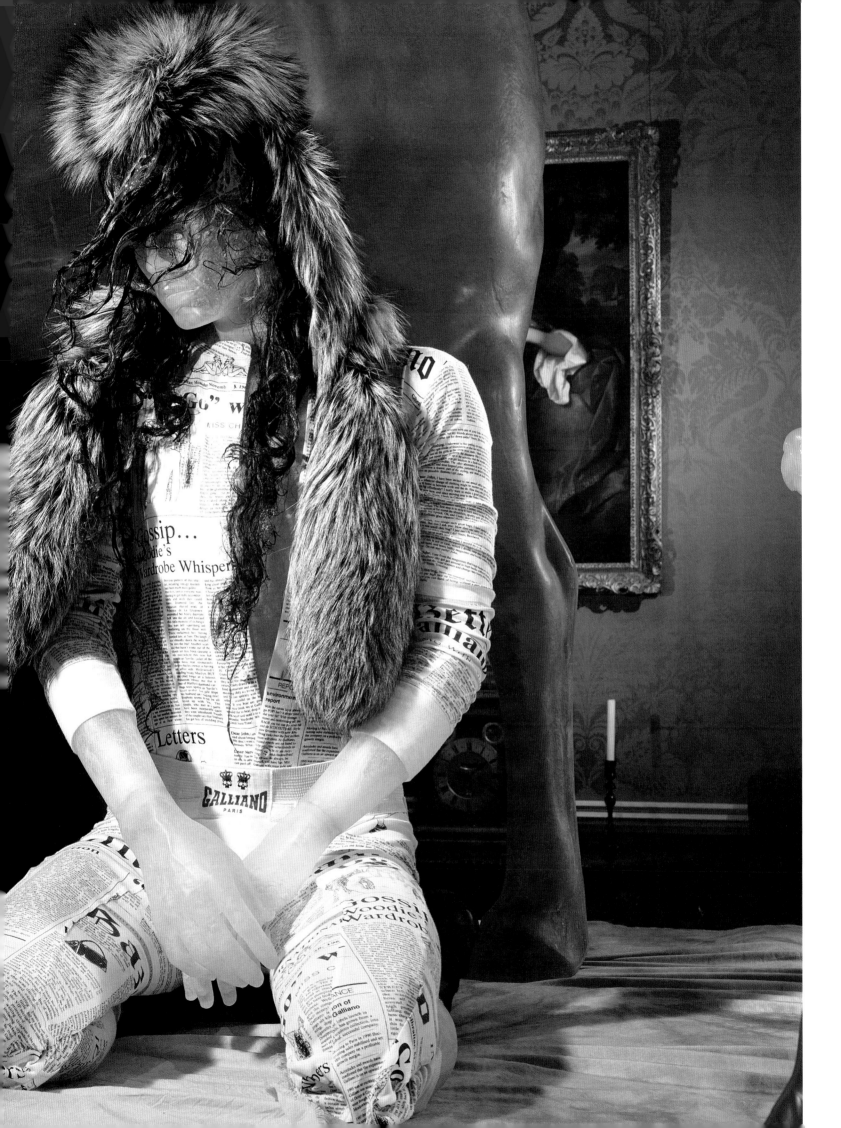

Gossip...
Woodie's
Wardrobe Whis

Solid Oak wood wardrobe, Woodie is privy to all the best gossip in town, and while the coats are taking a break he is jotting down the scandal for you... You won't believe what I've just heard! Honestly the things you hear are enough to make your splinters stand on end. I have always been a huge follower and fan of fashion and in my profession I can tell you I've seen some real horrors over the years. But thankfully after a few wilderness years of bland bland black nylon numbers people seem to have got their style back. Take Tiara for instance, she is mother of two, and still at number one in the teeny bop parade. This pop starlet seems to be going from strength to strength. You didn't hear it from me, BUT last week she was dining in Nobby with a record executive, and she was wearing HIGH STREET. The little horror,

Previous partners of this starlet, including vintage masters had been much more polite. But then, just as everyone was starting to get really uncomfortable and wish they could leave, Diamond Dee, the exquisite shaved mink of Princess de La Glamoure, swooshed her heavy diamente belt into the air and knocked this little monster of its hanger. She was left squirming and muttering on the floor until Tiara reclaimed her, having partied late, at 3am. The laughter virtually shook the wardrobe into the bar! Another scandal that hasn't come out of the closet yet has been causing a stir everywhere this new hot couple go. Savile, jacket of the suave movie star, strenuously denies that his owner is having an affair with Hollywood's dazzling beauty Marilyn. BUT the chief hanger at a famous restaurent infom...

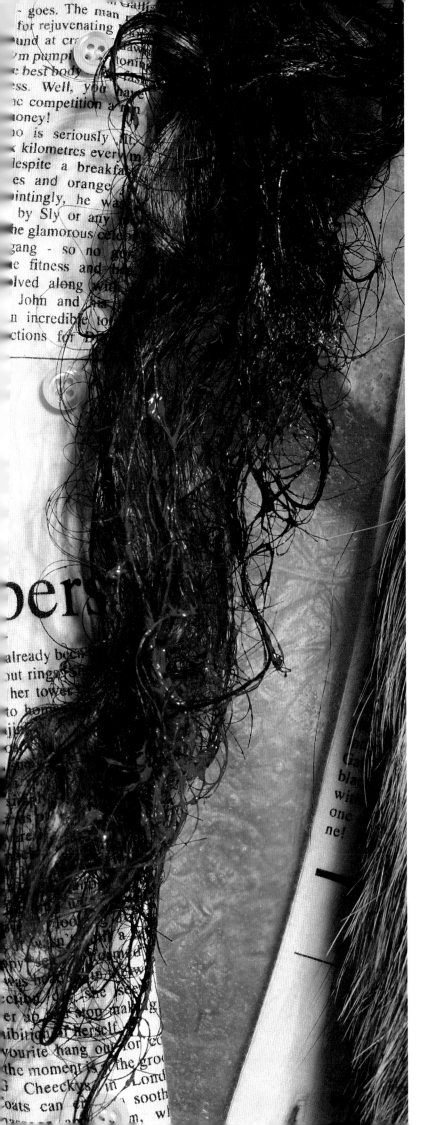

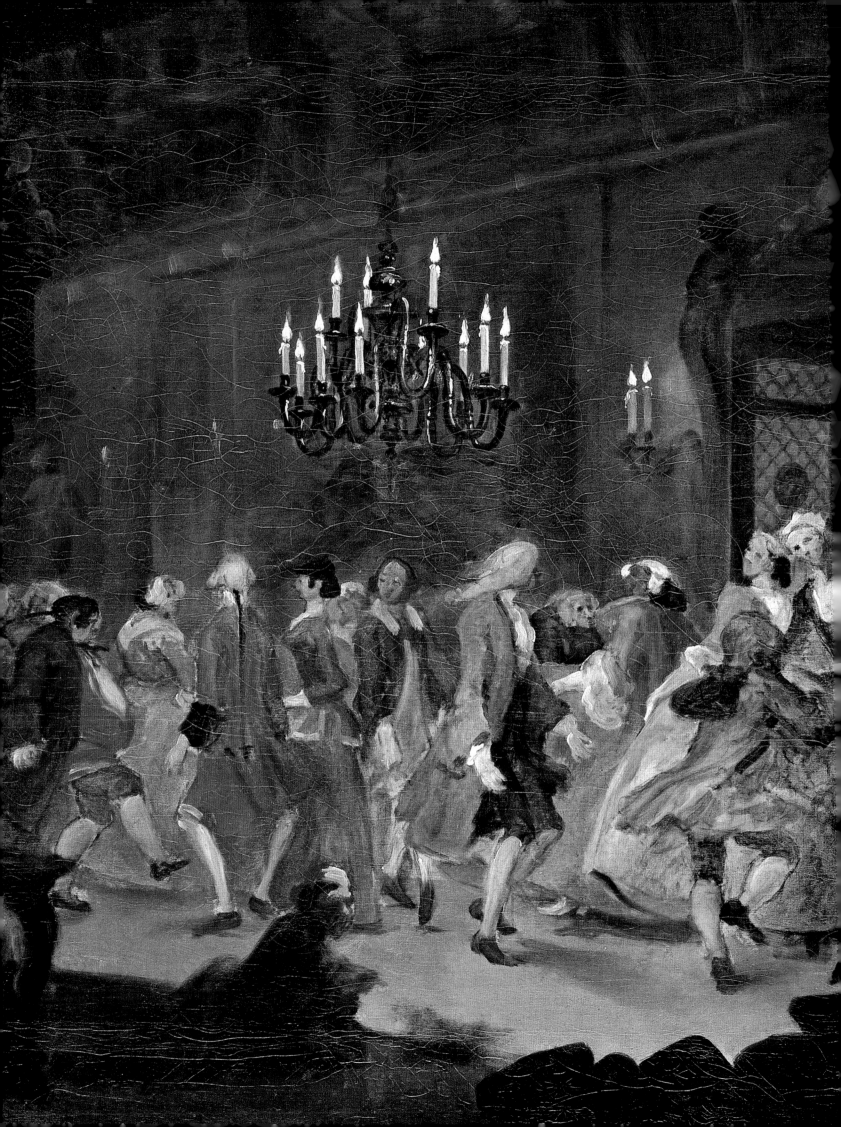

By the late eighteenth and early nineteenth centuries, fox hunting had emerged as an integral feature of country society, a symbol of unity, vitality, stability, and harmony. It was a social sport that, at least on the level of the ideal, brought together all classes of people in a spectacle of cordiality and conviviality. Off the field, hunt clubs organized a number of social events, such as meets, races, and hound shows, many of which, in the spirit of fox hunting, were open to everyone. Other forms of entertainment, including hunt balls and dinners, were less egalitarian. Dinners, which became reasonably commonplace in the last quarter of the eighteenth century, were usually limited to men. Class rather than gender determined the formalities of hunt balls, which became increasingly popular from the late eighteenth century. They were major social events to which only the gentry, or those with claims to gentility, were invited. Unlike dinners, which, in one form or another occurred on a weekly basis, balls were often given at the end of a season.

From the early 1800s, many hunts, or at least those with either prestige or pretensions, specified evening as well as daytime uniforms. Two styles of coat were worn in the field, namely the skirted and the swallow tail, the former being regarded as the more practical and the latter as the more dashing. A tailcoat, cut along the same lines as formal evening wear, prevailed for hunt balls and dinners. Not unlike field coats, they were much admired by women for their suavity. As Harriette Wilson, the notorious Regency courtesan whose patrons included Lord Byron and the Duke of Wellington, observed in her memoirs, "The evening hunting dress is red, lined with white, and the buttons, and whole style of it, are very becoming. I could not help remarking that these gentlemen never looked half so handsome, anywhere in the world, as when, glowing with health, they took their seats at dinner in the dress and costume of the Melton hunt." Red or scarlet had been allied with fox hunting long before Harriette Wilson was writing, a fact owing, perhaps, to the rural association between hunting and Toryism (red, at the time, being the color of the Tories, blue that of the Whigs).

The vignette entitled "The Hunt Ball," based on William Hogarth's *The Country Dance* (ca. 1745, p. 124), follows the sartorial etiquette of hunt balls with the male figures dressed in hunt dress suits by Henry Poole & Co. and H. Huntsman & Sons, two of the oldest firms on Savile Row. Their histories and successes are closely linked with the sporting fraternity, especially those of Henry Poole, who in the mid- to late 1800s boasted a list of clients that included some of the most raffish bloods in the country. Such a blood was the Earl of Stamford, master of the Quorn from 1856 to 1863, who famously shocked polite society by marrying a circus equestrienne. Lady Stamford, in turn, shocked hunting society through her role in the "Skittles" affair. Skittles (whose real name was Catherine Walters) was one of the most celebrated of the Victorian courtesans. Like Lady Stamford, she had been a circus equestrienne and, therefore, a proficient horsewoman. She enjoyed fox hunting and often rode to the Quorn hounds, much to the chagrin of the countess, who had gone to great lengths to escape her déclassé background. Lady Stamford prevailed upon her husband to bar Skittles from the field, which he did reluctantly. While Lord Stamford was criticized publicly for violating the democratic nature of fox hunting, his wife, not surprisingly, was attacked privately for her blatant hypocrisy.

Britain, at least abroad, was well known for its moralizing tendencies, which, in terms of artistic practice, were most forcefully expressed through the tradition of satire and caricature. Providing a raw and candid analysis of a person or situation, satirical prints and caricatures abounded from 1760 to 1900. Many focused on modish fashions, such as corsets, panniers, and crinolines, taken to extremes by women. Indeed, extremity was considered a particularly British characteristic (one of the original meanings of eccentric, another national attribute, is extremity). In his *Letters on the English and French Nations* (1747), Abbé Jean le Blanc wrote that the English "do not seem capable of being moderate in anything." Extremity remains one of the hallmarks of British fashion, and, in "The Hunt Ball," is expressed in the dazzling, historicist confections of John Galliano, Alexander McQueen, and Vivienne Westwood. Their designs are not only a celebration of the theatricality of British fashion history, but also of its originality. Like the styles from the eighteenth and nineteenth centuries to which they allude, they are the product of Britain's eternal paradox, the simultaneity of its tradition and its transgression.

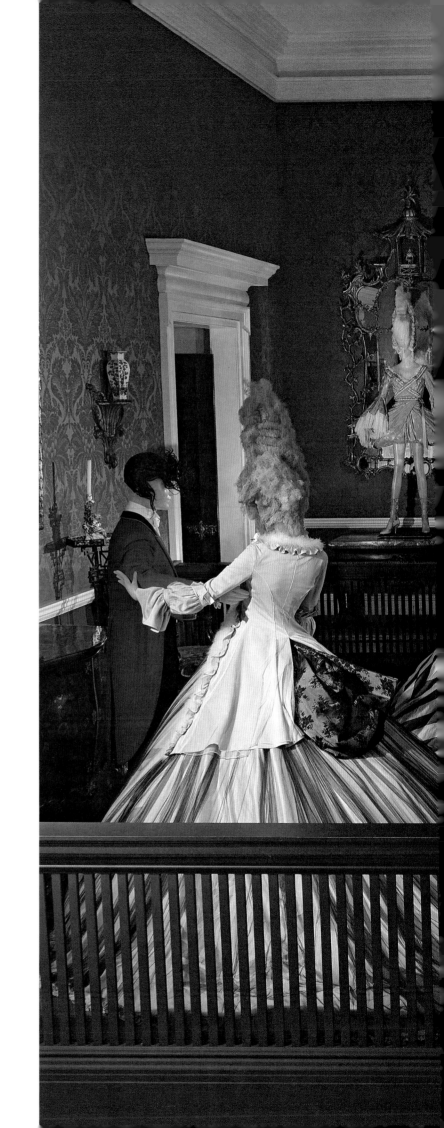

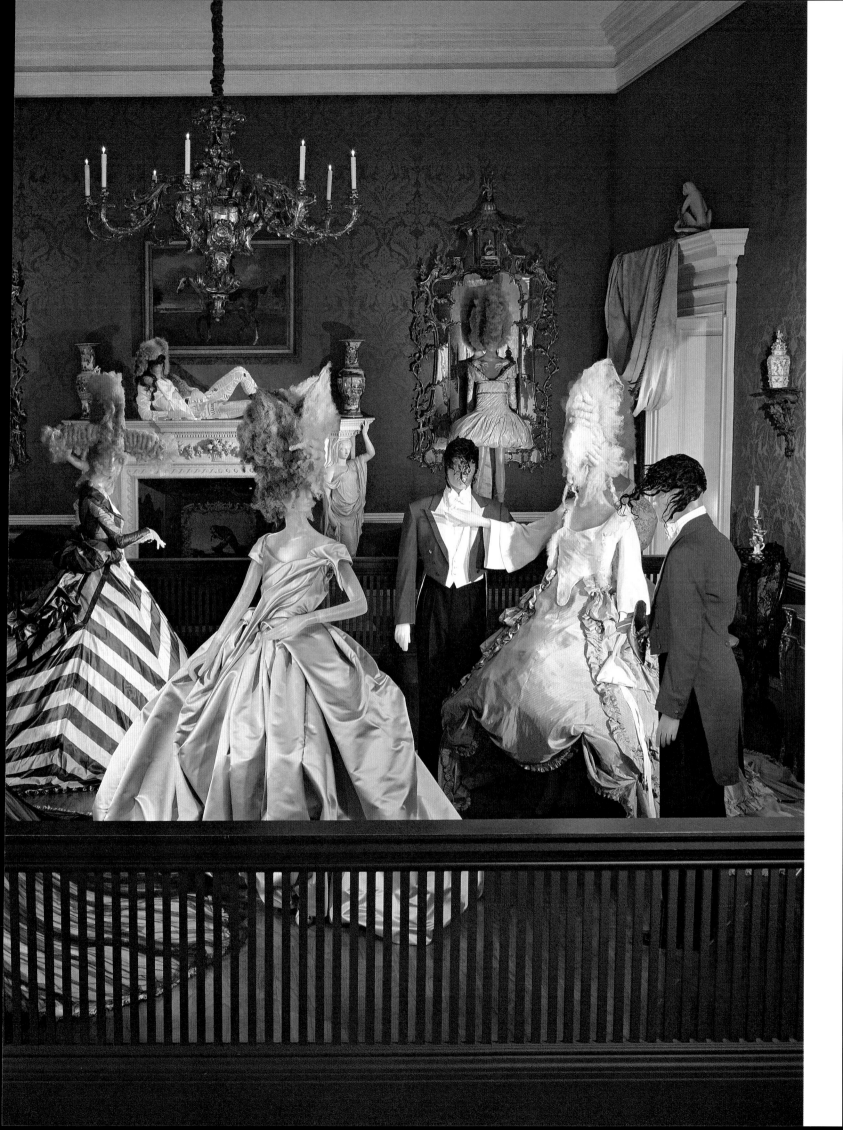

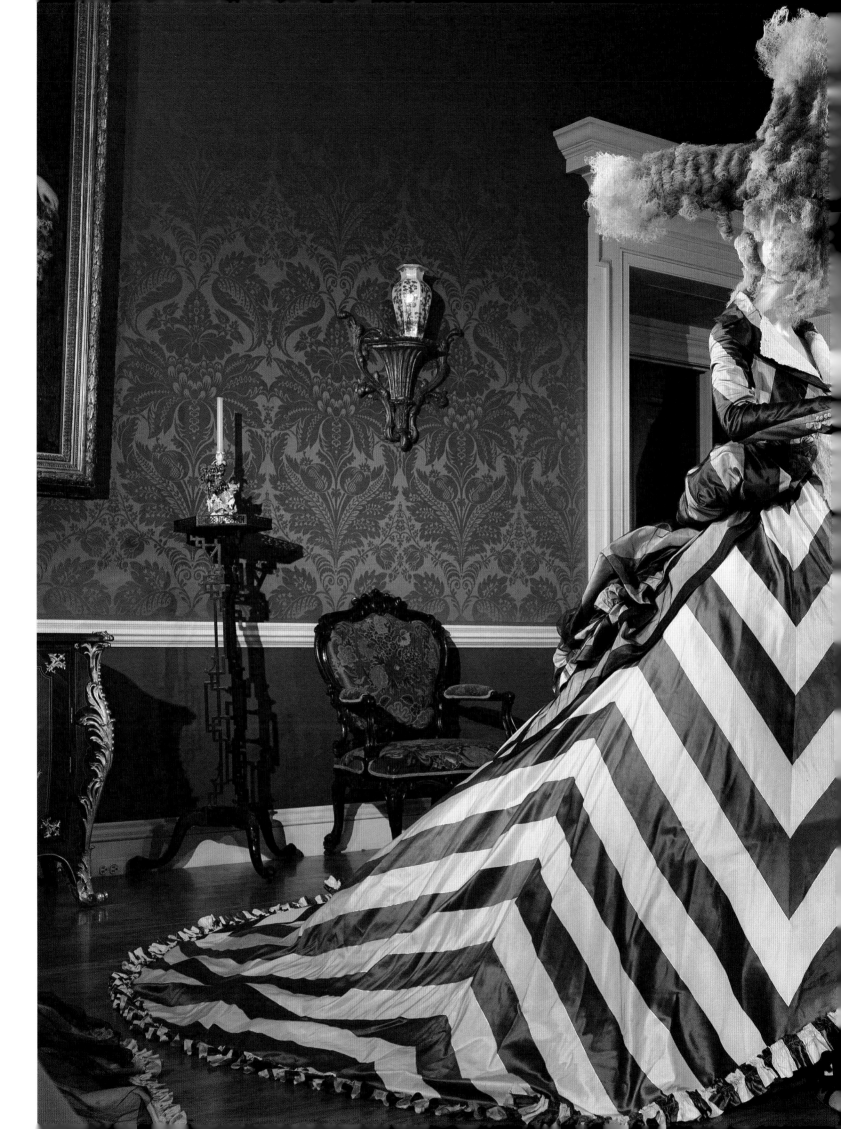

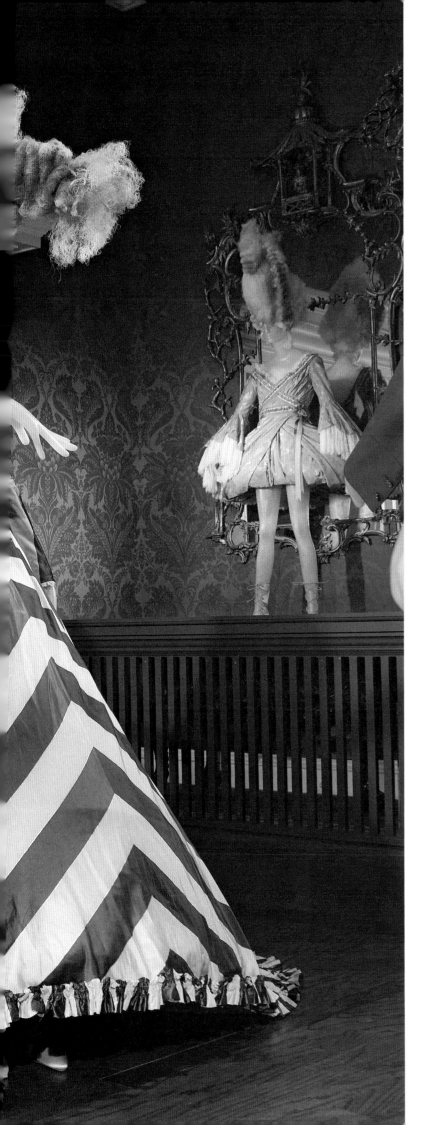

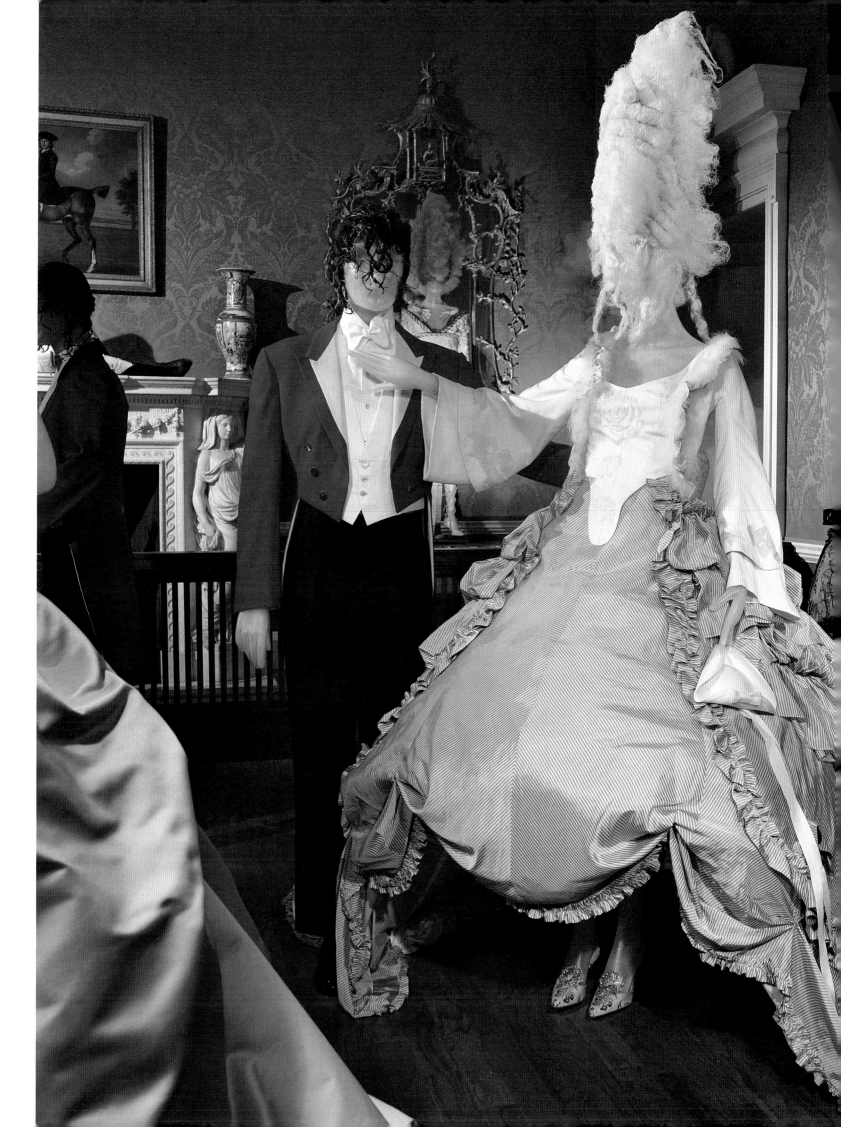

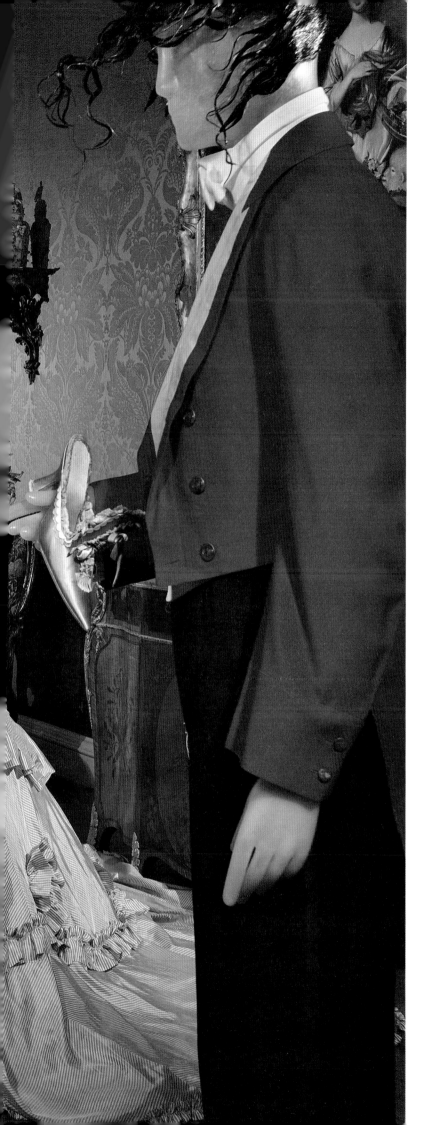

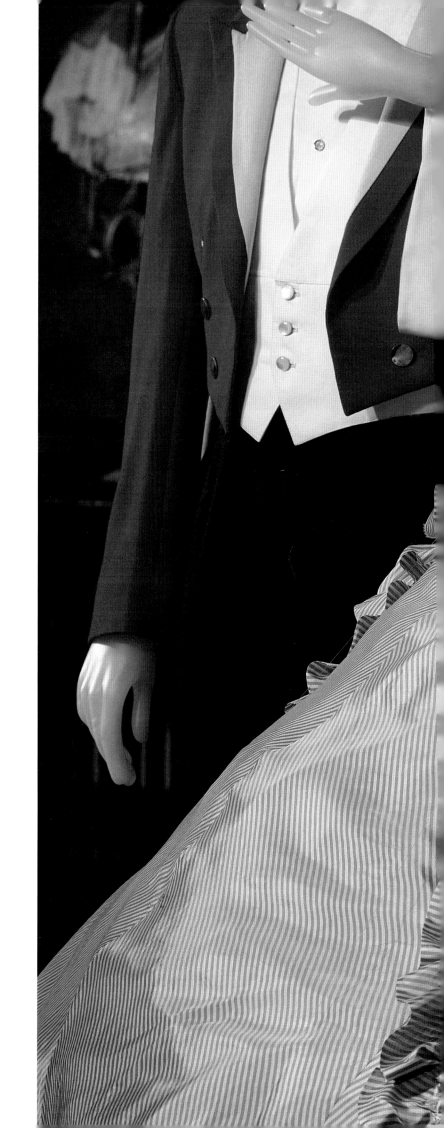

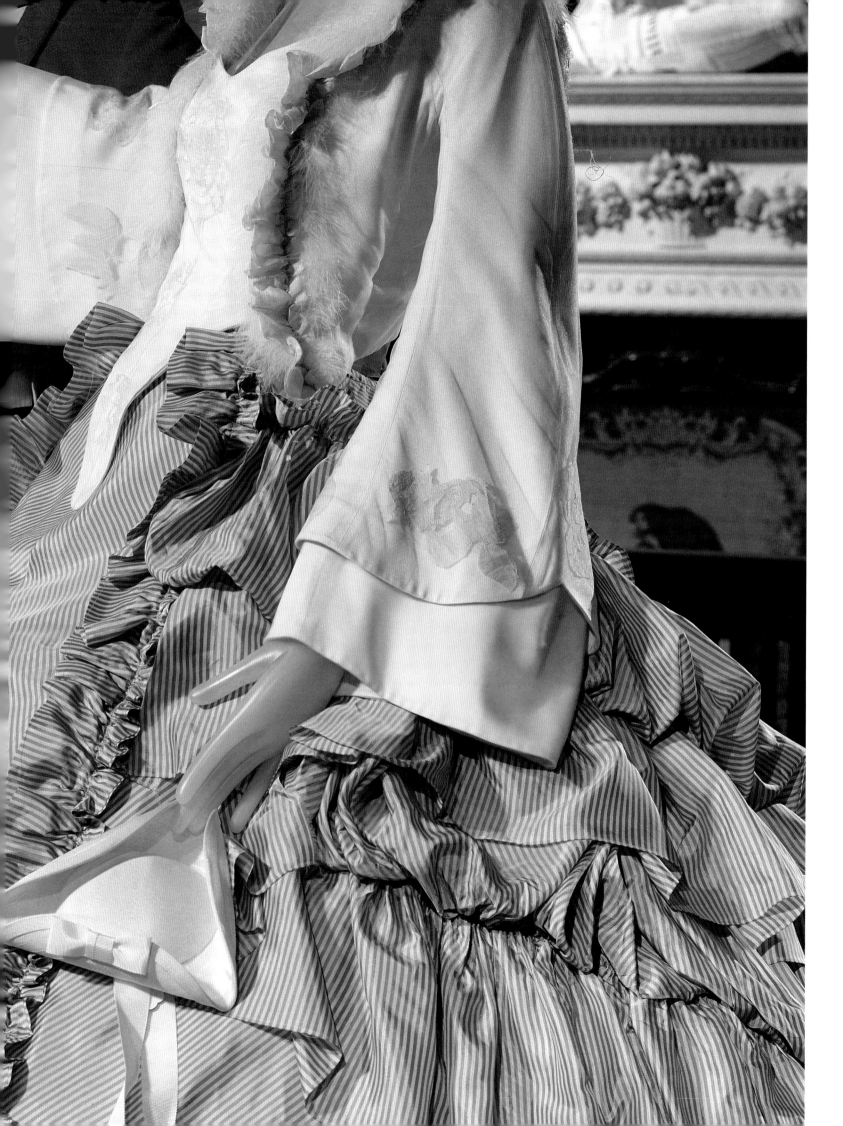

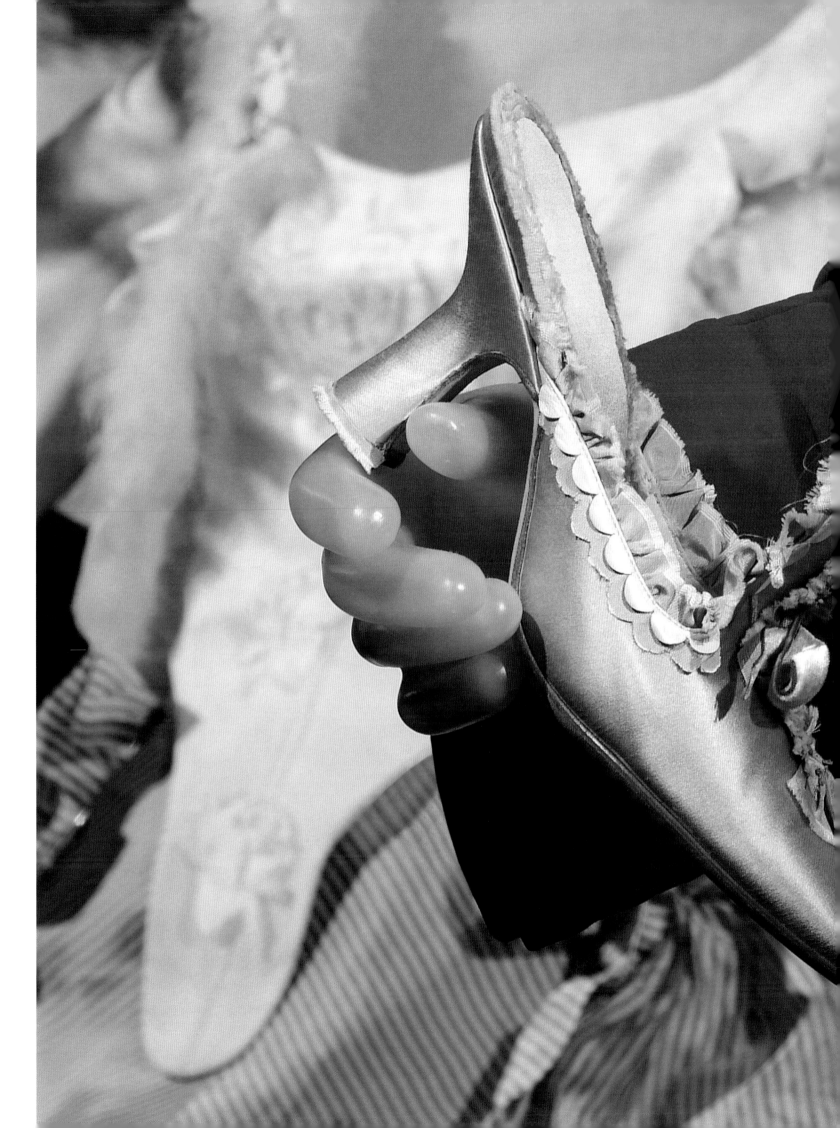

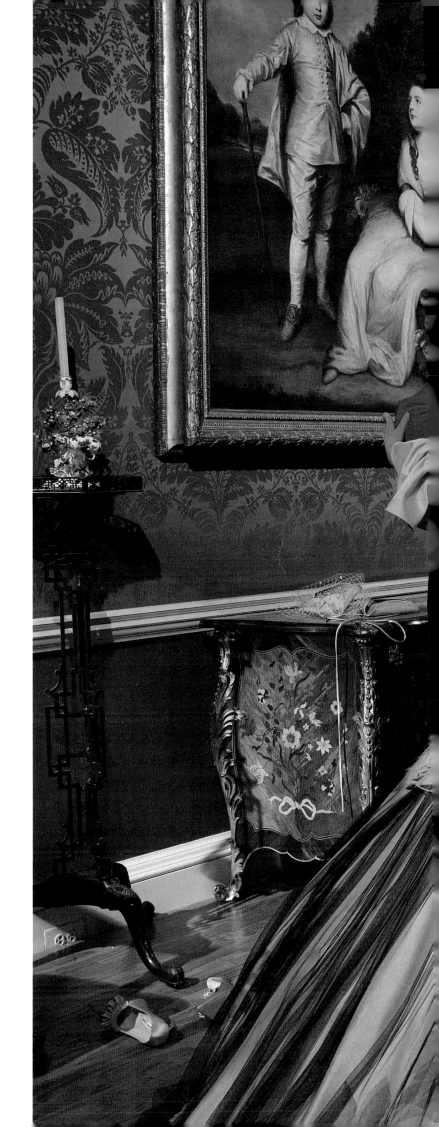

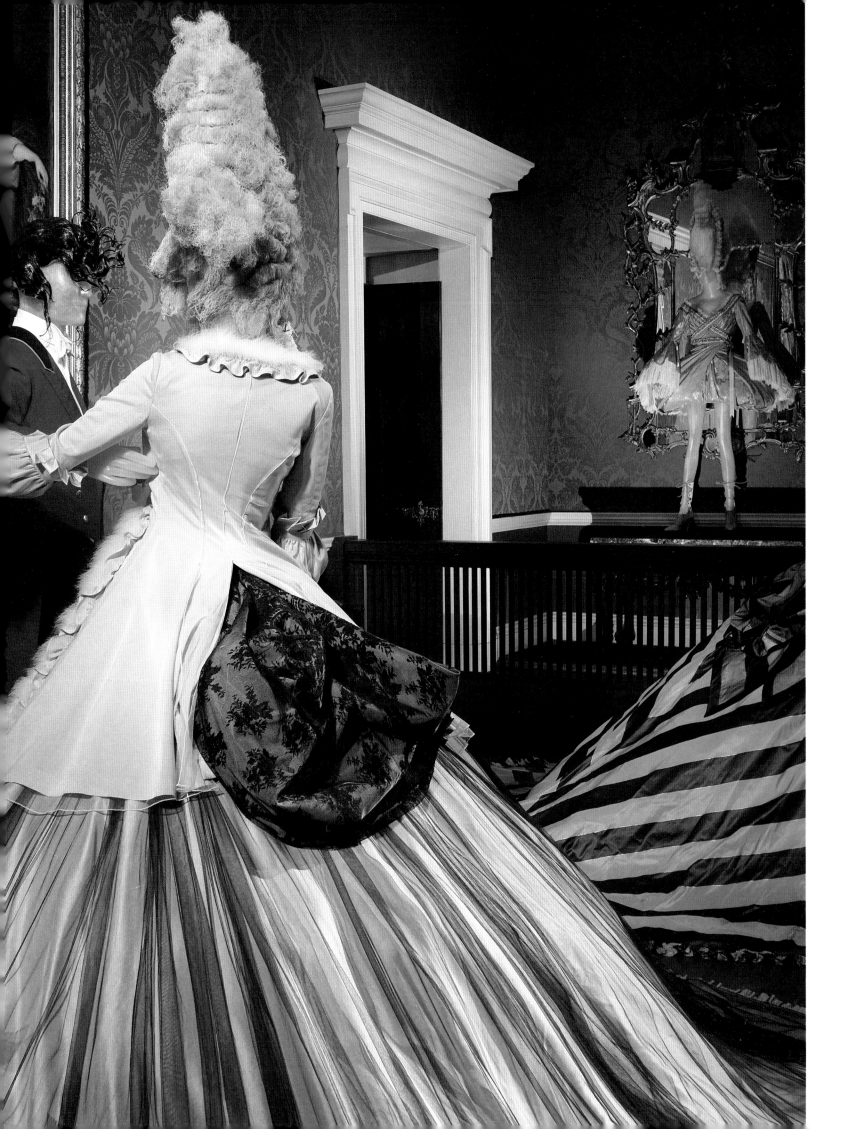

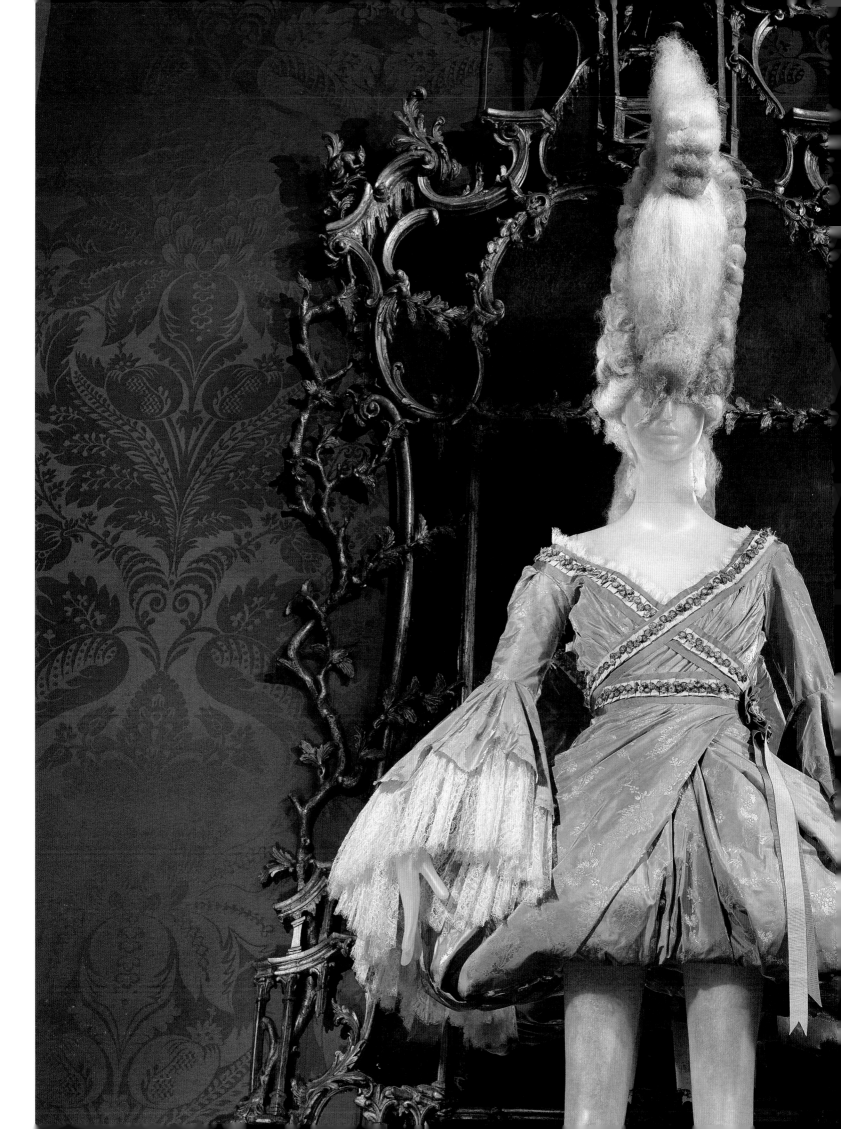

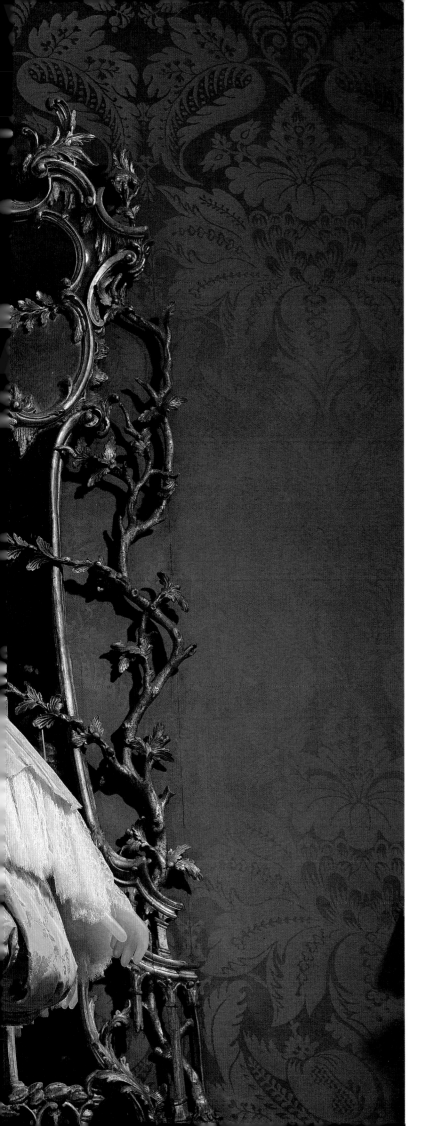

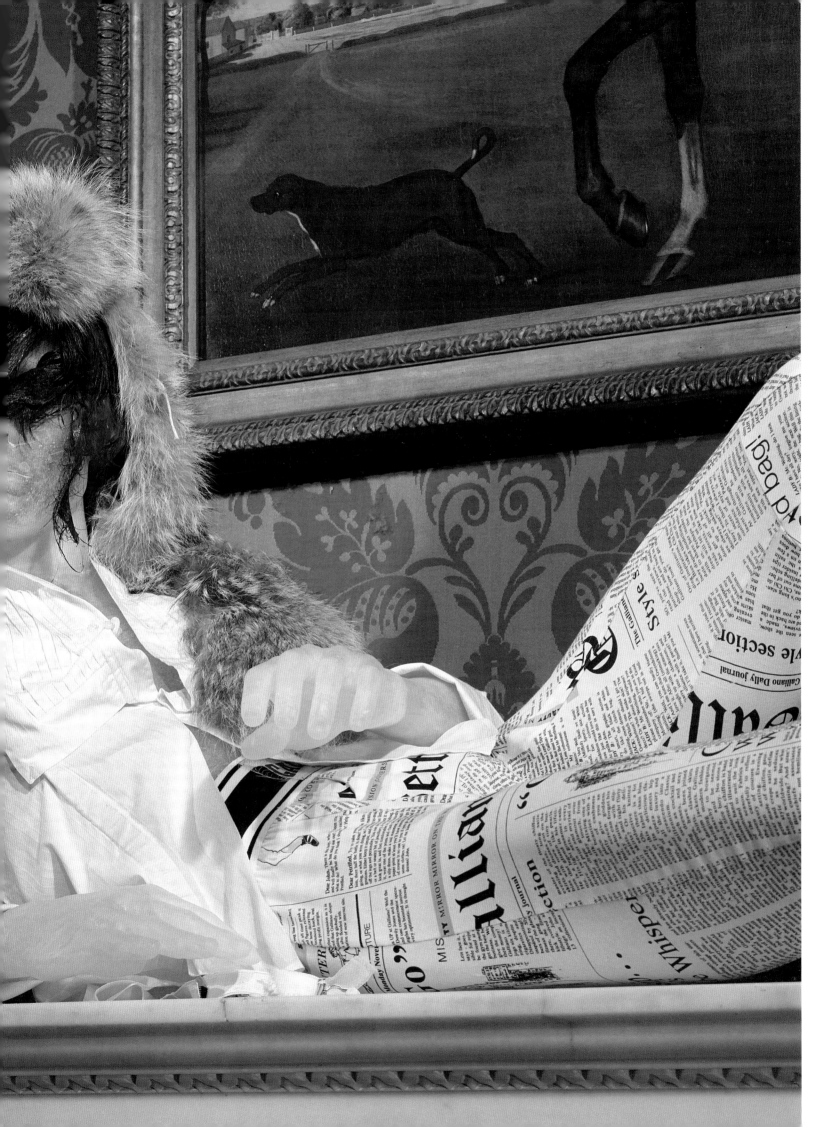

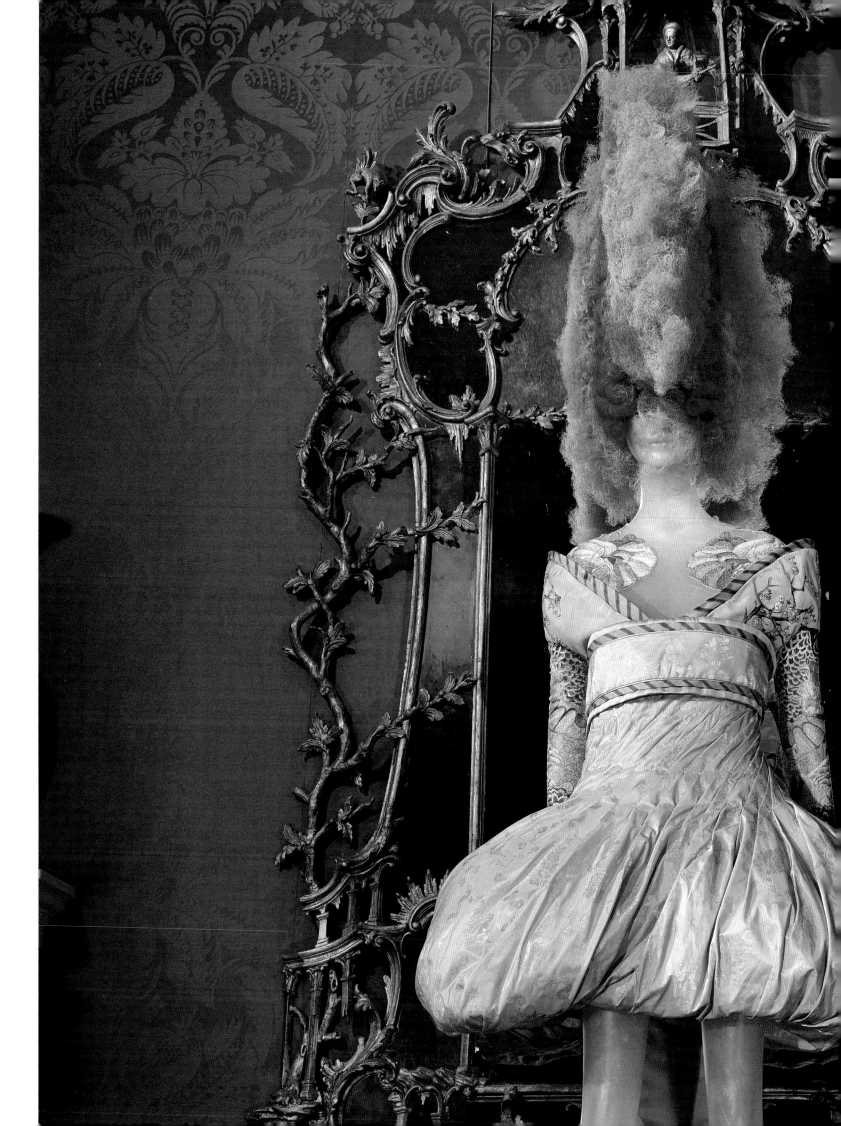

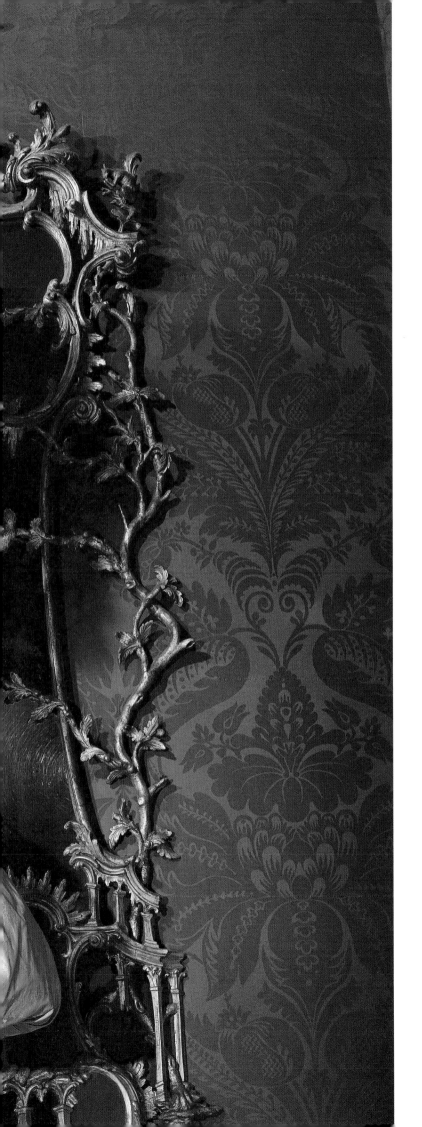

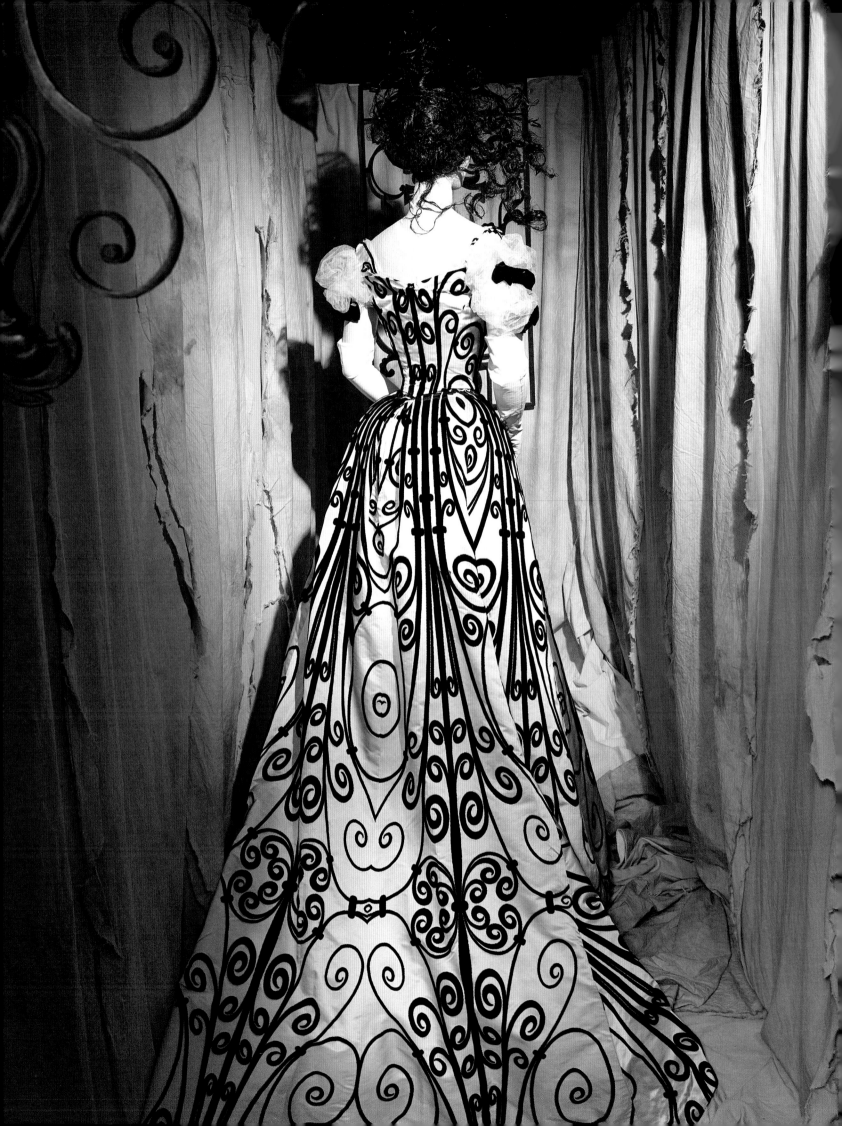

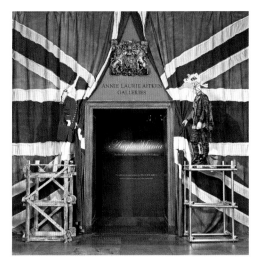

JOHN BULL

Entrance to "AngloMania"

British. Suit, ca. 1750–75. Red wool. The Metropolitan Museum of Art, Isabel Shults Fund, 1986 (1986.30.4a–d)

Malcolm McLaren, British (b. 1946) and Vivienne Westwood, British (b. 1941). Ensemble, ca. 1977–78. Parachute shirt of blue cotton with silk and cotton patches; bondage jacket and trousers of blue and red wool plaid. Parachute shirt: Courtesy of the Stolper Wilson Collection. Bondage jacket and trousers: The Metropolitan Museum of Art, Purchase, Richard Martin Estate Fund, 2006 (2006.159a, b)

British. Armorial Panel, ca. 1660–88. Limewood, parcel silver, and gilt. The Metropolitan Museum of Art, Gift of Irwin Untermyer, 1964 (64.101.1210)

David Bowie, British (b. 1947) and Alexander McQueen, British (b. 1969). Coat worn by David Bowie, 1996. Red, white, and blue cotton. Courtesy of David Bowie

British. Mirror, ca. 1720. Glass, gilt brass, gilt gesso, walnut, and walnut veneer. The Metropolitan Museum of Art, Gift of Irwin Untermyer, 1964 (64.101.1002)

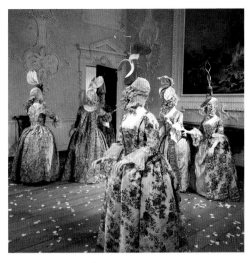

THE ENGLISH GARDEN

Dining Room from Kirtlington Park, Oxfordshire (ca. 1748)

Kirtlington Park was built for Sir James Dashwood (1715–1779) between 1742 and 1746 by William Smith (1705–1747) and John Sanderson (d. 1783). The house and its park, which was laid out by Lancelot "Capability" Brown (1716–1783), are situated about ten miles north of Oxford. The dining room's plaster decoration is derived from a design signed by John Sanderson (act. 1730–74) and was executed by Thomas Roberts (1711–1771). At the four sides of the ceiling are panels emblematic of the seasons. The overmantel painting of a landscape with figures is signed by John Wootton (ca. 1682–1765) and dated 1748. The marble chimneypiece can be attributed to John Cheere (d. 1787) or Sir Henry Cheere (1703–1781). The mahogany doors and shutters are equipped with their original gilt-bronze hardware. The oak floor was probably cut from trees felled on the estate. As documented by microscopic examination of the various layers of paint, the color of the room approximates that of the original.

British. Mantua (open robe and petticoat), ca. 1708. "Bizarre" silk with pink ground brocaded with polychrome silk threads and gold threads. The Metropolitan Museum of Art, Purchase, Rogers Fund, and Isabel Shults Fund, and Irene Lewisohn Bequest, 1991 (1991.6.1a, b)

Philip Treacy, British (b. Ireland, 1967). Hat ("*Paphiopedilum philippinense* Orchid"), spring/summer 2000. Green and brown synthetic stretch jersey and white and purple synthetic organza. Courtesy of Philip Treacy London Haute Couture

British. *Robe à l'anglaise* (closed robe), ca. 1725. Spitalfields silk with brown ground brocaded with rust and beige silk threads. The Metropolitan Museum of Art, Purchase, Irene Lewisohn Bequest, 1964 (C.I.64.14)

Philip Treacy, British (b. Ireland, 1967). Hat ("Pitcher Plant Leaf"), spring/summer 2000. Green synthetic stretch jersey. Courtesy of Philip Treacy London Haute Couture

British. *Robe à l'anglaise* (closed robe), fabric ca. 1725. Spitalfields silk with ivory ground brocaded with polychrome silk threads. Courtesy of Royal Ontario Museum, Gift of Kathleen Mary Savory (2001.81.1)

Philip Treacy, British (b. Ireland, 1967). Hat ("*Paphiopedilum* Orchid"), spring/summer 2000. Pink synthetic stretch jersey, green and white synthetic organza, and green clipped ostrich feathers. Courtesy of Philip Treacy London Haute Couture

British. *Robe à la française* (open robe and petticoat), fabric ca. 1730. Spitalfields silk with green ground brocaded with polychrome silk threads. The Metropolitan Museum of Art, Purchase, Irene Lewisohn Bequest, 1959 (C.I.59.54a, b)

Philip Treacy, British (b. Ireland, 1967). Hat ("*Phaleonopsis* Orchid"), spring/summer 2000. Cream straw and cream and green synthetic stretch jersey. Courtesy of Philip Treacy London Haute Couture

British. *Robe à la française* (open robe and petticoat), fabric ca. 1730s. Spitalfields silk with blue ground brocaded with polychrome silk threads, and trimmed with fly fringe. The Metropolitan Museum of Art, Purchase, Catherine D. Wentworth Bequest, 1948 (48.187.709a, b)

Philip Treacy, British (b. Ireland, 1967). Hat ("*Paphiopedilum* Irish Eyes Orchid"), spring/summer 2000. Green synthetic stretch jersey and green and purple silk synthetic organza. Courtesy of Philip Treacy London Haute Couture

British. *Robe à l'anglaise* (open robe and petticoat), fabric ca. 1730s. Spitalfields silk with cream ground brocaded with polychrome silk threads. The Metropolitan Museum of Art, Rogers Fund, 1934 (34.108)

Philip Treacy, British (b. Ireland, 1967). Hat ("Slipper of Aphrodite"), spring/summer 2000. Pink synthetic stretch jersey and green and white clipped ostrich feathers. Courtesy of Philip Treacy London Haute Couture

British. *Robe à l'anglaise* (closed robe), fabric ca. 1730s. Spitalfields silk with mauve ground brocaded with polychrome silk threads. Courtesy of Cora Ginsburg, LLC

Philip Treacy, British (b. Ireland, 1967). Hat ("*Paphian* Orchid"), spring/summer 2000. Pink, white, and green synthetic stretch jersey, pink straw, and pink clipped ostrich feathers. Courtesy of Philip Treacy London Haute Couture

British. *Robe à la française* (open robe and petticoat), fabric ca. 1750s. Spitalfields silk with pink ground brocaded with polychrome silk threads and trimmed with fly fringe. Courtesy of Cora Ginsburg, LLC

Philip Treacy, British (b. Ireland, 1967). Hat ("Asiatic Slipper Orchid"), spring/summer 2000. Green synthetic stretch jersey and white and purple clipped ostrich feathers. Courtesy of Philip Treacy London Haute Couture

Hussein Chalayan, British (b. Cyprus, 1970). Dress, autumn/winter 2000–2001. Pink nylon tulle. Courtesy of Hussein Chalayan

Manolo Blahnik, British (b. Spain, 1942). Shoes ("Balleri"), spring/summer 1995. Black leather. Courtesy of Manolo Blahnik

John Gumley, British (d. 1726) and James Moore, British (d. 1729). Chandelier, ca. 1715. Gilt gesso on wood with gilt-metal mounts. The Metropolitan Museum of Art, Purchase, Wrightsman Fund, and Mrs. Charles Wrightsman Gift, by exchange, 1995 (1995.141)

John Wootton, British (1682–1765). *Classical Landscape with Hunters and Gypsies*, 1748. Oil on canvas. The Metropolitan Museum of Art, Fletcher Fund, 1931 (32.53.2)

François Boucher, French (1703–1770). *Washerwomen*, 1768. Oil on canvas. The Metropolitan Museum of Art, Gift of Julia A. Berwind, 1953 (53.225.2)

148

François Boucher, French (1703–1770). *Shepherd's Idyll*, 1768. Oil on canvas. The Metropolitan Museum of Art, Gift of Julia A. Berwind, 1953 (53.225.1)

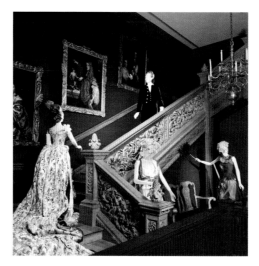

UPSTAIRS/DOWNSTAIRS

Staircase from Cassiobury Park, Hertfordshire (ca. 1677–80)

The staircase, attributed to Edward Pearce (ca. 1635–1695), comes from Cassiobury Park (now destroyed), Hertfordshire, and was executed between 1677 and 1680 for Arthur Capel, first Earl of Essex (1632–1683). The scrollwork balustrade and pinecone finials are of ash, and the handrail and stringcourse are of pine.

House of Worth, French (1858–1956). Court dress, ca. 1888. Skirt of lilac satin; train and bodice of ivory, green, and yellow voided velvet. Courtesy of Museo de la Moda y Textil, Santiago, Chile

British. Court suit, ca. 1877. Blue silk velvet. The Metropolitan Museum of Art, Gift of Mary Pierrepont Beckwith, 1969 (C.I.69.33.16a–f)

Henry Poole & Co., British (founded 1846). Livery from Dalmeny House, 1880s. Coat of green wool broadcloth with silver braid trim; breeches of wool plush with silver braid trim; waistcoat of yellow wool broadcloth with silver braid trim. Courtesy of Henry Poole & Co.

Hussein Chalayan, British (b. Cyprus, 1970). Dress, spring/summer 2002. Black lace, black silk, black crepe, black cotton, and black georgette. Courtesy of Hussein Chalayan

Hussein Chalayan, British (b. Cyprus, 1970). Dress, spring/summer 2002. Blue lace, blue crepe, blue cotton, blue nylon tulle, and mauve *changeant* taffeta. Courtesy of Hussein Chalayan

Hussein Chalayan, British (b. Cyprus, 1970). Dress, spring/summer 2002. Beige cotton, green cotton, green nylon tulle, "rusted" cotton canvas, pink silk tulle, with metal sequin and plastic bead embroidery. Courtesy of Hussein Chalayan

British. Settee, ca. 1730–35. Walnut, gilt gesso, modern silk. The Metropolitan Museum of Art, Fletcher Fund, 1924 (24.136.1)

Jeremiah Johnson, British (act. 1668–1690). Longcase clock with calendar, ca. 1685–90. Oak with walnut veneer and various marquetry woods and gilt- and silvered brass. The Metropolitan Museum of Art, Gift of Irwin Untermyer, 1962 (62.214.1)

Sir Peter Lely (Pieter van der Faes), British (b. Holland, 1618–1680). *Mary Capel (1630–1715), Duchess of Beaufort, and Her Sister Elizabeth (1633–1678), Countess of Carnarvon*, ca. 1660. Oil on canvas. The Metropolitan Museum of Art, Bequest of Jacob Ruppert, 1939 (39.65.3)

Sir Peter Lely (Pieter van der Faes), British (b. Holland, 1618–1680). *Sir Henry Capel (1638–1696)*, ca. 1660. Oil on canvas. The Metropolitan Museum of Art, Bequest of Jacob Ruppert, 1939 (39.65.6)

Jacob Huysmans, British (b. Flanders, ca. 1633?–1696). *Earl of Rochester (1647–1689) with a Monkey and a Book*, ca. 1675. Oil on canvas. Private collection

Robert Peake the Elder, British (act. by 1576, d. 1619). *Princess Elizabeth (1596–1662), Later Queen of Bohemia*, ca. 1606. Oil on canvas. The Metropolitan Museum of Art, Gift of Kate T. Davison, in memory of her husband, Henry Pomeroy Davison, 1951 (51.194.1)

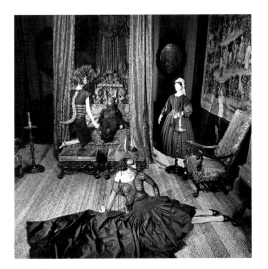

State Bed from Hampton Court, Herefordshire (ca. 1698)

The state bed of carved oak and pine covered with blue silk damask was made for a courtier of King William III, Thomas Baron Coningsby (1656–1729) at Hampton Court, Herefordshire. With its richly carved tester and headboard, it is related to designs by Daniel Marot (1663–1752), architect to William and Mary.

Possibly Sarah Ann Unitt, British (dressmaker to Queen Victoria, 1851–76). Dress worn by Queen Victoria, 1862–63. Black silk, black silk crepe, and white lawn cotton. Courtesy of The Museum of London (54.137/1–4)

Alexander McQueen, British (b. 1969). Dress, spring/summer 1998. Black canvas coated with silver glitter. Courtesy of Alexander McQueen

Shaun Leane, British (b. 1969) for Alexander McQueen, British (b. 1969). Body jewelry ("Spine Corset"), spring/summer 1998. Aluminum. Courtesy of Shaun Leane and Alexander McQueen

Manolo Blahnik, British (b. Spain, 1942). Shoes ("Bhutan"), spring/summer 2006. Black leather and titanium. Courtesy of Manolo Blahnik

Alexander McQueen, British (b. 1969). Ensemble worn by Gwyneth Paltrow to the Academy Awards in 2002, autumn/winter 2002–3. Shirt of black nylon; skirt of black silk taffeta and black silk organza. Courtesy of Alexander McQueen

Philip Treacy, British (b. Ireland, 1967). Hat, autumn/winter 2001–2. White damask, black damask, and black lace with black crystal embroidery. Courtesy of Philip Treacy London Haute Couture

Manolo Blahnik, British (b. Spain, 1942). Shoes ("Torna"), spring/summer 1994. Black satin with black plastic bead and black rhinestone embroidery. Courtesy of Manolo Blahnik

Simon Costin, British (b. 1963). Brooch ("Rabbit Skull Pin"), 1987. Rabbit skull, silver, rock crystal, and hematite. Courtesy of Simon Costin

Alexander McQueen, British (b. 1969). Man's ensemble, autumn/winter 2006–7. Trousers of red, black, and yellow wool plaid; cape-jacket of black wool with black metal thread and black crystal embroidery. Courtesy of Alexander McQueen

Shaun Leane, British (b. 1969) for Alexander McQueen, British (b. 1969). Body jewelry ("Jawbone"), spring/summer 1998. Aluminum. Courtesy of Shaun Leane and Alexander McQueen

British. State bed, ca. 1698. Oak and silk damask. The Metropolitan Museum of Art, Gift of Mr. and Mrs. William Randolph Hearst Jr., 1968 (68.217.1)

John Vanderbank, British (act. 1683–1717) and The Great Wardrobe Tapestry Workshop, British, (founded mid-15th century). Tapestry ("The Concert"), ca. 1690–1715. Polychrome wool and silk. The Metropolitan Museum of Art, Gift of Mrs. George F. Baker, 1953 (53.165.1)

John Vanderbank, British (act. 1683–1717) and The Great Wardrobe Tapestry Workshop, British, (founded mid-15th century). Tapestry ("The Toilet of the Princess"), ca. 1690–1715. Polychrome wool and silk. The Metropolitan Museum of Art, Gift of Mrs. George F. Baker, 1953 (53.165.2)

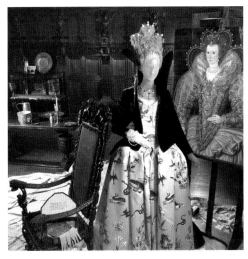

Elizabethan Room, Great Yarmouth, Norfolk (ca. 1595–1600)

The carved oak paneling of this room came from a house on the Hall Quay, Great Yarmouth, Norfolk. It was built at the end of the sixteenth century for William Crowe, a bailiff of Yarmouth and a member of the Company of Spanish Merchants. The coat of arms of this trading company is set over the original stone chimneypiece of the room. The company traded exclusively with the Low Countries, and the decoration of the room is strongly influenced by Netherlandish styles of the time. The carving, which incorporates male and female term figures and architectural motifs freely derived from classical models, has been called "probably the most elaborate specimen of late Tudor woodwork of its kind." The room lacks its original plaster ceiling, which was enriched with moldings and pendants. In the eighteenth century, Crowe's descendants sold the house, which by 1788 had been converted into an inn known as the Star Hotel. Charles Dickens is thought to have used the Star Hotel as a setting in his novel *David Copperfield* (1850). The inn was demolished in 1935, and the Yarmouth post office now stands on the site.

Vivienne Westwood, British (b. 1941). Ensemble, autumn/winter 1997–98. Dress of silver duchesse satin printed with birds, flowers, and aquatic motifs; jacket of black velvet and black satin with gold-plated and simulated pearl jewelry. Courtesy of Vivienne Westwood

Simon Costin, British (b. 1963). Necklace ("Incubus Necklace"), 1987. Silver, copper, glass phials, baroque pearls, and human semen. Courtesy of Simon Costin

British. *Portrait of a Noblewoman*, late 16th century. Oil on wood. The Metropolitan Museum of Art, Gift of J. Pierpont Morgan, 1911 (11.149.1)

British. Armchair, ca. 1685–88. Walnut and modern velvet. The Metropolitan Museum of Art, John Stewart Kennedy Fund, 1918 (18.110.18)

British. Chimneypiece, ca. 1600. Carved stone. The Metropolitan Museum of Art, Edward Pearce Casey Fund, 1965 (65.182.2)

British. Paneling, ca. 1595–1600. Oak. The Metropolitan Museum of Art, Edward Pearce Casey Fund, 1965 (65.182.1)

Vivienne Westwood, British (b. 1941). Ensemble, autumn/winter 1987–88. Bodice and skirt of burgundy silk velvet; cape of synthetic ermine fur; crown of polychrome wool with synthetic ermine fur trim; shoes of wood and black leather. Courtesy of Los Angeles County Museum of Art, Costume Council Fund, M.2002.97a–f

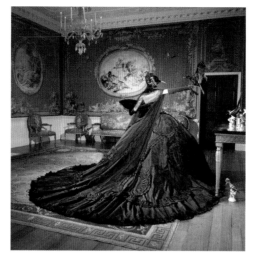

FRANCOMANIA

Tapestry Room from Croome Court, Worcestershire (ca. 1771)

Lancelot "Capability" Brown (1716–1783) was responsible for the plan of the grounds at Croome Court, Worcestershire, the seat of the Earls of Coventry, and for the design of the house, which was his first essay in architecture. Parts of the interior were executed from Brown's designs between 1751 and 1760, when Robert Adam (1728–1792) replaced him as architect. The tapestry room was begun in 1763 and finished in 1771. The sixth Earl of Coventry (1722–1809) commissioned the tapestries in Paris in August 1763. The set was delivered and in place by June 1771. The group was the first using this design to be woven with a crimson background, and it may have been the first made specifically to extend around four walls of a room without architectural frames.

House of Worth, French (1858–1956). Dress, ca. 1898–1900. Skirt and bodice of white silk satin and black silk voided velvet. The Metropolitan Museum of Art, Gift of Eva Drexel Dahlgren, 1976 (1976.258.1a, b)

John Galliano, British (b. Gibraltar, 1960) for Christian Dior Haute Couture, French (founded 1947). Dress ("Maria Luisa"), spring/summer 1998. Black silk taffeta. The Metropolitan Museum of Art, Gift of Christian Dior Couture Paris, 1999 (1999.494a–h)

Stephen Jones, British (b. 1957). Headdress ("Raven"), 2006. Black coq feathers. The Metropolitan Museum of Art, Purchase, The Alfred Z. Solomon Estate, 2006 (2006.209)

Workshop of Jacques Neilson, French (1714–1788) at Gobelins Manufactory, French (founded 1440). After designs by Jean-Germain Soufflot (1713–1780), Maurice Jacques (b. ca. 1712), and François Boucher (1703–1770). Three tapestries representing the Four Elements, ca. 1764–71. Polychrome silk and wool. The Metropolitan Museum of Art, Gift of Samuel H. Kress Foundation, 1958 (58.75.2-.4)

Workshop of Jacques Neilson, French (1714–1788) at Gobelins Manufactory, French (founded 1440). Frames made by John Mayhew, British (1736–1811) and William Ince, British (act. ca. 1758–1794). Set of two settees and six armchairs, fabric, ca. 1760–67; frames, 1769. Gilt fruitwood, multicolored silk, and wool. The Metropolitan Museum of Art, Gift of the Samuel H. Kress Foundation, 1958 and 1959 (58.75.15-.22)

Possibly Robert Adam, British (1728–1792). Made by John Mayhew, British (1736–1811) and William Ince, British (act. ca. 1758–1794). Pier mirror, 1769. Pine, gilt, and glass. The Metropolitan Museum of Art, Gift of the Samuel H. Kress Foundation, 1958 (58.75.131)

John Wildsmith, British (1757–1769). Frame made by John Mayhew, British (1736–1811) and William Ince, British (act. ca. 1758–1794). Side table, top, 1769; frame, 1794. Pine, gilt, and various marbles and semiprecious stones. The Metropolitan Museum of Art, Gift of the Samuel H. Kress Foundation, 1958 (58.75.130a, b)

Joseph Wilton, British (1722–1803) and John Wildsmith, British (act. 1757–1769). Chimneypiece, 1760. Marble and lapis lazuli. The Metropolitan Museum of Art, Gift of the Samuel H. Kress Foundation, 1958 (58.75.1b)

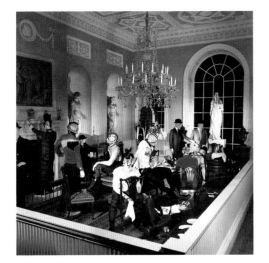

THE GENTLEMEN'S CLUB

Dining Room from Lansdowne House, London (1766–69)

Lansdowne House, designed by Robert Adam (1728–1792) and situated at the southwest corner of Berkeley Square, London, was begun for Prime Minister John Stuart (1713–1792), third Earl of Bute, who sold it, unfinished, about 1765 to William Petty-Fitzmaurice (1737–1805), Earl of Shelburne, later first Marquess of Lansdowne and a leading Whig statesman of the period. The house was completed from Adam's designs for Lord Shelburne in 1768 and was a meeting place for Whig social and political circles in the eighteenth and nineteenth centuries. Originally, the niches of the dining room held nine ancient marble statues acquired by Lord Shelburne in Italy from the artist Gavin Hamilton (1723–1797). The statue of Tyche is the only sculpture original to the room and dates from the second century A.D. The others are plaster casts. The original furniture, designed by Adam and executed by John Linnell (1729–1796), no longer survives. The central block of the house still stands, at the corner of Fitzmaurice Place and Lansdowne Row, and was converted into a club in 1930, when the two wings were demolished.

Henry Poole & Co., British (founded 1846). Livery, ca. 1927. Jacket and trouser of blue facecloth; waistcoat of yellow facecloth. Courtesy of Henry Poole & Co.

Jacket by F. Scholte, British (Dutch, tailor to HRH the Duke of Windsor, 1919–59) and Trousers by H. Harris, American (tailor to HRH the Duke of Windsor ca. 1940s–70s). Formal evening suit (white tie) worn by HRH the Duke of Windsor; jacket, 1938; trousers, 1965. Jacket of midnight blue wool with black grosgrain facings; trousers of midnight blue wool with black grosgrain side trim. The Metropolitan Museum of Art, Gift of the Duchess of Windsor, 1974 (1974.185.3a–c)

Philip Treacy, British (b. Ireland, 1967). Hat worn by HRH the Duchess of Cornwall on the occasion of her marriage to HRH the Prince of Wales, 2005. Feathers and crystals. Courtesy of HRH the Duchess of Cornwall

Anderson & Sheppard Ltd., British (founded 1906). Formal evening suit (white tie), 2006. Jacket of black worsted wool with black grosgrain facings; trousers of black wool with black grosgrain side trim. Courtesy of Anderson & Sheppard Ltd.

Stella McCartney, British (b. 1971). Evening suit, 2006. Jacket of white wool with white satin facings; trousers of white wool. Courtesy of Stella McCartney

Stephen Jones, British (b. 1957). Hat ("Swing"), autumn/winter 1997–98. Metal and crystals. Courtesy of Stephen Jones

Alexander McQueen, British (b. 1969). Formal evening suit (black tie), autumn/winter 2006–7. Jacket of black wool with black satin facings; trousers of black wool with black satin side trim. Courtesy of Alexander McQueen

Alexander McQueen, British (b. 1969). Formal evening suit and cape (black tie), autumn/winter 2006–7. Jacket of black wool with black satin facings; trousers of black wool with black satin side trim; cape of black silk tulle with gold thread embroidery. Courtesy of Alexander McQueen

Carlo Brandelli, British (b. 1968) for Kilgour Ltd., British (founded 1882). Two-piece suit, 2006. Blue wool and cashmere with blue and white spots. Courtesy of Kilgour Ltd.

Richard James, British (founded, 1992). Two-piece suit, 2006. Gray wool and cashmere with pink windowpane check. Courtesy of Richard James

Christopher Bailey, British (b. 1972) for Burberry, British (founded 1856). Two-piece suit, spring/summer 2006. Blue wool and mohair. Courtesy of Burberry

Timothy Everest, British (b. 1961). Three-piece suit, 2006. Black flannel with pink bouclé stripe. Courtesy of Timothy Everest.

Henry Poole & Co., British (founded 1846). Three-piece suit, 2006. Blue worsted wool with white rope stripe. Courtesy of Henry Poole & Co.

Richard Anderson Ltd., British (founded 2001). Two-piece suit, 2006. Gray flannel with white chalk stripe. Courtesy of Richard Anderson Ltd.

H. Huntsman & Sons, British (founded 1849). Two-piece suit, 2006. Gray flannel Glen Urquhart plaid (Prince of Wales check) with blue windowpane. Courtesy of H. Huntsman & Sons

Paul Smith, British (b. 1946). Three-piece suit (British Collection) 2006. Gray wool with white rope stripe. Courtesy of Paul Smith

Ozwald Boateng, British (b. 1967). Two-piece suit, autumn/winter 2003–4. Red wool with rhinestone embroidery. Courtesy of Ozwald Boateng

Malcolm McLaren, British (b. 1946) and Vivienne Westwood, British (b. 1941). Ensemble, ca. 1976–78. T-shirt ("Two Cowboys") of white cotton with red silkscreen; bondage trousers of red and black striped cotton corduroy. T-shirt: The Metropolitan Museum of Art, Gift of Barbara and Gregory Reynolds, 1985 (1985.375.11). Bondage trousers: Courtesy of Resurrection

Stephen Jones, British (b. 1957). "Mohawk" headdress ("Fags"), 2006. Paper and tobacco. The Metropolitan Museum of Art, Purchase, Alfred Z. Solomon Estate, 2006 (2006.204)

Malcolm McLaren, British (b. 1946) and Vivienne Westwood, British (b. 1941). Bondage suit, ca. 1977–78. Jacket and trousers of red, green, and blue wool plaid. The Metropolitan Museum of Art, Purchase, Richard Martin Estate Fund, 2006 (2006.164a, b)

Stephen Jones, British (b. 1957). "Mohawk" headdress ("Bin Liners"), 2006. Black plastic and black coq feathers. The Metropolitan Museum of Art, Purchase, Alfred Z. Solomon Estate, 2006 (2006.206)

Malcolm McLaren, British (b. 1946) and Vivienne Westwood, British (b. 1941). Ensemble, ca. 1977–78. Sweater of red, blue, black, and green mohair; bondage trousers of black cotton sateen with black wool kilt. Courtesy of Resurrection

Stephen Jones, British (b. 1957). "Mohawk" headdress ("Myra"), 1994. Plastic, cotton, and velvet. Stephen Jones. Courtesy of Stephen Jones

Malcolm McLaren, British (b. 1946) and Vivienne Westwood, British (b. 1941). Ensemble, ca. 1977–78. Sweater of red, blue, pink, black, and green mohair; bondage trousers of black cotton sateen with black wool kilt. Sweater: Courtesy of Resurrection. Bondage trousers: The Metropolitan Musuem of Art, Purchase, Richard Martin Bequest, 2003 (2003.479a-c)

Stephen Jones, British (b. 1957). "Mohawk" head-dress ("Barbed Wire"), 2006. Metal and rubber. The Metropolitan Museum of Art, Purchase, The Alfred Z. Solomon Estate, 2006 (2006.205)

Malcolm McLaren, British (b. 1946) and Vivienne Westwood, British (b. 1941). Ensemble worn by Adam Ant, ca. 1977–78. T-shirt ("You're gonna wake up one morning and know what side of the bed you've been lying on") of white cotton and polychrome silkscreen; bondage trousers of black cotton sateen with black cotton terrycloth "nappy"; boots ("Spiderman") of black suede with gray check. T-shirt, bondage trousers, and boots: The Metropolitan Museum of Art, Purchase, Richard Martin Estate Fund and The Friends of the Costume Institute Fund, 2006 (2006. 253.7; 2006.253.18; 2006.161a, b). "Nappy": The Metropolitan Museum of Art, Purchase, NAMSB Foundation Fund, 2006 (2006.12b)

Stephen Jones, British (b. 1957). "Mohawk" headdress ("Broken Records"), 2006. Vinyl. The Metropolitan Museum of Art, Purchase, The Alfred Z. Solomon Estate, 2006 (2006.208)

Malcolm McLaren, British (b. 1946) and Vivienne Westwood, British (b. 1941). Ensemble worn by Adam Ant, ca. 1977–78. T-shirt ("Tits") of white cotton with blue silkscreen; bondage trousers of black cotton sateen with black wool kilt. The Metropolitan Museum of Art, Purchase, Richard Martin Estate Fund and The Friends of the Costume Institute Fund, 2006 (2006.253.15, 2006.253.19, 2006.253.23)

Stephen Jones, British (b. 1957). "Mohawk" headdress ("Fanzine"), 2006. Paper. The Metropolitan Museum of Art, Purchase, The Alfred Z. Solomon Estate, 2006 (2006.210)

Malcolm McLaren, British (b. 1946) and Vivienne Westwood, British (b. 1941). Ensemble, ca. 1977–78. T-shirt ("You're gonna wake up one morning and know what side of the bed you've been lying on") of white cotton and polychrome silkscreen; bondage jacket and trousers of black cotton sateen. T-Shirt: The Metropolitan Museum of Art. Gift of Barbara and Gregory Reynolds, 1985 (1985.375.10). Bondage jacket and trousers: The Metropolitan Museum of Art, Purchase, Irene Lewisohn Bequest, 2004 (2004.15a, b)

Stephen Jones, British (b. 1957). "Mohawk" headdress ("Doc Marten"), 2006. Rubber. The Metropolitan Museum of Art, Purchase, The Alfred Z. Solomon Estate, 2006 (2006.201)

Malcolm McLaren, British (b. 1946) and Vivienne Westwood, British (b. 1941). Ensemble, ca. 1977–78. Parachute shirt of red cotton with silk and wool patches; bondage trousers of red cotton. Parachute shirt: The Metropolitan Museum of Art, Purchase, Richard Martin Estate Fund, 2006 (2006.158). Bondage trousers: Courtesy of PunkPistol

Stephen Jones, British (b. 1957). "Mohawk" headdress ("Tampons"), 2006. White cotton and blue cotton. The Metropolitan Museum of Art, Purchase, The Alfred Z. Solomon Estate, 2006 (2006.207)

Jacket designed and worn by Johnny Rotten (John Lydon), British (b. 1956), made by Vivienne Westwood, British (b. 1941). Ensemble, ca. 1977–78. Jacket of blue and red wool plaid; T-shirt ("God Save The Queen") of cotton with blue silkscreen; trousers of black satin and blue wool; boots of black leather with metal studs. Jacket: Courtesy of John Lydon. T-shirt, trousers, and boots: The Metropolitan Museum of Art, Purchase, Richard Martin Estate Fund, 2006 (2006.160, 2006.165, 2006.162a, b)

Malcolm McLaren, British (b. 1946) and Vivienne Westwood, British (b. 1941). Ensemble, ca. 1977–78. Shirt ("Anarchy"), of cream and brown striped cotton with silk and wool patches; bondage trousers of black cotton sateen. Shirt: The Metropolitan Museum of Art, Gift of Barbara and Gregory Reynolds, 1985 (1985.375.6). Bondage trousers: The Metropolitan Museum of Art, Purchase, NAMSB Foundation Fund, 2006 (2006.12a)

John Galliano, British (b. Gibraltar, 1960). Dress, spring/summer 1986. White muslin. Courtesy of John Galliano

Manolo Blahnik, British (b. Spain, 1942). Shoes ("Idoneo"), spring/summer 2003. White satin and glass beads. Courtesy of Manolo Blahnik

Thomas Chippendale, British (1718–1779). Set of chairs, ca. 1772. Mahogany and modern morocco leather. The Metropolitan Museum of Art, Purchase, Lila Acheson Wallace and The Annenberg Foundation Gifts, Gift of Irwin Untermyer and Fletcher Fund, by exchange, Bruce Dayton Gift, and funds from various donors, 1996 (1996.426.1–.14)

THE HUNT

Bernard Weatherill, British (founded 1912). Hunt ensemble from the Haydon Hunt, Northumberland (founded 1845), ca. 1980. Coat of red wool with black velvet collar; breeches of wool and cotton. Courtesy of Bernard Weatherill

John Galliano, British (b. Gibraltar, 1960). Ensemble, autumn/winter 2004–5. Long johns of white cotton with black newspaper print; jockstrap of white cotton and nylon; boots of black leather. Courtesy of John Galliano

Stephen Jones, British (b. 1957) for John Galliano, British (b. Gibraltar, 1960). Headdress, autumn/winter 2004–5. Silver fox fur. Courtesy of Stephen Jones and John Galliano

Vivienne Westwood, British (b. 1941). Ensemble, autumn/winter 1994–95. Jacket of red wool with black velvet collar; boots of black leather. Courtesy of Vivienne Westwood

Stephen Jones, British (b. 1957). Hat ("Tally Ho"), autumn/winter 1997–98. Red wool, black velvet, and black synthetic fur. Courtesy of Stephen Jones

John Galliano, British (b. Gibraltar, 1960). Ensemble, autumn/winter 2005–6. Jacket of red wool with black wool collar and lapels and red silk trim; trousers of cream canvas and beige leather; shoes of brown leather; hat of black velvet. Courtesy of John Galliano

Christopher Bailey, British (b. 1972) for Burberry, British (founded 1856). Trench coat dress, spring/summer 2006. Lilac and red silk faille. Courtesy of Burberry

Stephen Jones, British (b. 1957). Hat ("London"), autumn/winter 2005–6. Blue straw, black velvet ribbon, white printed cotton, and patch with gold and silver thread embroidery. Courtesy of Stephen Jones

Christopher Bailey, British (b. 1972) for Burberry, British (founded 1856). Trench coat, autumn/winter 2006–7. Beige wool and fox fur. Courtesy of Burberry

British. Pair of chandeliers, ca. 1725. Gilt wood, gesso, and ormolu candle sockets. The Metropolitan Museum of Art, Gift of Irwin Untermyer, 1970 (1970.148.1, .2)

Thomas Gainsborough, British (1727–1788). *Mrs. Ralph Izard* (Alice DeLancey, 1746/47–1832), 1772. Oil on canvas. The Metropolitan Museum of Art, Bequest of Jeanne King deRham, in memory of her father, David H. King Jr., 1966 (66.88.1)

Willem Wissing, British (b. Holland, 1656–1687). *Portrait of a Woman*, ca. 1687. Oil on canvas. The Metropolitan Museum of Art, Bequest of Jacob Ruppert, 1939 (39.65.7)

Daniel Mijtens the Elder, British (b. Holland, 1590–1647/48). *Charles I* (1600–1649), *King of England*, 1629. Oil on canvas. The Metropolitan Museum of Art, Gift of George A. Hearn, 1906 (06.1289)

Sir Godfrey Kneller, British (b. Germany, 1646/49–1723). *Charles Beauclerk* (1670–1726), *Duke of St. Albans*, ca. 1690. Oil on canvas. The Metropolitan Musuem of Art, Bequest of Jacob Ruppert, 1939 (39.65.8)

Thomas Gainsborough, British (1727–1788). *Mrs. Grace Dalrymple Elliott* (1754?–1823), ca. 1778. Oil on canvas. The Metropolitan Museum of Art, Bequest of William K. Vanderbilt, 1920 (20.155.1)

Sir Joshua Reynolds, British (1723–1792). *Captain George K. H. Coussmaker* (1759–1801), ca. 1782. Oil on canvas. The Metropolitan Museum of Art, Bequest of William K. Vanderbilt, 1920 (20.155.3)

Sir Joshua Reynolds, British (1723–1792). *Anne Dashwood* (1743–1830), *Later Countess of Galloway*, ca. 1764. Oil on canvas. The Metropolitan Museum of Art, Gift of Lillian S. Timken, 1950 (50.238.2)

Enoch Seeman the Younger, British (1694–1744). *Sir James Dashwood* (1715–1779), *2nd Baronet*, 1737. Oil on canvas. The Metropolitan Museum of Art, Victor Wilbour Memorial Fund, 1956 (56.190)

Joseph Wright of Derby, British (1734–1797). *Portrait of a Woman*, ca. 1770. Oil on canvas. The Metropolitan Museum of Art, Gift of Heathcote Art Foundation, 1986. (1986.264.6)

Thomas Gainsborough, British (1727–1788). *Portrait of a Man, Called General Blyth*, ca. 1770. Oil on canvas. The Metropolitan Museum of Art, Bequest of Lillian S. Timken, 1959 (60.71.7)

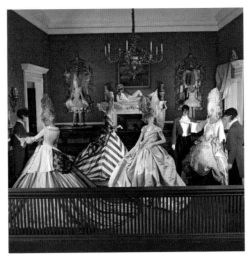

THE HUNT BALL

H. Huntsman & Sons, British (founded 1849). Formal dress hunt ensemble from the Iroquois Hunt, Kentucky (founded 1880), ca. 1970s. Jacket of red baratha wool with black silk velvet collar and pale blue grosgrain facings; trousers of black wool with black grosgrain side trim. Courtesy of H. Huntsman & Sons

H. Huntsman & Sons, British (founded 1849). Formal dress hunt ensemble, ca. 1970s. Jacket of red baratha wool with black wool collar and red grosgrain facings; trousers of black wool with black grosgrain side trim. Courtesy of H. Huntsman & Sons

Henry Poole & Co., British (founded 1846). Formal dress hunt ensemble from the New Forest Hunt, ca. 1890–1910. Jacket of red broadcloth wool with green velvet collar and cream grosgrain facings; trousers of black wool with black grosgrain side trim. Courtesy of Henry Poole & Co.

British. Formal dress hunt ensemble, ca. 1897. Jacket of red broadcloth wool with cream grosgrain facings; trousers of black wool with black grosgrain side trim. Jacket: The Metropolitan Museum of Art, Gift of Emily N. Wilson, 1980 (1980.199.2). Trousers: The Metropolitan Museum of Art, Gift of Clay H. Barr, in memory of Jay D. A. Barr, 1995 (1995.442.10c)

John Galliano, British (b. Gibraltar, 1960). Ensemble, spring/summer 1994. Jacket of lavender silk satin, cream silk tulle, and white swans down trim; skirt of pink silk, black silk tulle, and black silk lace. Courtesy of John Galliano

Manolo Blahnik, British (b. Spain, 1942). Shoes ("Lamour"), spring/summer 2006. Lavender silk satin. Courtesy of Manolo Blahnik

John Galliano, British (b. Gibraltar, 1960). Ensemble, spring/summer 1994. Jacket of gray and pink striped silk taffeta with silver stripe, black silk tulle, and cream lace; skirt of gray and pink striped silk taffeta with silver stripe, and black silk tulle. Courtesy of John Galliano

Manolo Blahnik, British (b. Spain, 1942). Shoes ("Zorat"), spring/summer 1975. Pink and black silk satin. Courtesy of Manolo Blahnik

John Galliano, British (b. Gibraltar, 1960). Ensemble, spring/summer 1994. Jacket of white silk, white silk tulle, and white swans down; skirt of blue and white striped silk. Courtesy of John Galliano

Manolo Blahnik, British (b. Spain, 1942). Shoes, spring/summer 2006. Beige silk with polychrome silk thread and rhinestone embroidery. Courtesy of Manolo Blahnik

Stephen Jones, British (b. 1957). Hat ("Tricorn"), spring/summer 1994. White silk and white grosgrain ribbon. Courtesy of Stephen Jones

Vivienne Westwood, British (b. 1941). Ensemble, autumn/winter 1992–93. Bodice of pink tulle with white cotton overlay; skirt of pink cotton organdy and white tulle. Courtesy of Vivienne Westwood

Manolo Blahnik, British (b. Spain, 1942). Shoes ("Soya"), autumn/winter 1997–98. Pink silk satin and pink feathers. Courtesy of Manolo Blahnik

Vivienne Westwood, British (b. 1941). Dress, autumn/winter 2005–6. Pink duchesse satin. Courtesy of Vivienne Westwood

Manolo Blahnik, British (b. Spain, 1942). Shoes, autumn/winter 2005. Pink silk satin with pink velvet ribbon, lilac silk ribbon, and lilac leather trim. Courtesy of Manolo Blahnik

Alexander McQueen, British (b. 1969). Ensemble, spring/summer 2005. Skirt of lilac silk brocaded with silver threads; jacket of lilac silk with polychrome silk thread embroidery; body stocking of cream nylon with polychrome silk thread embroidery. Courtesy of Alexander McQueen

Manolo Blahnik, British (b. Spain, 1942). Shoes ("Circus"), spring/summer 1997. Gray silk faille. Courtesy of Manolo Blahnik

Alexander McQueen, British (b. 1969). Dress, spring/summer 2005. Pink silk brocaded in silver thread with red and pink silk rosettes. Courtesy of Alexander McQueen

Manolo Blahnik, British (b. Spain, 1942). Shoes ("Circus"), spring/summer 1997. Gray silk faille. Courtesy of Manolo Blahnik

John Galliano, British (b. Gibraltar, 1960). Ensemble, autumn/winter 2004–5. Shirt of white cotton; leggings of white cotton with black newspaper print; shoes of black leather. Courtesy of John Galliano

Stephen Jones, British (b. 1957) for John Galliano, British (b. Gibraltar, 1960). Headdress, autumn/winter 2004–5. Coyote fur. Courtesy of Stephen Jones and John Galliano

British. Chandelier, ca. 1750–60. Carved gilt linden wood. The Metropolitan Museum of Art, Gift of Irwin Untermyer, 1950 (50.82)

Attributed to John Michael Rysbrack, British (1694–1770). Mantel, ca. 1745–50. Marble. The Metropolitan Museum of Art, Gift of The Hearst Foundation, 1956 (56.234.4)

Attributed to Thomas Moore, British (ca. 1700–1778). Fire screen, ca. 1755–60. Mahogany. The Metropolitan Museum of Art, Gift of Irwin Untermyer, 1964 (64.101.1155)

Sir Joshua Reynolds, British (1723–1792). *George, Viscount Malden (1757–1830), and His Sister, Lady Elizabeth Capel (1755–1834),* 1768. Oil on canvas. The Metropolitan Museum of Art, Gift of Henry S. Morgan, 1948 (48.181)

James Seymour, British (1702–1752). *Portrait of a Horseman,* 1748. Oil on canvas. The Metropolitan Museum of Art, Gift of the children of the late Otto H. and Addie W. Kahn (Lady Maud E. Marriott, Mrs. Margaret D. Ryan, Roger W. Kahn, and Gilbert W. Kahn), 1956 (56.54.1)

Sir Joshua Reynolds, British (1723–1792). *Thomas (1741–1825) and Martha Neate, Later Mrs. Williams, and Their Tutor, Mr. Needham,* 1748. Oil on canvas. The Metropolitan Musuem of Art, Gift of Heathcote Art Foundation, 1986 (1986.264.5)

[Page 6] Sir Peter Lely (Pieter van der Faes), British (b. Holland, 1618–1680). *Barbara Villiers, Countess of Castlemaine* (1641–1709), *as a shepherdess*, ca. 1666. Oil on canvas. The Collection at Althorp

[Page 8] Jacob Huysmans, British (b. Flanders, ca. 1633–1696). *Lord Rochester* (1647–1680) *with a Monkey and a Book*, ca. 1675. Oil on canvas. Private collection

[Pages 10–11] William Hogarth, British (1697–1764). Detail of *The March to Finchley*, ca. 1749–50. Oil on canvas. The Foundling Museum, London. Photograph courtesy of Bridgeman Art Library

[Pages 14–15] William Hogarth, British (1697–1764). Detail of *The Gate of Calais, or O! The Roast Beef of Old England*, ca. 1748–49. Oil on canvas. Tate Gallery, London. Photograph courtesy of Art Resource, NY

[Page 18] James Gillray, British (1756–1815). Detail of *'Politeness' The state of Anglo-French relations played out by John Bull and his French counterpart*, 1779. Pen, ink, and wash on paper. Mary Evans Picture Library

[Page 28] George Stubbs, British (1724–1806). Detail of *Lady Reading in a Park*, ca. 1768–70. Oil on canvas. Private collection. Photograph courtesy of Bridgeman Art Library

[Page 38] Joseph Highmore, British (1692–1780). Detail of *Pamela Preparing to Go Home*, ca. 1743–44. Oil on canvas. National Gallery of Victoria, Melbourne, Australia, Felton Bequest, 1921

[Page 50] Robert Walker, British (1599–1658). *John Evelyn* (1620–1706), 1648. Oil on canvas. National Portrait Gallery, London

[Page 62] Anonymous. *Queen Elizabeth I* (1533–1603), ca. 1599. Oil on canvas. Hardwick Hall, Derbyshire. © National Trust Photo Library/John Hammond

[Page 68] Sir Joseph Highmore, British (1692–1780). *Maria Gunning, Countess of Coventry* (1733–1760), 1745. Oil on canvas. Waddesdon, The Rothschild Collection (The National Trust). Photograph by Mike Fear © The National Trust, Waddesdon Manor

[Page 74] Richard Dighton, British (1795–1880). Detail of *The Dandy Club*, 1818. Etching. © The Royal Pavilion, Libraries & Museums, Brighton & Hove

[Page 106] George Stubbs, British (1724–1806). Detail of *Laetitia, Lady Lade* (d. 1825), 1793. Oil on canvas. The Royal Collection © 2006 Her Majesty Queen Elizabeth II

[Page 124] William Hogarth, British (1697–1764). Detail of *The Counry Dance*, ca. 1745. Oil on canvas. Tate Gallery, London. Photograph courtesy of Art Resource, NY

[Page 156] Thomas Gainsborough, British (1727–1788). Oil on canvas. *Mrs. Grace Dalrymple Elliott* (1754?–1823), 1778. The Metropolitan Museum of Art, Bequest of William K. Vanderbilt, 1920 (20.155.1)

[Page 158] Sir Joshua Reynolds, British (1723–1792). *Captain George K. H. Coussmaker* (1759–1801), 1782. Oil on canvas. The Metropolitan Museum of Art, Bequest of William K. Vanderbilt, 1920 (20.155.3)

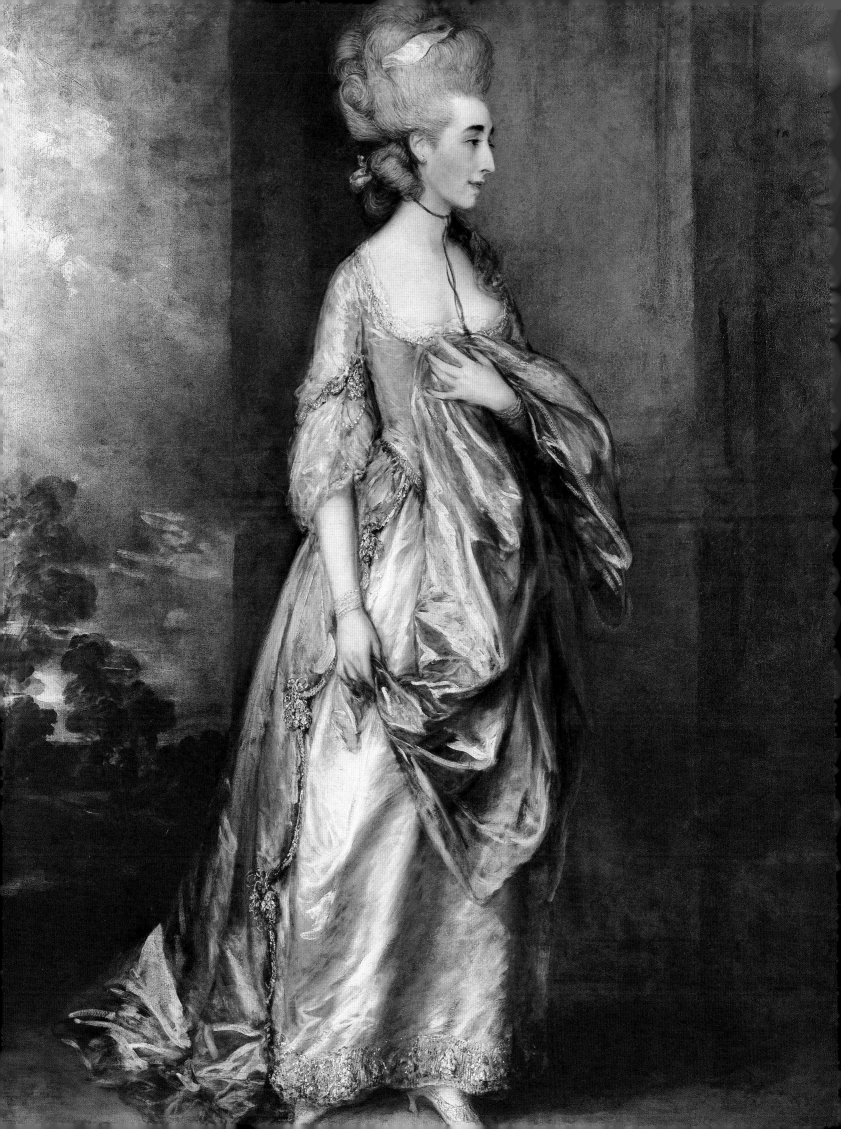

SELECT BIBLIOGRAPHY

Arch, Nigel, and Joanna Marschner. *Splendour at Court: Dressing for Royal Occasions since 1700*. London: Unwin Hyman, 1987.

Arnold, Janet, ed. *Queen Elizabeth's Wardrobe Unlock'd*. Leeds: Maney, 1988.

Arnold Rebecca. "Vivienne Westwood's Anglomania." In *The Englishness of English Dress*, edited by Christopher Breward, Becky Conekin, and Caroline Cox, pp. 161–72. Oxford: Berg, 2002.

Beard, Geoffrey. *The Compleat Gentleman: Five Centuries of Aristocratic Life*. New York: Rizzoli, 1993.

Breward, Christopher. "The Dandy Laid Bare: Embodying Practices and Fashion for Men." In *Fashion Cultures: Theories, Explorations, and Analysis*, edited by Stella Bruzzi and Pamela Church Gibson, pp. 221–38. London: Routledge, 2000.

Breward, Christopher, Becky Conekin, and Caroline Cox, eds. *The Englishness of English Dress*. Oxford: Berg, 2002.

Buck, Anne. "Pamela's Clothes." *Costume: Journal of the Costume Society of Great Britain* 26 (1992), pp. 21–31.

Buruma, Ian. *Voltaire's Coconuts, or, Anglomania in Europe*. London: Weidenfeld & Nicolson, 1999.

Chalmers, Patrick R. *The History of Hunting*. Philadelphia: J. B. Lippincott, 1936.

Chenoune, Farid. *A History of Men's Fashion*. Paris: Flammarion, 1993.

Cicolini, Alice. *The New English Dandy*. London: Thames & Hudson, 2005.

Clayton, Michael. *The Chase: A Modern Guide to Foxhunting*. London: Stanley Paul, 1987.

Davey, Kevin. *English Imaginaries: Six Studies in Anglo-British Modernity*. London: Lawrence & Wishart, 1999.

Evans, Caroline. *Fashion at the Edge: Spectacle, Modernity, and Deathliness*. New Haven: Yale University Press, 2003.

Gaunt, William. *Court Painting in England from Tudor to Victorian Times*. London: Constable, 1980.

Ginsburg, Madeleine. "Rags to Riches: The Second-Hand Clothes Trade 1700–1978." *Costume: Journal of the Costume Society of Great Britain* 14 (1980), pp. 121–35.

Gittings, Clare, and Peter C. Jupp, eds. *Death in England: An Illustrated History*. New Brunswick, N.J.: Rutgers University Press, 2000.

Groningen Museum. *Hussein Chalayan*. Exh. cat. Contributions by Caroline Evans et al. Rotterdam: NAi Publishers, 2005.

Groom, Nick. *The Union Jack: The Story of the British Flag*. London: Atlantic Books, 2006.

Hunt, Tamara L. *Defining John Bull: Political Caricature and National Identity in Late Georgian England*. Aldershot: Ashgate, 2003.

Itzkowitz, David C. *Peculiar Privilege: A Social History of English Foxhunting, 1753–1885*. Hassocks: Harvester Press, 1997.

Jarrett, Derek. *England in the Age of Hogarth*. New Haven: Yale University Press, 1986.

Kelly, Ian. *Beau Brummell: The Ultimate Dandy*. London: Hodder & Stoughton, 2005.

Longrigg, Roger. *The History of Foxhunting*. London: Macmillan, 1975.

Mackay-Smith, Alexander, Jean R. Druesedow, and Thomas Ryder. *Man and the Horse: An Illustrated History of Equestrian Apparel*. Exh. cat. New York: Metropolitan Museum of Art, 1984.

Mason, Philip. *The English Gentleman: The Rise and Fall of an Ideal*. New York: William Morrow, 1982.

McCreery, Cindy. *The Satirical Gaze: Prints of Women in Late Eighteenth-Century England*. Oxford: Clarendon Press, 2004.

McWilliam, Neil. *Hogarth*. London: Studio Editions, 1993.

Metropolitan Museum of Art. *Period Rooms in the Metropolitan Museum of Art*. Contributions by Amelia Peck et al. New York: Metropolitan Museum of Art, 1996.

Morley, John. *Death, Heaven, and the Victorians*. London: Studio Vista, 1971.

Postle, Martin, ed. *Joshua Reynolds: The Creation of Celebrity*. Exh. cat. London: Tate Publishing, 2005.

Ribeiro, Aileen. *The Art of Dress: Fashion in England and France 1750 to 1820*. New Haven: Yale University Press, 1995.

Ribeiro, Aileen. *Dress and Morality*. New York: Holmes & Meier, 1986.

Ribeiro, Aileen. *Dress in Eighteenth-Century Europe, 1715–1789*. 2d ed. New Haven: Yale University Press, 2002.

Ribeiro, Aileen. "On Englishness in Dress." In *The Englishness of English Dress*, edited by Christopher Breward, Becky Conekin, and Caroline Cox, pp. 15–28. Oxford: Berg, 2002.

Rogers, Ben. *Beef and Liberty*. London: Chatto & Windus, 2003.

Rosenthal, Michael. *British Landscape Painting*. Ithaca, N.Y.: Cornell University Press, 1982.

Rosenthal, Michael, and Martin Myrone, eds. *Thomas Gainsborough, 1727–1788*. Exh. cat. New York: Abrams, 2002.

Rothstein, Natalie. *Silk Designs of the Eighteenth Century*. London: Thames & Hudson, 1990.

Schor, Esther. *Bearing the Dead: The British Culture of Mourning from the Enlightenment to Victoria.* Princeton: Princeton University Press, 1994.

Staniland, Kay. *In Royal Fashion: The Clothes of Princess Charlotte of Wales & Queen Victoria, 1796–1901*. London: Museum of London, 1997.

Strong, Roy C. *Portraits of Queen Elizabeth I*. Oxford: Clarendon Press, 1963.

Tate Gallery. *Manners & Morals: Hogarth and British Painting 1700–1760*. Exh. cat. London: Tate Gallery, 1987.

Turner, Roger. *Capability Brown and the Eighteenth-Century English Landscape*. Rev. ed. Chichester: Phillimore, 1999.

Walker, Richard. *Savile Row: An Illustrated History*. New York: Rizzoli, 1989.

Walpole, Horace. *The Yale Edition of Horace Walpole's Correspondence*. 5 vols. Edited by W. S. Lewis. Oxford: Oxford University Press, 1983.

Warner, Malcolm, and Robin Blake. *Stubbs and the Horse*. Exh. cat. New Haven: Yale University Press, 2004.

Waterfield, Giles, Anne French, and Matthew Craske. *Below Stairs: 400 Years of Servants' Portraits*. Exh. cat. London: National Portrait Gallery, 2003.

Wharncliffe, Lord, ed. *The Letters and Works of Lady Mary Wortley Montagu*. 2 vols. 3d ed. New York: AMS Press, 1970.

Wilcox, Claire. *Vivienne Westwood*. London: V&A Publications, 2004.

Wilton, Andrew. *The Swagger Portrait: Grand Manner Portraiture in Britain from Van Dyck to Augustus John, 1630–1930*. Exh. cat. London: Tate Gallery, 1992.

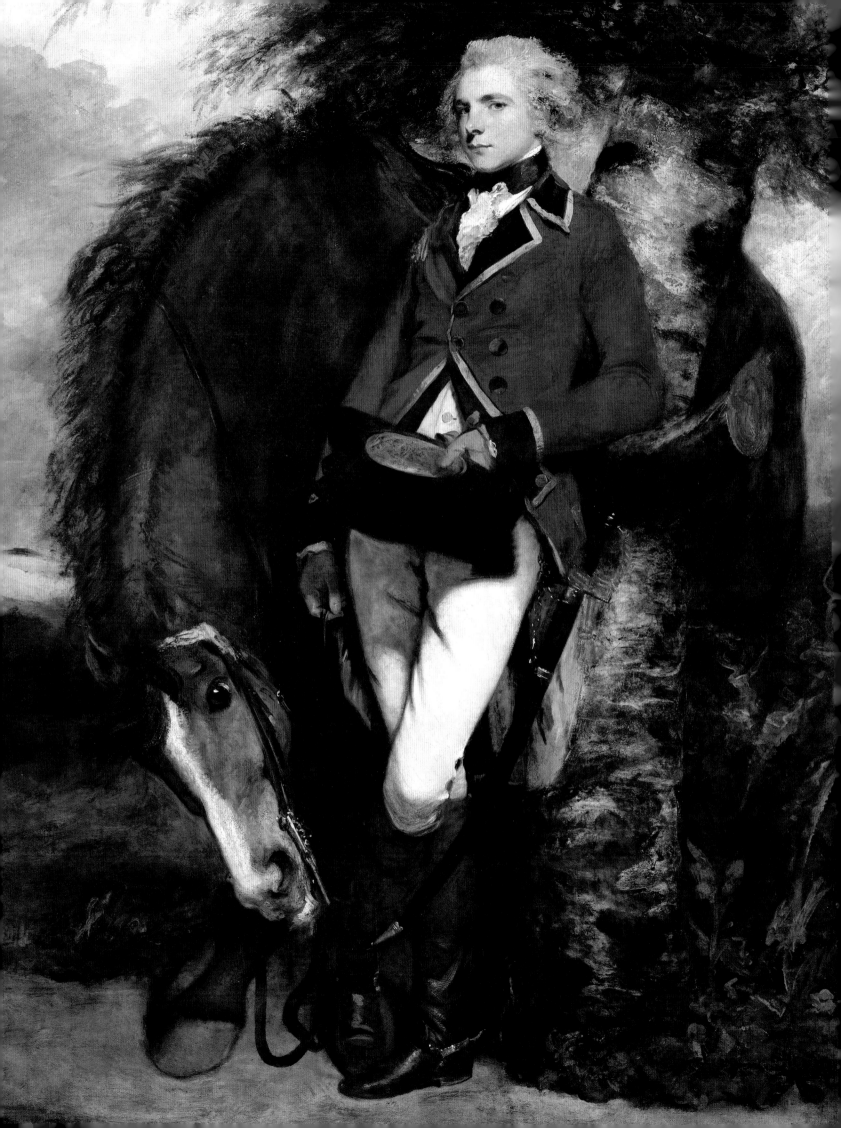

I am grateful to the many people who provided generous support for the exhibition "AngloMania" and this handsome publication. In particular I am fortunate to have had the advice and encouragement of Philippe de Montebello, director of The Metropolitan Museum of Art; Emily K. Rafferty, president of The Metropolitan Museum of Art; Nina McN. Diefenbach, vice president for Development and Membership; Harold Koda, curator in charge of The Costume Institute; Ian Wardropper, Iris and B. Gerald Cantor Chairman, European Sculpture and Decorative Arts; Daniëlle O. Kisluk-Grosheide, curator, European Sculpture and Decorative Arts; Anna Wintour, editor in chief of American *Vogue*; and Burberry, specifically Rose Marie Bravo, chief executive, and Christopher Bailey, creative director, who generously donated funds to the exhibition and this catalogue. I also thank Condé Nast for providing additional support for both projects.

Patrick Kinmonth and Antonio Monfreda, creative consultants, were responsible for staging the room vignettes that made the exhibition such a success and this book so striking.

Julien d'Y's, the wig designer, created the remarkable wigs for the mannequins, investing them with both character and movement.

My colleagues in The Costume Institute have been invaluable in every aspect. I extend my deepest gratitude to Sara Bernstein, Elizabeth Bryan, Pia Christensson, Elyssa Da Cruz, Michael Downer, Joyce Fung, Jessica Glasscock, Charles Hansen, Amanda Haskins, Stéphane Houy-Towner, Jessa Krick, Julie Le, Rebecca Matheson, Bethany Matia, Marci Morimoto, Tatyana Pakhladzyhan, Christine Paulocik, Shannon Price, Jessica Regan, Lita Semerad, Kristen Stewart, and Yer Vang.

I would also like to extend my sincerest appreciation to the docents, interns, and volunteers of The Costume Institute, Torrey Thomas Acri, Ajiri Aki, Kitty Benton, Barbara Brickman, Jane Butler, Patricia Corbin, Danielle Devine, Eileen Ekstract, Karen Fong-Luna, Susan Furlaud, Corey Garcia, Rachel Harris, Caroline Hickman, Colleen Hill, Elizabeth Hyman, Betsy Kallop, Elizabeth Arpel Kehler, Susan Klein, Jennifer Klos, Philis Kreitzman, Elizabeth Kromelow-Dietz, Susan Lauren, Nina Libin, Joan Lufrano, Rena Lustberg, Veronica McNiff, Butzi Moffitt, Doris Nathanson, Ellen Needham, Wendy Nolan, Julia Orron, Pat Peterson, Christine Petschek, Phyllis Potter, Ann Poulson, Rena Schklowsky, Eleanor Schloss, Bernice Shaftan, Nancy Silbert, Judith Sommer, Andrea Vizcarrondo, Muriel Washer, Signe Watson, Bernice Weinblatt, DJ White, Krista Willis, and Sonja Wong.

For the ongoing support of The Friends of The Costume Institute and The Visiting Committee of The Costume Institute, I am especially grateful.

Apart from allowing The Costume Institute access to the Annie Laurie Aitken Galleries, members of the Department of European Sculpture and Decorative Arts contributed generously of their time and knowledge. I am indebted to Shirley Allison, Thomas P. Campbell, James David Draper, Roger Haapala, Marva Harvey, Johanna Hecht, Lorraine Karafel, Wolfram Koeppe, Elizabeth Lee Berszinn, Cybèle Gontar, Robert Kaufmann, Jessie McNab, Jeffrey Munger, Marina Nudel, Melinda Watt, Erin E. Pick, Melissa Smith, Juan Stacey, Denny Stone, Bedel Tiscareño, Clare Vincent, and Rose Whitehill.

I am also grateful to members of the department of European Paintings including Katharine Baetjer, Andrew Caputo, Dorothy Kellett, Theresa King-Dickinson, Gary Kopp, and John McKanna.

Photographer Joseph Coscia Jr. of the Photograph Studio of The Metropolitan Museum of Art beautifully translated the vignettes of the exhibition into the wonderful photographs that comprise this volume. He is to be highly commended.

The Editorial Department of The Metropolitan Museum of Art, under the guidance of John P. O'Neill, editor in chief, provided the expertise to make this book a reality. Special thanks go to Margaret R. Chace, Joan Holt, Gwen Roginsky, Kamu Romero, and Paula Torres.

Takaaki Matsumoto, assisted by Hisami Aoki, Keith Price, and Amy Wilkins, carried out the book's design with typical finesse.

I would also like to thank colleagues from various departments at The Metropolitan Museum of Art for their assistance, including Rosayn D. Anderson, Pamela T. Barr, Mechthild Baumeister, Kay Bearman, Christine S. Begley, Kim Benzel, Sheila Bernstein, Eti Bonn-Muller, Einar Brendalen, Barbara Bridgers,

159

Nancy C. Britton, Cindy Caplan, Andrew Caputo, Paul Caro, Cristina Carr, Jennie Choi, Aileen K. Chuk, Michael Cocherell, Kathrin Colburn, Clint Coller, Emilia Cortes, Sharon H. Cott, Christine Coulson, Deanna Cross, Willa M. Cox, Cristina del Valle, Jennifer Dodge, Priscilla F. Farah, Catherine Fukashimi, Helen Garfield, Sophia Geronimus, Patricia Gilkison, Jessica Glass, Claire Gylphé, Rachel Harris, Harold Holzer, Min-Sun Hwang, Catherine Jenkins, Michael Jenkins, Marilyn Jensen, Kristina Kamiya, Blanche Perris Kahn, Andrea Kann, Beth Kovalsky, Alexandra Klein, Andrey Kostiw, Will Lach, Michael Langley, Kerstin Larsen, Oi-Cheong Lee, Jennifer Leventhal, Richard Lichte, Annette Luba-Lucas, Amanda Maloney, Kristin M. MacDonald, Nina S. Maruca, Annie Matson, Missy McHugh, Taylor Miller, Mark Morosse, Herbert M. Moskowitz, Rebecca L. Murray, Maya Naunton, Christopher Noey, Nadine Orenstein, Sally Pearson, Elena Phipps, Diana Pitt, Doralynn Pines, Hilda Rodriguez, Fred Sager, Midori Sato, Sabine Rewald, Crayton Sohan, Soo Hee Song, Lasley Poe Steever, Donna Sutton Williams, Linda Sylling, Gary Tinterow, Elyse Topalian, Valerie Troyansky, Philip T. Venturino, Romy Vreeland, Jenna Wainwright, Alexandra Walcott, Sian Weatherill, Vivian Wick, Betsy Wilford, Karin L. Willis, Deborah Winshel, Sandra Wiskari-Lukowski, Chinyan Wong, Heather Woodworth, Steve Zane, Elizabeth Zanis, Florica Zaharia, and Egle Zyas.

I am extremely grateful to the lenders to the exhibition not only for their loans but also for allowing me to reproduce their costumes in this catalogue. My thanks go to, Richard Anderson (Clive Gilkes, Brian Lishak), Anderson & Sheppard (John Hitchcock, Colin Heywood, Karl Matthews, Josie Rowland, Anda Rowland), Manolo Blahnik (Joe Fountain), Ozwald Boateng (Jazz Virdee, Leandra Hernandez), David Bowie (Eileen d'Arcy), Budd Ltd. (Andy Rowley, Sarah Webster), Burberry (Christopher Bailey, Rose Marie Bravo, John Cross, Marsha Ilsley, Erika Johnson, Sarah Manley), Bernard Weatherill Limited (Hugh Holland, Michael Smith, Anthony Smith), G. J. Cleverly & Co. Ltd. (George Glasgow, Andrew Murphy), Hussein Chalayan (Milly Patrzalek), Simon Costin, Timothy Everest (Claudia Ottobrino), Museo de la Moda y Textil, Santiago, Chile (Jorge Yarur Bascuñan, Nathalie Hatala), Lorraine Goddard, John Galliano (Jelka Music), Cora Ginsburg LLC (Titi Halle, Michele Majer, Leigh Wishner), Henry Poole & Co. Ltd. (Joshua Byrne, Angus Cundey, Keith Levett), Huntsman (Poppy Charles, Peter Smith), Richard James (Olok Banerjee, Toby Lamb, Nancy Oakley, Brian Pusey, Annamarie Scott), Stephen Jones (Alexis Teplin), Kilgour (Carlo Brandelli, Richie Charlton, Anne Marie Ng, Lara Mingay), Shaun Leane (Olivia Norman), Los Angeles County Museum of Art (Dr. Nancy Thomas, Kaye Spilker, Melinda Kerstein), James Locke & Co. Ltd. (Janet Taylor), John Lydon (Anita Camarata), Stella McCartney (Arabella Rufino), Alexander McQueen (Aiden Alden, Myriam Coudoux, Amie Wallace, Kerry Youmans), The Museum of London (Edwina Ehrman, Oriole Cullen, Nickos Gogolos), The Museum of the City of New York (Phyllis Magidson), Resurrection (Katy Rodriguez), Royal Ontario Museum (Alexandra Palmer), Paul Smith (Cindy Vieira, Clive Williams, Colette Youell), PunkPistol, Stolper-Wilson Collection (Andrew Wilson, Paul Stolper), Philip Treacy (Nina Farnell-Watson), and Vivienne Westwood (Andreas Kronthaler, Carlo d'Amario, Murray Blewett, Kathryn Dale, Denise Zamarioni)

Special thanks to: Rebecca Arnold, Harry Bolton, Marion Bolton, Hamish Bowles, Clare Brown, Grace Coddington, Rosemary Harden, Ian Kelly, Joell Kunath, Bernice Kwok-Gabel, Francois Leroy, Joanna Marschner, Susan Prichard, Sonnet Stanfill, and David Vincent.